GETTING
YESTERDAY RIGHT

GETTING YESTERDAY RIGHT

Interpreting the heritage of Wales

J. GERAINT JENKINS

AMBERLEY

Let me have understanding,
for it was not in my mind
to be curious of the high
things but of such as pass
us by daily.

2 Esdras, chapter IV, verse 23

First published 1992
This edition published 2009

Amberley Publishing
Cirencester Road, Chalford,
Stroud, Gloucestershire, GL6 8PE

www.amberley-books.com

British Library Cataloguing in Publication Data.
A catalogue record for this book is available from the British Library.

ISBN 978 1 84868 152 1

Typesetting and Origination by Amberley Publishing.
Printed in Great Britain.

CONTENTS

PREFACE

It is said that during the 1970s a new museum was opened somewhere in Britain every fortnight; heritage centres, preserved industrial sites, town trails and historic houses open to the public proliferated. These sites and facilities provide a semblance of solidity in an era when our landscapes and townscapes are rapidly changing, mass production and new technology have replaced older craft skills and unemployment is high. The heritage business has flourished as a result of our increased leisure time and our nostalgia for what seems a less complex and less stressful way of life.

This book examines the growth of historically oriented institutions in Wales. The preservation, conservation and interpretation of historical sites, buildings and artefacts is of great importance, but has the conservation movement and our preoccupation with the past gone too far? Is the past the only future that we have as a nation? Are we attempting to preserve too much without giving enough thought to the lasting value of the things preserved? Will future generations thank us for handing down so many historical artefacts? Is this land of Wales rapidly becoming one vast museum warranting signs at Queensferry and on the Severn Bridge, proclaiming 'This land is now open to the public'? Those are some of the questions posed in this volume.

With over thirty years experience as a member of staff of the National Museum of Wales, at the Welsh Folk Museum and the Welsh Industrial and Maritime Museum, I was given the opportunity of visiting a large number of heritage sites and tourist attractions in Wales. Most of the information presented in this book is of necessity based on field-work and personal observation. As the inaugural Chairman of the Society for the Interpretation of Britain's Heritage and museum consultant with the Carnegie UK Trust and other organisations, I visited many interpretive facilities in other parts of Britain, the European continent and North America. This survey, although confined to the heritage industry in Wales, also has implications for the development of museums and interpretive centres in other parts of the United Kingdom and elsewhere.

J. Geraint Jenkins
April 1992

ACKNOWLEDGEMENTS

In the preparation of this volume I would like to thank my former colleagues at the National Museum of Wales for their assistance. In particular I would like to thank Dr Bill Jones, Dr Dafydd Roberts and Mr Richard Keen. My thanks to Mrs Anne Bunford for typing the manuscript and Ms Liz Powell of the University of Wales Press for her help, encouragement and editorial skills, and to my son, Richard Jenkins, for the maps. My thanks too to the staffs of all the institutions I visited and to Mr Geoff Rich, former Editor of the South Wales Echo who read my original manuscript and made many valuable suggestions.

A NOTE ON ILLUSTRATIONS

Unless otherwise acknowledged, all photographs in this book are from the archives of the National Museum of Wales, Museum of National History and the National Waterfront Museum.

1 THE LAND OF THE RED DRAGON

Over the last quarter of a century a worldwide preoccupation with preserving the visible signs of a rapidly disappearing past has led to the establishment of thousands of institutions which in one way or another seek to interpret history. In Britain recent years have witnessed a spectacular growth in the business of preserving the past, a proliferation of heritage centres and museums, an increase in the number of historic houses and preserved industrial sites open to the public. On major and minor roads, a rash of brown direction signs points the visitor to a variety of sites all supposedly representative of the disappearing heritage of these islands. 'In all of us' wrote Alex Hailey in *Roots*, 'there is a hunger, marrow-deep, to know our heritage, to know who we are and where we come from. Without this enriching knowledge there is a hollow yearning. No matter what our attainments in life, there is still a vacuum and the most disquieting loneliness.'

'Heritage is very much a word of the 1980s', said D. Light.[1] 'Yet it is a word that lacks a clear definition. In its widest sense, heritage refers to what is inherited, and this can encompass almost every facet of both natural and man-made environments. However the key point about heritage is that it concerns features and artefacts from the past.' Today interest in the past has attained unprecedented levels. Nostalgia is rife, and is attracting more and more people. It embraces almost all of the past and many present landscapes.[2] Faced with an increasingly unfamiliar and uncertain future, many people may be seeking security and stability in the supposedly safer world of the past. As the attraction of the past grows, history becomes an increasingly marketable resource and Lowenthal notes that remembrance of times past is a growth industry in almost every developed country. Hence it is hardly surprising that the 1980s witnessed 'the wholesale incorporation of "history" into the mainstream of British life'.[3] This decade has seen the emergence of what has become known as the 'heritage industry'.[4]

In Wales, the degradation of the countryside, pollution, unemployment, industrial decay, demise of a language and the lowering of traditional values are all symptoms of the present age's rush into the uncertain future. The wholesale destruction of town-centres and industrial sites during the 'swinging sixties'—that decade of public vandalism, of high-rise flats and industrial deserts—brought a crisis to the attention of many. To make

matters even worse, the so-called 'Welsh way of life' was being eroded very rapidly, the Welsh language was in decline and the country has, during the last three decade or so, entered a period of crisis with notable elements of its heritage disappearing like melting snow. The reactions to the crisis are well known: the creation of official bodies such as Cadw, the Countryside Commission and the Welsh Language Board; the establishment of the Welsh Language Society, of amenity groups and preservation societies. There has been a stupendous growth in establishments concerned with the material and social heritage of Wales, folk museums and farm museums, country parks and heritage trails, preserved mills and cottages and preserved slate quarries, coal mines, copper and lead mines. In some parts of the country, the preservation of the heritage has reached epidemic proportions with the result that visitors could be forgiven for thinking that parts of this land are entirely geared to cater for summer tourists. 'Instead of manufacturing goods we are manufacturing heritage' says Robert Hewison. 'What was once the world's workshop is rapidly being turned into its biggest museum.'

Undoubtedly it has been tourism more than anything else that has fuelled the new heritage movement, with the result that certain tourist honeypots such as Snowdonia and the county of Pembroke are over-supplied with attractions while other regions equally important in the heritage of the Welsh people have not been interpreted in any way. Or had not until recently. In the 1980s that situation began to change and less scenically attractive areas such as the Rhondda and Rhymney Valleys and industrial Deeside were drawn into the web of tourism.

Far too often when a building or site or even a town has outlived its useful life, tourism is presented as the elixir that will cure all its ills. This has happened in the Rhondda Valley and Merthyr Tudful for example, as the coal industry has been obliterated. The north Wales town of Blaenau Ffestiniog, that once supplied the world with roofing materials, is now a town of 'tourist providers' rather than slate quarrymen. It has, according to a recent publicity brochure, 'Shops, magnificent scenery and song, sheep in the High Street, waterfalls, walks and fine fishing, slate quarries, site of Britain's newest railway station, pumped storage [for the creation of hydro-electric power], plenty of parking and the last fulling mill to run on water power, now a museum'. Blaenau Ffestiniog has become an unlikely tourist honeypot.

Before 1950 Wales had about fifty establishments concerned with some aspects of the history and heritage of Wales. These were mainly town museums and historic monuments that attracted relatively few visitors. Over the next nineteen years a further forty-eight attractions were opened to give a total of ninety-eight by the time the Wales Tourist Board was formed in 1969. With its ability to provide grants for the creation of new

The romance of the love spoon as depicted on a mass-produced tea towel purchased on Llandudno Pier, 1990

attractions there was a rapid acceleration and between 1969 and 1976 a further forty-five new attractions had been opened, subsequently growing by ten or twelve a year to a present-day total of about 325. And through them all the red dragon in its various guises marches as a symbol of Welsh identity. On craft products and sweatshirts, on wall plaques and love spoons, that emblem of the Welsh people, once a symbol of bravery and victory over the Saxon white dragon, has been established as a formidable marketing logo.

Of course there is nothing new in the development of tourism as a substitute for industrial production in times of crisis and retraction. In July 1935, Thomas Jones writing in the *New Statesman* said, 'If we want to turn South Wales into an industrial museum there's no shortage of blueprints'. Consider this:

> Details of the best way of laying out the national ruin so as to make it attractive to American tourists and remunerative to the transport and catering companies may be left to be worked out by a committee... The Rhymney valley might be flooded and made into a lake... For the Rhondda and Merthyr areas we urge... an irrevocable Standing Order whereby all human beings would be evacuated to the Hounslow/Dagenham Green Belt. The Office of Works should then proceed to protect all approaches from souvenir hunters and should invite His Majesty to declare the area an Open

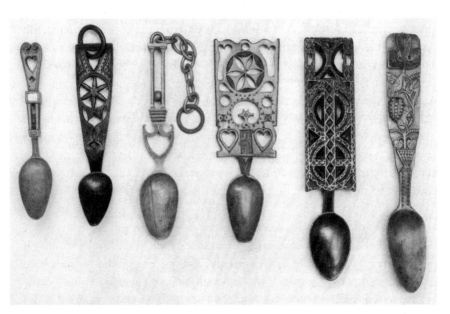

The real thing: hand-carved love spoons from the eighteenth and nineteenth centuries in the Welsh Folk Museum Collection

Museum... to illustrate the Industrial Revolution. Some winding engines should be kept in open repair to enable visitors to descend the pit shafts and explore the subterranean galleries an experience which should be no less thrilling than a visit to the catacombs of Rome.

Even if the interpretive facilities have been set up as the result of tourist demand, integrity and authenticity should be fundamental to what is provided. Unplanned tourism can destroy a great deal of what should be presented and interpreted, and there is also a grave danger in the overprovision of tourist facilities. The north Wales slate industry for example is now interpreted in at least seven preserved quarries while local maritime museums in Gwynedd have proliferated: Nefyn, Porthmadog, Caernarfon, Aberdyfi, Holyhead and Barmouth already have one, while others like Amlwch, Moelfre and Menai Bridge would like one. With the scarcity of relevant material and the absence of a trained staff and conservation facilities, it is difficult to envisage the proper development of all these minor units. In south Wales, the coal industry is already fully interpreted at Blaenafon, Afan Argoed, Crynant, Swansea, Abertillery, Pontypool and Cardiff, while the ambitious Rhondda Heritage Park is developing rapidly at Treforest on the site of the old Lewis Merthyr Colliery. Railway preservation societies, agricultural machinery societies and many others have proliferated in an age of increased leisure; while tracts of land that once supported a working population have now been developed by the dozen as heritage sites. Rusting heaps of metal and crumbling buildings, once an attraction to the scrap dealer, now attract the conservationist, albeit too late in the day in many instances. Have we now in certain fields of activity reached saturation point where we cannot accept more warehouses turned into industrial museums, more restored working pump engines and water-driven corn mills, more slate quarries, 'ye olde Welsh cottages' and 'Great Little Trains of Wales'? Of course, properly planned conservation and interpretive facilities are essential, but far too often, developments in Wales have been haphazard and unplanned and have depended on the whims and idiosyncrasies of individuals and groups. 'There is such a thing as trying to preserve too much', said Niels Jannasch,

... both man and the products of his endeavours are ephemeral indeed... Imagine what the world, especially the western world, would look like today if past generations had been as keen on collecting and preserving as we have been during the last twenty years. Perhaps one-fifth of our countries would by now be covered with museums, historic buildings, villages and towns, industries and historic harbours full of ships. A proportionate number of people would be busily occupied in administering and preserving the lot... Considering the

mad rush to preserve the past, we should think once in a while of Francis Bacon, who said... 'Antiquities are history defaced or some such remnants of history which have casually escaped the shipwreck of time...'[5]

In all establishments concerned with interpreting heritage there is a grave danger in presenting material that has romantic and nostalgic connotations. There are, for example, many exhibitions that extol the virtues of country life—the idyllic past that we in the late twenty-first century look back at with *hiraeth* and yearning. Is that reality? It was certainly not true of the major part of rural Wales; an inhospitable, poor land where the margin between existence and starvation was a very narrow one indeed. For many hill farmers, life was an endless battle against hostile elements; there were severe constraints on higher output from the land, the prospects of arable farming were poor and upland pastures could easily be obliterated by gorse, heather and reed. In a cold, wet and hostile environment the hill farmer was forced by circumstances to depend on his own ingenuity to make the best possible use of the limited resources available to him. That authentic picture of life on the land with its poverty and misery has hardly ever been presented in an interpretive facility in Wales. It is far easier to arrange 'ye olde Welsh farm kitchen', complete with dresser, cradle, Bible and framed picture of William Williams, Pantycelyn than to present an authentic picture of the poverty that characterized much of Welsh rural life.

The long story of man's encounter with the sea as presented in a number of Welsh maritime museums limits itself to 'the romance of the age of sail'. There are paintings of noble vessels in full rig, sailing deep blue seas; there are the nostalgic souvenirs brought back by sailing men from lands across the sea and there are pictures of contented groups of sailors. But beautiful though sailing vessels may have been, they only represented a short span in man's utilization of the oceans. More often than not, in dealing with those late nineteenth and early twentieth-century vessels, their role as the most dangerous form of transport ever devised is glossed over in an attempt to present an atmosphere of romance. The loss of life and the hardship associated with sailing vessels was appalling, for the truth about sailing is that it was cruel and unrelenting. But perhaps it would be unpalatable to the visiting tourist to follow the story of sail in all its misery.

When we visit the cosy tourist-oriented slate quarries of Gwynedd, is the picture of the slate quarryman and his community presented to us a truthful one? Were they all literary men concerned with composing *englynion* in strict metre for their fellow workers? Were they all concerned with philosophical and theological discussions in their staff canteens and did they *all* participate in the *eisteddfodau caban* that were so commonplace in Gwynedd? Did they indeed spend their leisure hours

carving slate clocks and slate fans? Contrast two descriptions of Blaenau Ffestiniog. The current guide book to Blaenau's largest tourist-oriented slate enterprise says:

> Slate was to North Wales what coal was to the South; a hidden mineral wealth that fired the imagination of Victorian speculators and attracted the migration of a remarkable generation of God-fearing men who gradually shed their rural cocoons to establish new urban communities with a distinctive folk culture. Some of our best known towns and harbours and their connecting roads and railways grew out of the new mines and quarries. So did many of our best poets, preachers, singers and writers.[6]

The picture that emerges in the interpretation of this particular site is of a happy, stereotyped community that contributed to the cultural wealth of the Welsh nation. There is no mention of the brutalizing environment of the slate quarries, nor of the constant hostility between masters and workers. Perhaps the reality of the Gwynedd slate industry is better reflected in the writing of a late-nineteenth-century minister of religion who had a profound knowledge of his people:

> They suffer regularly from rheumatism and often die from chronic and debilitating effects of consumption. Many things associated with their work are of necessity detrimental to their health. Notice the buildings, holed, bared and cold, where the slate splitter and slate dresser sit all day long. The walls of their shelters are but a heap of stones built in the most careless way; the wind and the rain drive through with ease and since the huts are built high up on the slate galleries, they are completely unsuitable accommodation for men to sit in for some twelve hours a day.[7]

It was Dr Dafydd Roberts who stated that 'The main pitfall in the preservation of the slate industry is to present a sanitized, innocuous industry and a happy community of men and masters, who conformed to the most popular stereotype of "The Welshman". Death and injury, insanitary houses and ill health, trade unionism and hatred of Anglicized masters are themes far too often ignored or merely glossed over to hurry on to the more desirable issues.'

In interpreting the heritage of Wales today, it is not enough to preserve the beautiful and discard the ugly, when the ugly might have been far more representative of the heritage we wish to present. As the nineteenth and twentieth centuries fade further into the past, the task of making people aware of the past and of providing a true understanding of their heritage becomes even more complex.

On the face of it, Wales, or at least parts of it, is well blessed with institutions, sites and commercial enterprises that have taken advantage of the heritage of the Principality as an eminently marketable commodity. On the one hand there are the craft workshops and craft retail shops that are all geared to supplying the needs of the tourist market, providing pottery and knitted garments, coloured candles and shepherds' crooks that are of necessity small and easily portable. On the other hand there are the museums and heritage centres, preserved workshops and industrial undertakings that have mushroomed. Whether all those establishments authentically represent the heritage of Wales is questionable, for more often than not, when a new enterprise is started, no questions are asked of whether that enterprise is truly representative of the heritage we wish to preserve and interpret. There is a grave danger in saying, 'We have a site, be it a disused quarry or an empty church, a coal mine or derelict industrial site, and since we are in a tourist area let us interpret it', rather than saying—'We have a theme that is of vital importance in the heritage of our people; let us find the best possible site where this can be done'. For example, the very important copper mining industry of north Wales that could be fully interpreted in the major Mynydd Parys area of Anglesey, is represented at Sygun copper mine—a mere minnow as copper mines go, near the tourist village of Beddgelert.

One of the main purposes of heritage interpretation should be to make the people of Wales aware of their own traditions and to promote pride in their history as a people. Preserved buildings and museums, visitor centres and industrial sites should encourage an awareness and understanding of landscape, settlement and environment. Those working in this field should concern themselves, with preserving, studying and presenting all those elements that, added together, make up the pattern of life in a national, regional or even a local context. Heritage may be likened to a patchwork quilt; its size and something of its general appearance is known, but it is necessary to ensure that all the pieces that make up the whole fit together and there are not too many pieces that are exactly alike. The resources available should be used in such a way that they contribute towards a full interpretation of the character and personality of the Welsh nation. There is far more to interpreting the heritage than taking over an old building or derelict site and opening it to the general public.

In the history of heritage interpretation in Wales, it seems that developers, and most of those are immigrant entrepreneurs, tend to copy other people's good ideas. This has resulted in phases, fads and fashions and over-provision in an attempt to extract as much money as possible from the visiting public. Since 1950, Wales has gone through its folk museum period where the country bygones of farm and kitchen are presented to a visiting, largely urban public; it has passed through its living farm museum

period where Welsh Black Cattle and Tamworth Pigs are presented as in zoological gardens. The slate industry, the coal industry, the wool textile industry and the corn milling trade have also been popular, while railway preservation groups and maritime history have had their days of glory. But parallel with this since about 1985, Wales seems to have entered a yacht marina period with the development of thousands of boat moorings and the provision of Lego-like second homes, chandleries, boutiques and restaurants on foreshores. In many cases significant features of the past have been obliterated in an attempt to cater for the extended leisure time of future generations and of course to extract the maximum return on captial investment. For example, today, nothing remains of Brunel's railway terminus and packet station at Neyland in Dyfed; Y Felinheli (Port Dinorwic) in Gwynedd with the slate warehouses, ship repair facilities and its atmosphere of a once busy port is now rapidly developing into a village of bijou houses and floating gin palaces that rarely leave their safe moorings—almost like mobile caravans that remain immobile on permanent, landscaped sites.

It is a matter of urgency that some coherence should be brought into the collecting of material objects and the preserving of heritage sites. The key to a proper policy of conservation is in-depth research, determining what is significant and worthy of preservation. There is always a temptation to spend time and energy on presenting and preserving the irrelevant and obscure, the curious and unusual rather than mainstream material that is of relevance to the life of the community. Blind alleys often beckon the interpreter. Without basic research work one can never be sure that the sites preserved and artefacts collected are of relevance in the story that is being presented. The National Wool Museum in the west Wales village of Drefach Felindre for example, would never have been established in that remote village had not a full survey of the history of the wool textile industry been carried out beforehand.[8] It was only as a result of an intensive historical and field study that it became possible to pinpoint Dre-fach Felindre, once known as 'the Huddersfield of Wales' as the right place to interpret the most widespread and important of Welsh rural industries.

The preservation of the curious is exemplified in the most sacred cow of the Welsh identity—Welsh national costume. With its yards of lace and prickly flannel, its layers of petticoats and tall hats, it may be nothing more than a myth; a romantic costume of nineteenth-century carnival brought into existence by the pressure of an earlier tourist marketing ploy aimed at making Wales different. Harpists and folk singers, dancers and children celebrating the feast of Wales's abstemious patron saint appear in versions of that unbecoming female dress although nylon may have replaced the old red flannel, and sandals the wooden-soled clogs once worn by country women.

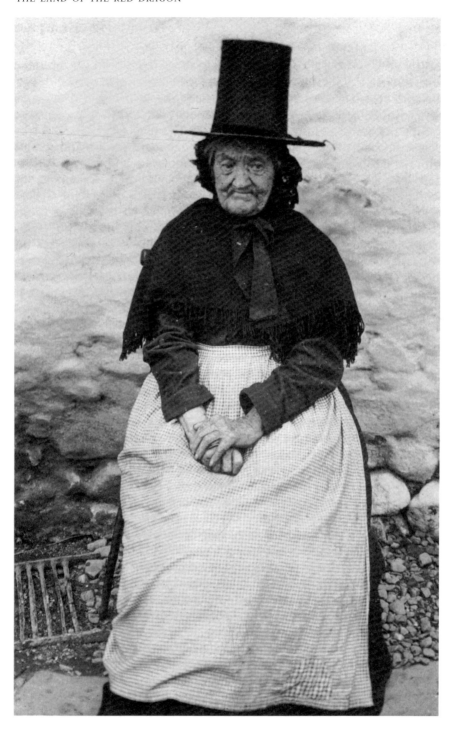

'Traditional' Welsh costume. Rhandmnwyn, Dyfed c. 1890

The so-called 'traditional Welsh costume' has a very short history indeed and that seen at *eisteddfodau* and folk festivals today is almost entirely a creation of fancy; it is the costume of the carnival rather than true peasant dress. Ffransis Payne in his paper 'Welsh Peasant Costume' has stated that:

> In all the enormous mass of evidence I have never met with any suggestion of a national costume for either men or women. There is no evidence that Welsh people of position or substance dressed differently from those of similar rank in other countries... down into the eighteenth century, I have never found anything specifically characteristically Welsh in the garments described. Ordinary folk too, in so far as they were able, followed the fashion, even though they followed it from afar.[9]

From the second half of the eighteenth century, however, one can see the retention of a form of female dress that was well divorced from contemporary fashion; this was a form of dress popular in many parts of the country including Wales.

In 1834 a formidable romantic Englishwoman, Augusta Hall, Lady Llanover, won a prize at the Gwent and Dyfed Royal Eisteddfod for her essay 'The Advantages Resulting from the Preservation of the Welsh Language and National Costume of Wales'. She upheld the use of heavy flannel for dresses and deplored the use of more colourful and lighter materials. On her Monmouthshire estates she even set up a woollen mill to produce the 'traditional' heavy flannels of Wales. She and her friends offered prizes in the *eisteddfodau* from the 1830s onwards for flannel, woollen stockings, cloaks and beaver hats.

'There were', says Payne:

> ... ten such competitions in the Abergavenny Eisteddford of 1853. Lady Llanover offered a prize of £5 for the best collection of patterns of Welsh flannels, 'in real National checks and stripes with the Welsh names by which they are known ... no specimens to be included which have not been well known for at least half a century. The object of the prize is to authenticate the real old checks and stripes of Wales and to preserve them... distinct from new fancy patterns...'

It is very significant that no one was worthy of the prize. No one could have won it because there were not any 'real national' checks and stripes. It is to be doubted indeed whether there were many such things in the whole of western Europe.

But even if there were no ancient and traditional patterns, the zeal and influence of this determined lady were such that the country did not mind

11

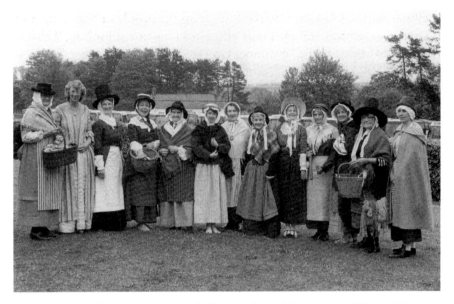

The variety of Welsh costume as modeled by members of the St Fagans Women's Institute 1989

being persuaded that these patterns did exist. Lady Llanover encouraged her friends from the country houses of Monmouthshire, Glamorgan, Brecknock and elsewhere to dress in this fashion at the eisteddfodau and upon other public occasions. Lady Llanover does not appear to have taken as much interest in a national costume for men, apart, that is, from some members of her household staff at Llanover. It was she who turned farm servants' working clothes into conscious, or rather self-conscious, national costume. She also left her mark on efforts that were being made to attract tourists to Wales.

By the end of the nineteenth century Welsh costume had become the stereotyped dress of the postcard makers, aimed at a tourist market. Blouse and skirt replaced the bedgown; a paisley shawl replaced the flannel shawl; and the 'models' used by early photographers 'were always ready when the camera called to weave garters, spin wool, collect eggs, knit or draw up their chairs to yet another open-air tea table.' Payne sums up the history of Welsh costume as follows, 'In the early part of the nineteenth century, the efforts of Lady Llanover and her friends had given new life and a new significance to an old rural costume that had hardly anything specifically Welsh about it, and, here towards the end of the century, we see commercial activity doing much the same kind of thing.' Yet the objects of these two movements were poles apart. The earlier was addressed almost entirely to the Welsh people themselves; but the later movement was directed at

the English. Lady Llanover wished to see all the people of Wales, the rich man in his mansion and the poor cottager who worked for him, Welsh in speech and custom—and costume. On the other hand, the later business with obsolete and phoney customs, souvenirs and comic postcards was symptomatic of a sickness, endemic in the bilingual community of late nineteenth century Wales.

And so, at the end of the century, all over Wales people began to interest themselves anew in a so-called national dress that had disappeared. There was not much interest in the harsh and ugly garments that occasionally survived from earlier times. It was the false and prettified ones of the studio portraits that were attractive.

Many of the heritage centres of Wales include an important museum element displaying the artefacts of rural and urban life. The proliferation of such institutions is worrying in that important items are becoming ever scarcer and as a result many items not worthy of preservation have been uplifted to the status of national treasures. In farm museums, for example, winnowing boxes and box mangles, ploughs by Ransomes and wagons by the Bristol Carriage Works, all very commonplace items, have been preserved by the dozen and many rural museums are nothing but monuments to the mass consumerism of the 1920s and 1930s. Many of these items are repainted, not in their original colours but with any old paint that came to hand—silver ploughs proliferate in farm museums.

With the setting up of heritage centres in chapels and warehouses, smallholdings and forest clearings there usually follows a desperate hunt for artefacts to fill those structures. Attics and auction rooms disgorge all manner of useful lots that can be installed in a display; lots that may or may not be representative of the heritage that is presented. Many of those collections presented to the public are 'cabinets of curiosities' that have little relevance to the life of the local community. More often than not, only small items can be collected with the result that a museum collection can often provide a false picture of life within the community that it represents. Furthermore, the miscellaneous collections that are presented sometimes lack any documentation at all and have been amassed more out of acquisitive mania than in a spirit of scholarly research.

The preservation of substantial buildings and of extensive sites is a time-consuming and expensive exercise which may involve an establishment in a heavy programme of maintenance and repair. Conservation of certain artefacts may demand an expertise that is no longer common. For example, the preservation of sailing vessels has been proposed by a number of institutions and individuals. 'Those ships were well and strongly built' said a recent Texan advertisement, 'but their intended life span is long passed... effort and money on a scale far greater than ever before is needed to save

them.' Perhaps a replica of a sailing ship with extensive use of fibreglass and plastic would be far more realistic, for to preserve a wooden vessel even in a dry dock requires endless attention. Without an extensive and highly skilled staff and an almost bottomless pocket it is difficult to promote ship preservation. One would need staff with a considerable knowledge of shipwrighting, anchor and chain smithing, mast and spar making and block and sail making. A plentiful supply of slowly seasoned oak, lignum vitae, cast iron and copper sheathing would also be necessary. The problems of finding the appropriate raw materials and discovering expertise are bound to get worse as time progresses. In other fields of conservation both expertise and raw materials are getting scarcer day by day. Millwrights and boilermakers, wattle weavers and pattern makers are few and far between and their skills may well disappear sooner rather than later.

The identification of artefacts and of sites and the listing of undigested facts are not sufficient to hold the interest of the general public today. Heritage needs to be presented in context and as part of a story told in an imaginative way. The material objects in a museum's collections—the houses we attempt to preserve, the industrial sites that we conserve—should above all contribute to an understanding of the community that they represent. Collection and preservation is not an end in itself but merely a means of reaching a people in whose past the artefacts on display had the meaning of everyday things, and preserved buildings the meaning of homes and workplaces. In many institutions objects from sugar cutters to box mangles and from mortising chisels to candlesticks are held up to view as if they were Monet paintings, without reference to their historical, social and cultural background.

'Interpretation' says Freeman Tilden, the pioneer of the subject in North America, 'is the stimulation of a visitor's interest in a resource and the promotion of understanding, to give his visit enjoyment and meaning'.[10] The primary purpose according to Tilden is to explore the significance of a resource and encourage an awareness and an understanding of a landscape, settlement or region. It is concerned with natural resources, with the role of man and the economic, social and cultural conditions of the past and present that contribute to the identity of a land and its people. It has a duty to inspire and fire the imagination of the visiting public. A long way indeed from the serried ranks of farm equipment and domestic utensils, idle vehicles, rusty machines that are too often associated with a museum of social and cultural life.

We need in Wales a proper national or at least a regional plan of priorities. This would prevent the gross duplication that is seen today when every local museum of domestic bygones is exactly the same as the next

*Yet another 'ye olde Welsh Kitchen'—at the Museum of Welsh Antiquities, Bangor
(Photograph: Museum of Welsh Antiquities)*

and when every local museum has its obligatory 'ye olde Welsh cottage kitchen'. It is essential that an inventory be drawn up perhaps by an as yet unspecified public or statutory body, listing what is worthy of preservation and is of importance in the heritage that we wish to present. For every field of activity, in agriculture and rural life, industrial history and cultural life there needs to be a blueprint for development. Certainly that blueprint cannot be produced unless it is based on research work and a thorough understanding of each subject area by those compiling the blueprint.

Obviously in Wales some machinery for the proper development of interpretation is needed whereby the often isolated efforts of individuals and of groups could be co-ordinated. Work on the conservation and presentation of the heritage, some of it of miniscule importance, has tended to be haphazard and fortuitous and has depended on the whims and idiosyncrasies of individual enthusiasts. There is no overall plan to indicate what is worthy of preservation and what could be allowed to disappear, with the result that there has been a considerable duplication of facilities and the squandering of limited financial resources. Financial assistance from a wide variety of grant-aiding bodies has often been thinly spread over a broad range of projects without any subsequent monitoring of the development and standards of presentation in those ventures. Financial assistance and expert advice should be channelled towards those facilities that are feasible and can make a real contribution to the interpretation of the heritage of a nation. Indeed it is essential that grant-aiding bodies should be able to turn for expert advice, as the Carnegie United Kingdom Trust always does, before committing funds to a particular project.

One of the most important proposals accepted by well-attended national conferences on the heritage of Wales in the early 1980s was the suggestion that an advisory service for interpreting the Principality be set up as a matter of urgency, possibly through a statutory body. The service would be concerned with encouraging the proper development of interpretation and to improve standards of research and presentation. The advisory personnel would evaluate the proposals of various interpretive provision. Perhaps it could even evaluate through a star system the quality of the various establishments! It was also proposed that such an advisory service would act in a co-ordinating capacity, bringing together agencies and individuals. Without proper provision for research and advisory services, without planning and monitoring and coherent policies of grant-aid, the very meaning of Welshness is in danger of being cheapened and watered down. The people of Wales, and those who come to visit and find out about us, deserve better.

Notes

1. Light, D. 'The Contribution of the Geographer to the study of Heritage', *Cambria* Vol. 15 No.2 (1989), p. 127.

2. Lowenthal, D. *The Past is a Foreign Country* (Cambridge, 1985), p. 333.

3. Hardy, D. 'Historical Geography and Heritage Studies, *Area* Vol. 20, p. 333.

4. Hewison, R. *The Heritage Industry: Britain in a Climate of Decline* (London 1987).

5. Jannasch, N. 'Maritime Museums of the Future'; *International Congress of Maritime Museums, Proceedings* (Paris 1986), pp. 189–90.

6. Wynne-Jones, I. *Llechwedd Slate Caverns Guide Book* (Blaenau Ffestiniog) p. 1.

7. Ambrose, W.R. Talysarn Lecture 1871 quoted by G. R. Jones *Gwyr Glew y Garreg Lâs (*BBC Radio Lecture 1974); pp. 33–4.

8. Jenkins, J. G. *Dre-fach Felindre and the Woollen Industry* (Llandysul 1984 ed.)

9. Payne, Ff. G. 'Welsh Peasant Costume'; *Folk Life* Vol. 2 (1966), p. 42–57.

10. Tilden, Freeman *Interpreting our Heritage* (2nd. Ed. North Carolina, 1967, p. 10).

2 INTERPRETING THE FARMING SCENE

Until the phenomenal industrial expansion of Wales in the late eighteenth and nineteenth centuries, the economic, social and cultural life of the nation depended very heavily on agriculture. A large proportion of the acreage of Wales is still overwhelmingly agricultural, for industrial development was concentrated on its southern and north-eastern sections where a substantial part of the Welsh population now lives.

As far as the formal interpretation of rural life is concerned, the Welsh countryside on the whole has not received the same attention as its industries and urban areas. Nevertheless, all that is rapidly changing, for within the last few years, farm museums of varying quality have been established in the tourist oriented regions of the Principality. Societies concerned with the preservation of agricultural tools and especially horse- or tractor-drawn implements have proliferated, and vintage machinery shows have become a feature of the social life of many a rural neighbourhood. Farm walks and farm holidays too have attracted an inceasing number of visitors and the Welsh farming scene is gradually being revealed to a largely urban public. In Wales, there is obviously a long way to go in providing a coherent and balanced picture of the importance of farming in the life of the community. But it is not enough to collect the mass-produced implements of arable farming and paint them in all colours of the rainbow; the real need is to provide an insight into the life of the people of the land over the centuries. The importance of livestock in a pastoral land should be emphasized and the rural crafts and industries that depended on agriculture need to be interpreted.

When a rural museum embarks on a programme of amassing a representative collection of agrarian tools and implements, great care has to be taken in selecting relevant material. Throughout the ages farmers have attempted to ease their labours and increase the productivity of their farms by devising ever more efficient pieces of equipment to till their land, feed their animals and carry their crops. This process has prevailed from the dawn of civilization to the present day and the curator is faced with the well-nigh impossible task of selecting and preserving a small proportion of those tools and implements. Even if one confines oneself to the number of agricultural implements, the specifications for which are deposited in the Patent Office, it is clear that a museum can only hope to collect a very

small proportion of the available material. Patent Office records show that between 1650 and 1850, 203 root pulpers and cutters for example were patented. During the same period there were 773 threshing machines patented, 1,020 ploughs and 1,125 reaping machines. In addition there must have been thousands of other farm implements covering all farming processes, from milking cattle to winnowing grain and from crushing clods to bird scaring, that were never patented. Indeed it is safe to say that only a very tiny proportion of the implements in use in the countryside were ever actually registered at the Patent Office. For example, patent specifications do not include a single cart or wagon of distinctive regional design once found in their thousands in the countryside; they do not include more than a handful of horse-drawn ploughs made by village blacksmiths to supply the needs of their locality; they do not include locally made harrows and rollers, field gates and drag rakes which were made by craftsmen in a multitude of designs.

A farm museum can very easily find itself exhibiting a collection of mass-produced standardized material that does not illustrate the way of life of the community that it is claimed to represent. Very soon, the curator will be buried under an ever increasing heap of Fordson tractors and Ransome's riding ploughs, Bentall's beet lifters and McCormack's hay loaders and binders that are perhaps more readily available than the distinctive local variety of tools and implements. Many of the farm museums of Wales today are monuments to mass production and multinational companies of the recent past that provided standardized equipment to all parts of the world. A collection of agricultural implements could easily provide a museum with horrendous problems of management and conservation.

If it is the task of a farming museum to present a coherent picture of agrarian activity within a specific region or locality and if it wishes to prevent its total submersion under an ever-increasing plague of galloping rust, then a coherent policy of collection needs to be followed. The task of a local museum, surely, is to reflect the life of the community that it serves, for if a museum were to collect the vast miscellany of material that may be available, individuality will inevitably disappear and few differences between farm museums in one part of the country and another would be discernible. All would display their winnowing boxes and horse and tractor-drawn ploughs, their hay loaders and corn binders, reaping hooks and tractors that were almost certainly the products of some multinational manufacturer of agricultural machinery.

In determining what meaningful material should be collected, a knowledge of the geographical background to the objects in a museum is essential. When country craftsmen or farmers themselves were responsible for many tools and implements for the farms in their own locality, they took

into full consideration such features as soil and vegetation, topography and slope as well as the ingrained traditions of their locality. For example, from the point of view of agricultural transport, Wales is a land of sleds and two-wheeled horse-drawn carts.[1] Large, unwieldy four-wheeled vehicles would soon collapse on the steep slopes of the central uplands of Wales, and one would be looking vain for four-wheeled vehicles in those regions. Those elegant large vehicles did, however, occur in districts which from time immemorial have acted as geographical and cultural extensions of the English plain.[2] In the south the Vale of Glamorgan, that region of trim, thatched villages, represents an extension of lowland culture into Wales. Here are found bow wagons of superb design and elegance as an element of that cultural extension into Wales. Further north, along the valleys of the Wye, Usk, Severn and Dee, innumerable ideas from the English plain have passed through, penetrating the very heart of the highlands and here again you find the English four-wheeled wagon. But interesting and attractive though they may be those vehicles should not find a place in a farm museum in Cardigan or the Llŷn Peninsula if the terms of reference of those establishments are to interpret the local farming scene.

In the past, a great deal of the inventive skill of blacksmiths, country carpenters and agricultural engineers was aimed at easing the labours of the arable farmer; a museum located in the middle of an arable district will consequently have many more opportunities of collecting implements than a museum located in a region where animal husbandry was the

Sheep shearing at Llandderfel, Gwynedd c. 1910

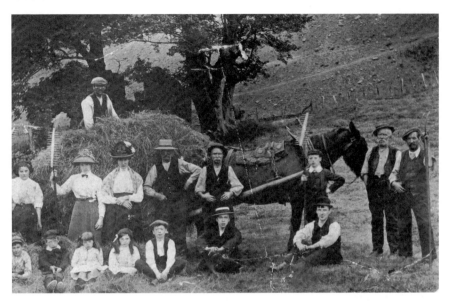

Carrying hay at Glyncorrwg, Mid Glamorgan c. 1900

basis of the economy. The greater part of Wales was devoted to livestock husbandry requiring few large implements, and a museum curator would look in vain for steam-ploughing equipment or complex seed-drills in dairying or sheep-raising districts.

Furthermore, the size of farm determined the amount of machinery that farmers possessed. Thus in southern Ceredigion for example, with its large number of small farms and dairying and stock-raising economy, farmers possessed few large implements, nor would every farm have its own threshing and milling equipment. Barn machinery for preparing animal feed—root pulpers and chaff cutters, hand mills and crushers would be more plentiful as would the equipment for cheese and butter making. Where there are substantial arable farms, as in the Vale of Glamorgan and the Powys/Hereford border, the farmers were by tradition able and ready to buy the most modern, expensive equipment available at any one time. By tradition too they were far readier to accept new inventions than the smallholder who has always dominated the Welsh farming scene. Over much of Wales, farming is carried out in small units on relatively poor soil, and the income of the peasant farmers was of necessity very low. For example, in mid-Wales until at least the outbreak of the Second World War, many farmers built the wheel-less sledges that they used for harvesting upland fields. All they required was some timber, nails, saw and hammer and they were are able to build perfectly efficient vehicles, well suited to the topography and economy of their region.

Agricultural exhibition at the Ceredigion Museum, Aberystwyth 1990 (Photograph: Ceredigion Museum)

Most of the revolutionary changes in agriculture have occurred since 1800. Prior to that date; indeed even up to 1914 in many parts of Wakes, farming existed in a state of medieval simplicity. Farmers depended almost entirely on a wide range of simple implements—ploughs and harrows—and a large labour force. New implements that appeared by the thousands in the nineteenth century were very slow to take root over the major part of Wales and for many years after their acceptance they were often used side by side with primitive hand tools. In many cases, farmers did not accept new labour-saving inventions until their labour forces had been depleted by a drift of workers to the industrial regions and by the First World War. In the presentation of Welsh agriculture therefore a balance between innovations and the most primitive equipment is desirable; but far too often it is the standardized innovations that have taken the fancy of curators. The North Wales Society for the Preservation of Agricultural Implements, for example, possesses a vast collection of implements and organizes a programme of shows and demonstrations throughout north Wales. Its collection of heavy agricultural implements and equipment is held by the individual members of the Society and is only brought together at periodic open days. Transportation of these implements is becoming ever more expensive and collectors are faced with restoration

and conservation problems of considerable magnitude. Many lack the expertise to undertake the necessary tasks, which is in part due to poor workshop facilities.

The range of tools and implements that are likely to come the way of a museum devoted to an interpretation of Welsh farming are likely to fall into seven broad categories:

1. Ploughing and preparing the land
2. Sowing and planting crops
3. Harvesting
4. Processing crops—threshing, milling etc.
5. Pastoral farming; animal feeding; shearing; milking etc.
6. Domestic activities—butter and cheese making, beer brewing etc.
7. Sources of power—water power, steam and oil engines, tractors etc.

Additionally other material, for example that relating to hedging, draining the land and a miscellany of craft material associated with a rural life are of considerable importance. To provide a balanced picture of life on the land a blend of all the relevant categories of material is necesary. In some areas one category will be far more important than another but it is vital that in all aspects of agrarian history, the local variations in tools and implements and in farming practices should be highlighted. After all in a regional or local farming museum, one is not trying to recreate a 'mini' science museum where the history and development of technology is all important.

Take the case of ploughing equipment that is preserved in considerable quantity by many institutions. In Wales ox-ploughing was widely practised until the end of the nineteenth century. According to medieval Welsh law twelve oxen, yoked in pairs, were necessary to pull the heavy wheeled ploughs of the period. Many of these ploughs were so inefficient in turning the soil that men and women armed with mattocks or wooden beetles had to be employed to cut up the furrows even further. The real advance in the design of ploughs came with the patenting of Stanyforth and Foljambe s famous Rotherham plough in 1730. This worked on completely new principles; it was a light, wooden plough without wheels, equipped with an iron share, mould-board and coulter. Only one pair of horses or oxen was required to draw it, and the draught animals and plough could be controlled by one ploughman. Gradually the design of the Rotherham swing plough spread to all parts of the country, adapted by blacksmiths and ploughwrights to local conditions of soil and slope, although the old heavy ploughs were still being used in some parts of the country until well into the nineteenth century.

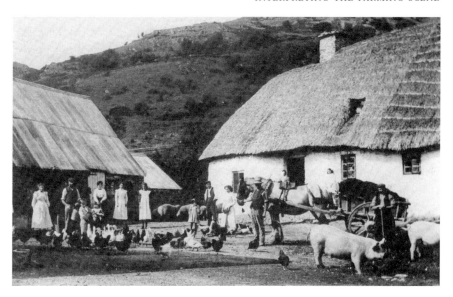

Farm yard, Celli Cadwgan Farm, Llanfaredd, Builth Wells, Powys c. 1900

The efforts of the County Agricultural Societies in promoting improved farm equipment cannot be over-estimated, for they encouraged the adoption of the Rotherham plough among other improved implements. One of the first Welsh craftsmen to build all-iron ploughs was Thomas Morris *(Twm Gôf)* of Login in Carmarthenshire, who began producing them in the 1830s. By the end of the nineteenth century a large number of ploughwrights' shops had been established in Wales, all producing local variations of the light Rotherham plough. For example, in west Wales a notable craftsman was Josiah Evans of Pontseli, Pembrokeshire, whose 'Number 6' and 'Number 7' ploughs became popular throughout west Wales, Brecknockshire and Radnorshire, and were taken by emigrants to Australia and North America. The Pontseli plough was specifically designed for ploughing sloping fields, and its mould-board, made at the Carmarthen foundry, was regarded as particularly efficient for cross-ploughing. Ffransis Payne in his *Yr Aradr Gymreig* (the Welsh Plough) points out that mould-boards of the Pontseli type were used as recently as 1935.[3] 'This casting, considerably improved... is still in use on scores of ploughs today and is still cast at Brecon', said a correspondent in the *Western Mail* in that year. He continues: 'This type of casting will never be ousted from the hillside farms of mid and west Wales, and it is not uncommon to see smith-made ploughs fitted with this casting win all the prizes in the championships swing plough class in certain districts.' Some plough mould-boards such as those used on the Dyffryn, Cardiganshire plough, were designed by farmers for production by local blacksmiths;

others used parts that were based on the design of plough parts produced by large-scale manufacturers. Until 1939, and even after, locally made swing ploughs were still being used in many parts of Wales, and these together with mass-produced implements bought from local agricultural ironmongers were responsible for ploughing most Welsh land.

The greatest innovation of all in Welsh agriculture was the widespread adoption of tractors, but in most parts this did not take place until the late 1930s. Although tractors were imported into Britain from America during the First World War, it was not until the 1930s that they became commonplace. In rural Wales from 1939 onwards the availability of light tractors and mounted equipment of the 'self-lift' variety revolutionized the mechanization of farm work; tractors were used less and less to pull horse-type equipment. But the new self-lift tractor-ploughs were the products of an industry located in such places as Uttoxeter and Ipswich, and their popularity spelt the eclipse of the village blacksmith who was concerned with providing farm equipment for his own community. By the end of the 1950s even a Welsh smallholder was able to afford a light tractor and some of its associated equipment.

As in all interpretive presentations, the context, be it geographical, economic, social or cultural is as important as the presentation of an artefact. Without the background information a collection of the tools and implements of farming may have little value. It was John Higgs[4] who cited the case of a handful of small pebbles 'collected on some occasion and labelled—"used by a shepherd for counting sheep"'. Any curator would be right to regard them with profound suspicion and sooner or later it is likely that they would be quietly disposed of. However, the exhibit could have been of value if the person who collected them had taken the trouble to find out and record the whole story, as it is found in George Ewart Evans's classic of Suffolk life:

> Pebbles used as counting tallies by G. Smith, shepherd of Blaxhall Suffolk. Sheep were counted by the score. When Smith was counting his sheep he placed a hurdle so that only two sheep could run through at the same time. As each pair went through he would say to himself 'You and your partner' ten times over. At the end of each ten he would drop a tally stone into his pocket and the number of stones at the end represented the number of score of sheep.[5]

To quote another example: in many agricultural collections in Welsh museums there are exhibited straw baskets, straw seed-lips and bee skeps.[6] None of these are of great intrinsic value neither are they particularly pleasing to the eye, but background information on their construction

Llwyn yr Eos Farm at St Fagans, where the history of farming before 1939 is interpreted

and use will make them far more interesting exhibits. How much more valuable it is to know that tradition has dictated that the bone awl, the only tool used in making coiled straw work, must come from a horse's hind leg and that the straw used be unbruised, unthreshed winter-sown wheat of the now obsolete *yr Hen Gymro* variety. The split bramble used for binding the rolls has to come from forests rather than hedgerows; it is said to be less prickly and more pliable. These coiled straw artefacts were the products of a community that depended almost entirely upon its own resources to produce the necessities of life.

In many countryside collections the tools and utensils of the past are presented as if they were pieces of fine art, but undoubtedly it is their context that provides reality. In the craft of wheelwrighting for example, presented in many museums, a crooked stick used to get the correct alignment in a dished wheel is almost unrecognizable as a tool unless presented in this context. In wattle hurdle-making, cudgels and moulding blocks mean very little on their own, while in thatching, thigh pads, yealm carriers and spars are only significant in the whole context of the craft. Drenching horns and plough spuds, seed dibbles and breast plough pads, bush harrows and plashing sticks are hardly recognizable as tools of considerable importance in agriculture unless the full context is explained.

It could be argued in a country traditionally associated with animal husbandry that the presentation of the actual breeds of Welsh farm

animals is of far greater relevance than the preservation of implements that were specifically concerned with the cultivation and harvesting of arable crops. A flock of Llanwennog or Beulah speckled-faced sheep is far more important than a Clayton and Shuttleworth traction engine or a Fordson Major tractor. Nevertheless farm parks set up in rural Wales have been remarkably unsuccessful.

The West Wales Farm Park for example, opened in 1977 at Blaenbedw Isaf Farm, Plwmp, Llandysul was closed in 1980. Preserving and displaying farm animals is a very expensive exercise and animals have to be fed and cared for when there are no paying tourists around and the income of a farm park is negligible. In addition, by their very nature farm parks are a fine weather attraction and no visitor is likely to be drawn to rain-swept, muddy fields to view flocks and herds of wet animals and birds. If farm animals are to be included in an interpretation of agriculture they must be part of a wider presentation, taking their place in their proper context as an element in a thematic display. Thus, for example the Acton Scott Working Farm Museum near Church Stretton in Shropshire, Shugborough Park farm near Stafford and Cogges Manor Farm near Witney, Oxfordshire are successful since the limited number of live animals illustrating local breeds are a part of a much wider presentation. They are not zoos with cages and small paddocks as were some of the ineffective and now defunct farm parks.

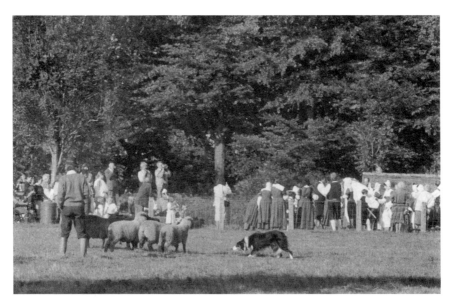

Sheep-dog handling demonstration at the Harvest Festival held at the National History Museum, St Fagans, 1990

At the National History Museum in St Fagans a number of traditional breeds of farm animal and poultry form an important part of the extensive interpretation of farming. There are two flocks of sheep—Welsh Black Mountain and Llanwennog—Welsh Black cattle, Welsh pigs, Welsh cobs, Emden and Brecon buff geese, ducks and a variety of traditional poultry breeds. These take their place in fields or as a part of the interpretation in re-erected and restored farmsteads.

Notes

1. Jenkins, J. G. *Agricultural Transport in Wales (*Cardiff 1962).
2. Jenkins, J. G. *The English Farm Wagon* (Newton Abbott 3rd. ed. 1983)
3. Payne, Ff. G. *Yr Aradr Gymreig* (Cardiff 1954) p. 129.
4. Higgs, J. W. Y. *Folk Life Collections and Classification* (London 1963) p. 37.
5. Evans, G. Ewart *Ask the Fellow who Cut the Hay,* (London 1956) pp. 51/2.
6. Jenkins, J. G. *A Cardiganshire Lip Worker* (Folk Life Vol. 3) pp. 87/9.

3 INDUSTRY IN A RURAL SETTING

Nothing is so evocative of a bygone way of life as a lone craftsman turning out by hand a whole variety of goods in iron or wood, glass or clay that a visitor can purchase as a memento of the land that he or she is visiting. A slowly revolving water-wheel driving creaking mill machinery; sparks flying from a blacksmith's anvil; the clicking of flying shuttles and the rich smell of leather all add up to the nostalgia that one associates with the leisurely pace of 'ye olde country life'. Futhermore there are the multitude of craft retail shops where the products of rural workshops, some from workshops in Bulgaria, Taiwan and Malaysia, are available for sale to the 'spending public'. Few villages and towns in Wales are without their craft shops. Here and there in defunct chapels, warehouses and mills as well as in purpose-built structures, are found 'Craft Centres'—complexes for four or six or more different craftsmen working under the same roof that not only provide the place of work for a variety of artisans, but more importantly provide a facility for the visiting, spending tourist. Candle making and pottery making, hand weaving and love-spoon carving are now major rural pursuits and the visiting tourist need never be short of genuine stone-ground wholemeal flour, Welsh honey or handwoven cloth from the wool of Jacob sheep. Craftwork of all kinds has become the flagship of the heritage industry and the handcraftsman has become the cornerstone of many facilities concerned with the interpretation of the more recent traditions of the people of Wales. Whether all those craftsmen represent the authentic traditions of the Principality, as many of them maintain, is very questionable indeed. Certain items of craftwork such as slate goods and love spoons, tapestry quilts and table mats and items of stoneware are being made almost in mass-production processes and the uniqueness and rarity value of those artefacts is no longer a consideration. For many saleable objects, saturation point has been reached.

Take the case of the love spoon that was once an item of considerable social and cultural relevance in Welsh peasant life.[1] From the early seventeenth century to the end of the nineteenth century the highly decorated spoon presented by its maker as a token of love to a girl was a very common feature of rural life. The earliest love spoons were simple and undecorated and were wooden copies of the metal spoons used by the wealthier members of the community. As time progressed the utilitarian

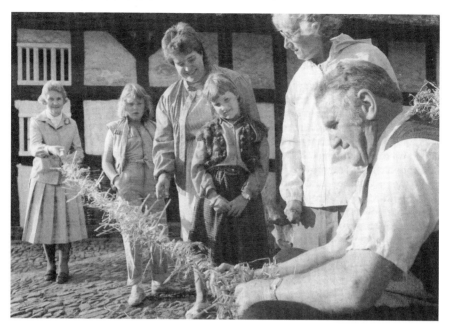

Evan M. Jones demonstrating the craft of straw rope-making at St Fagans Museum, 1989

functions of the spoon were discarded and by about the middle of the seventeenth century, the elaborate but useless love spoon seems to have been common in Welsh rural society. These spoons were not designed for use and most of them were very intricate and elaborate with slotted handles, chain links and carved patterns and initials. The aim wherever possible was to carve an intricate pattern out of a single piece of wood and since the donor of the spoon was also its maker he tried to emphasize the feeling and care that had gone into its making by elaborating the design as much as possible, as a symbol of the fervour of the carver's passion. The love spoon was therefore very much the product of an amateur tradition; it was a vehicle to display a man's skills. In recent years in the land of Wales, the love spoon has become a very saleable commodity produced in thousands by good, bad and indifferent hand-workers. Many use nothing but penknife and spokeshave but others cut out their designs on any old piece of wood with electrically driven bandsaws. In some workshops the carving of love spoons has become a mass-production process. Love spoons of all sizes decorate tavern walls; mini-versions appear on greeting cards; silver spoons are chained to bracelets and necklaces; fanciful books have been written about them while row upon row of them are displayed in every craft shop in the land. With tall hats and red dragons the love spoon takes its nostalgic place as a memento representing the ancient traditions of a national group.

In Wales as elsewhere, the craftsman came into being in order to fulfil society's needs; until fairly recent times, every rural community was largely self-sufficient and only on rare occasions did country people find it necessary to venture far outside their community and locality to search for the means of life. Most of the inhabitants of rural Wales were born, lived and died within the narrow confines of their own localities, and most realized their ambitions within their own communities to which they were bound by ties of blood, family and neighbourliness. But the rural neighbourhood was something more than a social entity; it was an economic entity as well, for most of the country dwellers' needs could be met by members of the local community itself. All the food required by the community could be produced locally; they had animals that could supply them with milk, meat, skins and wool; they had fields, gardens and orchards that supplied them with cereals, root crops, fruit and vegetables. In most parts of Wales until 1914, or even later in some areas, farming depended almost entirely on a wide range of hand tools, a large labour force and the cooperative effort of relatives and neighbours during the busy periods of the farming year.

During this period of near economic self-sufficiency, craft workshops in all parts of Wales were numerous and important, while domestic crafts such as butter and cheese making, beer brewing, pig salting and many others were widely practised. The products of the farm—corn, wool, animal skins—could always be taken to a nearby mill for processing. The products of those mills could be used by one of the many craftsmen of the neighbourhood to make something essential or could be used directly in the home. In many cases the craftsmen who processed farm produce were not paid in cash, but they were allowed to keep a proportion of the produce that a farmer brought in. For example, woollen manufacturers were allowed to keep a proportion of the fleeces that farmers brought to the mill for processing, which they made up into yarn, blankets and tweeds for sale on the open market. Other craftsmen involved in processing were tanners and curriers, concerned with leather production, charcoal burners and oil distillers concerned with processing timber, and maltsters, brewers and cider makers concerned with supplying beverages to the rural population. The processing crafts of Wales, where the craftsman was concerned with treating some raw material, usually demanded a range of immovable equipment and usually required water-power. For this reason, the processing industries were more often than not located in small factories or mills in river valleys, often in isolated places.

In addition to processing the raw material of the countryside, every Welsh rural neighbourhood had its craftsmen who were responsible for producing equipment for the farm. Essentials ranging from field gates

Melin Bompren: a Ceredigion corn mill typical of a number preserved and returned to milling order in Wales. Melin Bompren has been re-erected at the National History Museum.

to horseshoes and from ploughs to shovels could be produced locally by hosts of wheelwrights, carpenters and blacksmiths. Since each craftsman was concerned with producing equipment specifically for his own locality, and made that equipment to suit local conditions of soil and topography, considerable variation in tool design came into being. For example, if a farmer required a plough, local craftsmen were quite prepared to make one that was well adapted to the farmer's needs and land. All the furniture for the home could be made by specialized local cabinet makers and carpenters; all the utensils for the dairy and kitchen could be made by turners, white coopers, blacksmiths and other craftsmen. Horse harness, wearing apparel, boots, clogs, indeed everything country people required, could be produced locally. But even if a locality did not possess all the essential craftsmen, then there were always travelling dressmakers, saddlers, tailors and others who could pay visits even to the remotest farmhouse.[2]

Many of the creative craftsmen of rural Wales came into existence because raw material was available in a given locality which they used to meet a regional rather than a local demand. The pottery industry, for example, came into existence where there was a plentiful supply of suitable clay in close enough proximity to the coalfields to obtain fuel for firing kilns. At Ewenni, near Bridgend in Glamorgan, at least seven

potters' shops existed in the nineteenth century, while the history of the
Rumney Bridge Pottery near Cardiff may be traced back at least to the
fifteenth century. In north Wales, clay and coal existed in close proximity
at Buckley in Clwyd and a flourishing pottery, brick and tile industry
came into being in that town. At Newborough in Anglesey rush-mat
making became an important industry in a region where marram grass
grew profusely; wood turning became important in the well-wooded
Teifi Valley in west Wales, while livestock-rearing mid-Wales supported a
flourishing leather industry.

There are a number of factors in the geography and social history of
Wales that have had a considerable effect on the nature of industry here.
Much of Wales is mountainous and moist and this has meant that the basis
of the Welsh economy throughout the ages has been livestock farming,
rather than arable farming; animal breeding rather than cereal growing.
In many parts of lowland England, especially in the corn growing districts,
every rural locality and every village had its community of craftsmen who
produced goods for the arable farmer. Many villages had wheelwrights
who built heavy four-wheeled wagons to carry arable crops. There were
specialized rake makers and scythe-handle makers, harrow builders and
seed-drill manufacturers and many other skilled craftsmen who built tools
and implements for the arable farmer. Livestock farming does not need the
specialized and elaborate equipment of arable farming, and for this reason
the highly specialized craftsman of the English village has always been a
rarity in Wales.

A second factor that has had a profound effect on the development
of rural industry in Wales has been the isolation of the countryside. Due
to distances from the markets and large centres of population, rural
workshops in Wales have either remained small or have disappeared.
This, for example, is the main reason why an industry like woollen
manufacturing has declined so alarmingly. In the well-populated districts
of lowland England many small workshops established a hundred or
more years ago and that at one time formed an integral part of self-
sufficient village communities, have due to easy marketing conditions
become industries of major importance; but no such development took
place in Wales. Even in those cases where rural workshops have not
developed into major industries, craftsmen in lowland England have
often been able to continue in production as they are within reach of
extensive markets.

A third important factor in determining the character of Welsh rural
industry is the fact that much of Wales consists of large numbers of
small farms, widely dispersed over its surface. Since many farms may be
miles away from the nearest village and its workshops, Welsh farmers by

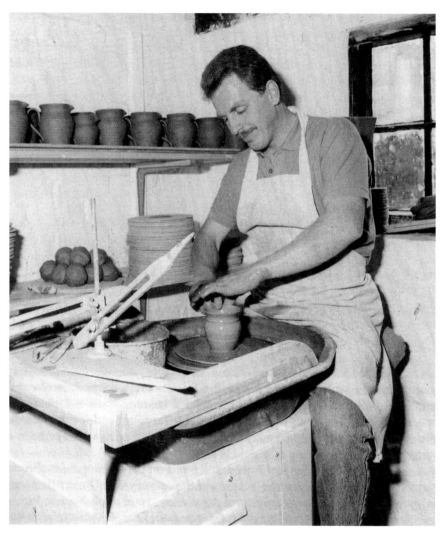

A demonstrating craftsman: Gareth Lloyd of the St Fagans Pottery, 1990

tradition made their own farm tools and equipment. The sledges used for transport in many parts of Wales, for example, were built by farmers from the material growing on their own farms. All they required was a saw, a hammer and a few nails and they were able to build a perfectly efficient vehicle. To many hill farmers, life was a perennial battle against the gorse, heather and reeds that constantly threatened to take over the limited amount of arable land. The income of the hill farmer was always small and he could never afford to pay a qualified craftsman for elaborate and costly equipment. The dispersed nature of the settlement meant too that Wales possessed many itinerant craftsmen, while the loneliness and

isolation of many rural communities gave rise to numerous leisure crafts. We can imagine the life of no more than sixty years ago as being far more leisurely than it is today. Entertainment was at a premium and many of the inhabitants of remote country districts practised some creative crafts in their spare time. It was this amateur tradition that gave us love spoons and stay busks, knitwear and quilts, perhaps the greatest expression of Welsh peasant culture.

How then does contemporary Welsh craftsmanship fit into the background of producing essentials for a community's use? Are more than a tiny proportion of practising craftsmen in Wales concerned with the traditional workmanship of the Principality or could they practise their trade anywhere in the world? Is Welsh craftsmanship today 'An Experience of Wales' as the Wales Crafts Council maintain? Wales is not a country 'filled with flat-capped Taffys and ladies in tall hats', but far too often that simplistic approach is prevalent in the promotion of the craft products of Wales. Many of the craftsmen that practise their trade in the remote corners of rural Wales are not Welsh at all but have their origins in the cities of England and have come to Wales 'in search of the good life'. With the production of scented candles and slate plaques, enamel jewellery and cotton aprons, pocket-money souvenirs and Celtic Magic perfumes, the image of craftsmanship in Wales has indeed changed.

A broad indication of what is available from Welsh workshops may be obtained from the current edition of the Wales Crafts Council *Buyers Guide*. The main categories of production are:

Architectural (including slate work)	Games (chess sets)
Bedlinen	Giftware
Brass	Glass
Bridal wear	Jewellery
Candles	Kitchenware
Ceramics	Kits for spinning
Clothing	Knitwear
Commemorative items	Leather
Confectionery	Lighting (reproduction gas lamps)
Dollies	
Dried flowers	Love spoons
Enamelling	Models (ceramic slate resin)
Equestrian (rocking horse)	Pictures and Plaques
Figurines	Pottery
Food	Pot Pourri
Furniture	Prints

Pyrography	Cards
Quilting	Textile goods
Rugs	Toiletries/Perfumery
Silk screening	Toys
Silver and glass	Wood turning
Slate	Yarns

Many of the products that emanate from Welsh workshops today have precious little to do with the traditional craftsmanship of the Welsh countryside and they could equally well be produced in Sussex or Northumberland, Tuscany or Tenerife, Crymych or Llanberis. If craftsmanship is to play its part in the interpretation of the heritage of the Welsh nation, then some recognition of the traditions of each craft is needed. The products that depended on the availability of raw material for the practice of a trade may reflect most specifically the workmanship of the people of Wales. Thus, for example, the wood-turning industry flourished in the Teifi Valley in west Wales because of the availability of suitable timber in the area; the potter's craft developed on the southern rim of the south Wales coalfield and in Deeside because of the availability of suitable clay and fuel to fire kilns. The wool textile industry and, to a lesser extent, the leather industry came into being because Wales is traditionally a stock-rearing country. In addition, the availability of water-power from the wildly rushing streams meant that crafts associated with the processing of raw materials developed in many areas.

Moreover, in a number of crafts there has been a continuity of tradition and the style of product produced by many a workshop may be traced back for centuries. Even when modern methods of workmanship and modern tools are used, the past can still provide a true craftsman with inspiration and a solid basis for the future of a competitive craft venture. Thus in pottery and in bowl turning, in furniture making and hand-weaving, some recognition of past achievements may produce quality items that are uniquely Welsh and will contribute in a very real way to the interpretation of the heritage of a nation. A visitor to Wales does not necessarily want to purchase items that can be bought in Burlington Arcade or at the festival shops of Baltimore Inner Harbor. An appreciation and a recognition of the richness of the Welsh craft tradition may be of considerable importance in the production of goods, though in design and techniques of production, craftsmen will of course not stick slavishly to the past.

Only a few of the age-old crafts of Wales have survived intact into the late twenty-first century. The craftsman is no longer the cornerstone in the fabric of rural society. Nevertheless some have been able to meet the

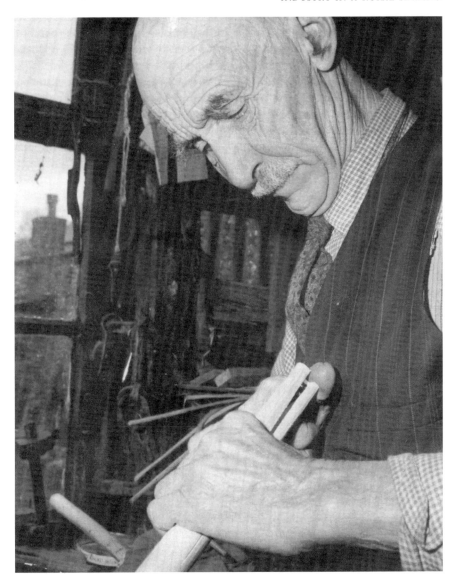

A traditional country craftsman: carpenter William Thomas of Llanymawddwy at work, 1965

challenge of changing circumstances. A few blacksmiths, for example, produce wrought-iron work of superb quality and others have taken advantage of the vogue for horse riding to act as shoeing smiths. In the same way there is a demand for saddlery although that demand today is met by less than half a dozen saddlers compared with more than 500 that worked in Wales in the 1920s. Some crafts such as pottery and woodcarving are more flourishing than they have ever been although only a few of them

39

have anything to do with the ingrained traditions of rural life where the availability of raw material in close proximity to a workshop was a prime concern.

An indication of the importance of craftsmanship to a rural area in the past is provided by the example of the Ceredigion district of Dyfed in 1831. According to *Pigot's Directory* for that year there were:

28 Saddlers	6 Basket makers
1 Whip maker	33 Millwrights
12 Printers	393 Tailors
15 Tinsmiths	523 Carpenters or Joiners
17 Clock makers	8 Thatchers
275 Blacksmiths	334 Stonemasons
75 Corn millers	5 Sail makers
158 Woollen manufacturers	13 Rope makers
(weavers etc)	43 Wheelwrights

The Ceredigion of the nineteenth century had no potters or macrame workers, no bridal-wear manufacturers nor producers of 'nostalgia' pictures, and certainly no professional makers of 'Traditional love spoons made of dark stained mahogany—totalling 15 different designs including ball in cage and links'. What is now reckoned to be traditional craftsmanship has changed out of all recognition, but nevertheless, 'Craft skills and values are being applied to satisfy contemporary needs and interests across all the market sectors... a fresh responsiveness to new markets and production techniques has been built upon the skills and traditions of craftsmanship.' So states the Wales Crafts Council, but whether more than a small proportion of the practising craftsmen of Wales pay homage to the ingrained traditions of centuries is a moot point.

In all promotional literature relating to Wales, the textile industry is highlighted as a beacon of Welsh rural endeavour, but old and established though that industry may be, it is but a mere shadow of what it was fifty or even twenty years ago.[3] From the Middle Ages until the outbreak of the First World War, the woollen industry was amongst the most important of all Welsh industries. It was certainly the most widespread, for it was impossible to move any distance at all without meeting some evidence for the existence of this important craft activity. The textile worker, whether he or she worked in the home or a factory building, was as essential to the rural community as the blacksmith or carpenter, for there was hardly a parish in the land without its contingent of spinners and weavers, dyers and fullers. In some parts of the country the manufacture of woollen goods

went beyond the stage of supplying a self-sufficient rural community with its requirements, for in those districts manufacturers were concerned with producing flannel woollen cloth that was exported to all parts of the world. Welsh cloth covered the slaves of North America and the armies of the Duke of Wellington; It was worn by coal-miners and steel-workers, farmers and navvies and was reputed to possess that 'peculiar softness of texture which renders [it] exceedingly well adapted to be worn next to the skin of the most delicate invalid'.

From the sixteenth century to the mid-nineteenth century, manufacturing was the chief industry in the old counties of Merioneth and Montgomery and between 1840 and the early 1920s fortunes were made by those concerned with the industry in the Teifi Valley in west Wales. In other parts of the country, outside the main areas of concentration, there were hundreds of small mills and domestic weaving establishments that catered for the needs of local communities. Today no more than seventeen woollen mills remain in production in Wales compared with the ninety still working in 1955. They are:

Tregwynt Factory, St Nicholas, Haverfordwest, Dyfed
Melin Teifi, Cambrian Mills, Dre-fach Felindre, Dyfed
Dyffryn Mill, Dre-fach Felindre, Dyfed
Melin Dolwerdd, Cwmpengraig, Dre-fach Felindre, Dyfed
Curlew Weavers, Troed-yr-Aur, Rhydlewis, Dyfed
Siwan, Llansawel Road, Llanybydder, Dyfed
Rock Mills, Capel Dewi, Dyfed
Middle Mill, Solfa, Dyfed
Wallis Mill, Ambleston, Dyfed
Elvet Mills, Cynwyl Elfed, Dyfed
Cwmllwchwr Mills, Ammanford, Dyfed
Cambrian Factory, Llanwrtyd Wells, Powys
Meirion Mill, Dinas Mawddwy, Gwynedd
Llangollen Weavers, Llangollen, Clwyd
Trefriw Woollen Mills, Trefriw, Gwynedd
Brynkir Woollen Mill, Golan, Gwynedd
Afonwen Mill, Mold, Clwyd

Those that remain at work today, in Dyfed and Gwynedd in particular, are remnants of a much more intensive pattern of distribution. Until the 1930s small comprehensive mills were vital to the economy of many a rural community. Although mills such as Tregwynt at St Nicholas in Dyfed and the Brynkir Mill at Golan in Gwynedd are today very dependent on the tourist industry as a source of revenue, they started off as essential

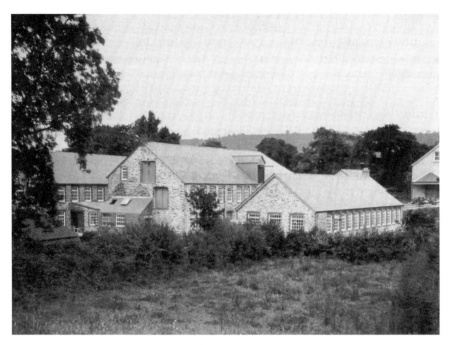

The National Wool Museum established in the Cambrian Mills of Dre-fach Felindre, Dyfed—a Village once known as the 'Huddersfield of Wales'

elements in the pattern of a self-contained local community life.

Other present-day Welsh mills have a somewhat different origin. They represent the remnants of one of the most important of native Welsh industries, concerned not so much with a local market, but with an extensive international one. In the Teifi Valley in Dyfed the industry still flourishes, albeit on a greatly diminished scale, and the few mills in that area are the remnants of a golden era in the history of rural Wales.

The most depressing feature of the post-1945 period in the history of the woollen industry has been the decline in the number of mills. Large modernized mills as well as small one-man businesses have closed by the dozen and although the market for Welsh cloth was extended with the introduction of double-woven 'tapestry' cloths, furnishing fabrics and light flannels to replace the traditional shawls, shirts and flannel drawers, the number of craftsmen supplying that demand had declined alarmingly. Those that remain in the industry are now heavily dependent on the seasonal tourist market.

One of the reasons for this decline has been the difficulty experienced by millowners in recruiting skilled labour. Almost all Welsh mills employ far fewer staff than they did in the past, and wages in the woollen industry compare unfavourably with those paid in other occupations. In most of

the mills there has also been a marked reluctance to invest in new capital equipment. Some mills have been modernized, but the majority have become dependent on dyed yarn produced by Yorkshire yarn producers and have been reduced to the status of specialized weaving mills, unconcerned with such vital processes as carding, spinning and cloth finishing. Another trend of the period 1950–75 was the difficulty of selling woollen mills as going concerns. When factory owners have wished to retire they have experienced great problems in selling and, for this reason alone, many have ceased production.

By tradition, the Welsh woollen industry is a producer of flannel. However, although mills still produce flannel, designed mainly for the fashion industry, the characteristic product of the Welsh woollen industry between 1950 and 1975 was double-woven 'tapestry' cloth and bedcovers. The origins of this multi-coloured, patterned material are obscure, but it seems that in the eighteenth century some intricate patterns were woven on hand-looms in north-east Wales. But tapestry material was as well-known in Scotland, in Kentucky, in north-west Canada and amongst the Indian tribes of the United States of America and there is nothing to indicate that this material, so often associated with Wales in recent years, was ever a part of the Welsh craft tradition. Before the 1930s, tapestry was hardly known

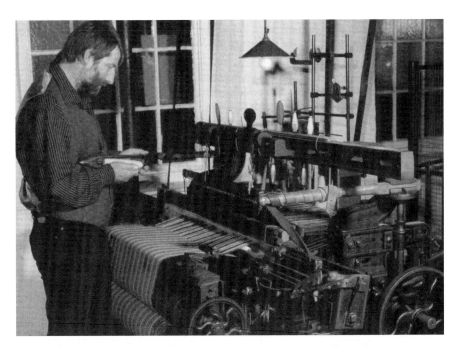

Weaving demonstration given by Keith Rees at the National Wool Museum

in Wales except in a few mills in the north. Like the fall in popularity of the 1940s honeycomb quilt, it seems that the market for tapestry is in decline and perhaps a reversion to flannel and the development of new fabrics may be necessary for the revival of our most important of Welsh rural industries.

Mills of all kinds are certainly important in the heritage business, selling their wares, whether they be bags of flour or tapestry place mats, to tourists. Of course only a tiny proportion of the hundreds of corn mills that existed in the past now operate. Most are run by incomers from other parts of Britain. The following are the fully-working corn mills of Wales:

> Bacheldre Mill, Churchstoke, Powys
> Felin Crewi, Penegoes, Machynlleth, Powys
> Pentrefoelas Mill, Pentrefoelas, Clwyd
> Pentre Mill, Loggerheads Country Park, Mold, Clwyd
> Cochwillan Mill, Tal-y-bont, Bangor, Gwynedd
> Melin Howel, Llanddeusant, Anglesey
> Melin Bompren, National History Museum, St Fagans, South Glamorgan
> Skenfrith Mill, Skenfrith, Gwent
> Y Felin, St Dogmaels, Cardigan, Dyfed
> Cenarth Mill, Cenarth, Dyfed
> Felin yr Aber, Llanwnen, nr. Lampeter, Dyfed
> Felin Newydd, Crugybar, Llanwrda, Dyfed
> Felin Wen, nr. Carmarthen, Dyfed
> Melin Maesdulais, Porth-y-rhyd, Dyfed

The splendid windmill at Llanddeusant on the Isle of Anglesey which had ceased milling in 1918 has now been restored and is a major attraction on the island. Many of the mills open to the public provide additional attractions apart from corn milling. Thus Felin Geri, near Newcastle Emlyn, has 'a replica eighteenth-century fort', rare breed animals, bakery, craft workshop, sawmill, trout pools and 'the only Japanese restaurant in Wales'. Cenarth Mill, a few miles away has its coracle exhibition, picture gallery and souvenir shop.

Craft establishments, be they mills or small workshops, be they producers of essential goods or tourist mementoes, are obviously a great attraction to the visiting public. Nevertheless, with the establishment of so many in purpose-built structures, disused factories and warehouses, and with substantial financial grants, saturation point for some craft products may soon be reached. The market is finite but production is ever-increasing.

Notes:

1. Owen, T. M. *Welsh Folk Customs* (Cardiff 1974 ed.) pp. 147 et seq.
2. Jenkins, J. G. *Traditional Country Craftsmen* (London 1965).
3. Jenkins, J. G. *The Welsh Woollen Industry* (Cardiff 1969).

4 INTERPRETING INDUSTRIAL HISTORY

The rapid de-industrialization of Britain within the last forty years or so has contributed considerably to an awareness of industrial history and to the mushrooming of societies and institutions concerned with the recording and preservation of features and equipment that were symbolic of Britain's greatness as the workshop of the world. In the 1950s according to Professor R. Harris, 'Industrial archaeology rapidly gained popularity, societies were formed, an endless stream of excursions and lectures arranged and an enthusiasm arose which made industrial archaeology almost a household word. Many intelligent people had found a new hobby'.[1] Hand in hand with the new-found interest, industrial museums were set up, industrial buildings, some of dubious importance, were preserved and the relics and paraphernalia of a more prosperous age were collected, displayed and recorded and even allowed to rot away through neglect in disused barns and factories. To many a well-meaning group or individual, the preservation of the relics of an industry was a momentous task and possibly more was collected than could reasonably be conserved. In this widely felt concern with a rapidly disappearing way of life, it was the artefact and the building—their preservation and conservation—that became the pre-occupation of the industrial archaeologist.

In Wales, during the period of enthusiasm in the sixties and early seventies in particular, a large number of artefacts were preserved, often in complete isolation from the complexes that once provided their meaning and reality. In splendid isolation for example, the Melingriffith Tinplate Works Water Pump has been preserved in the middle of an extensive housing estate on the outskirts of Cardiff. The pump was once used to return water from the feeder which drove the famous tinplate works to the Glamorganshire Canal alongside. Few traces of the tinplate works remain, the canal has been filled in and the pump remains as a stranded monument to a once important industry.

At the Elliott Colliery in New Tredegar, to quote another example, an engine house that accommodates a steam winding engine of 1891 was preserved. The engine house, described as 'a monument' in official circles, looks rather incongruous in the middle of a reclaimed industrial desert. The coal-mine, and its associated buildings and headgear, was demolished many years ago; the banks of terraced houses that surrounded it have

all disappeared and the network of railway lines and the slag heaps that provided a proper environmental context to the engine house are no more. In north Wales, the Dorothea Beam Engine in the Nantlle Valley is almost all that remains of the slate quarrying complex in the area and is regarded as 'a monument' rather than as one element in a once vital and complex industry. Other examples of 'monument' preservation in Wales are such isolated features as the Cwmbyrgwm Balance Pit Headgear near Abersychan, Smith's Pit building and chimney stack at Landore, Swansea and the Cwmafon Copperworks flue.

The conservation of industrial artefacts represents one aspect only of the huge task of interpreting the industrial heritage of a land that was once the world's workshop. In this 'post-industrial' age with the rapid changes in the nature of British industry, it seems that many enterprises are more than ready to get rid of obsolete and idle equipment if not to the scrapyard, then to museums and preservation groups who may be ready to accept them. Obviously not everything a museum is offered can be accepted for the problems of conservation and housing become insurmountable and a museum can soon find itself buried under an ever-growing heap of steam engines and power lathes, motor cars and forging hearths. Selective

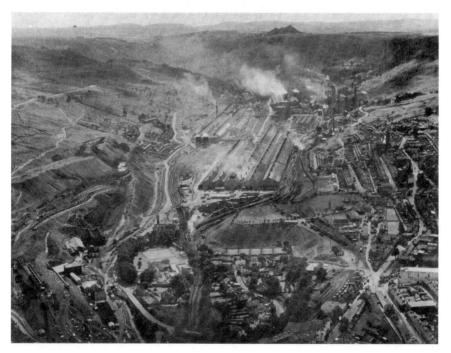

Ebbw Vale—site of the 1992 Garden Festival—as it was in its heyday, during the early 1960s, as a steel-making town.

conservation is essential for there is such a thing as trying to preserve too much; for certain categories of material and in certain regions, saturation point was reached many years ago.

Railway preservation societies, industrial archaeological societies and many others concerned with the nostalgia of Britain's industrial greatness have proliferated in an era of increased leisure. Tracts of land that once supported a working population have now been designated industrial trails in order to attract the tourist. For example, the town of Merthyr Tudful, once one of the world's leading iron-manufacturing centres, is now marketed not as a town of industrial achievement but as a tourist attraction based on the remnants and relics of its boom period. Only the crumbs of the feast now remain: urban regeneration programmes and improvement schemes have swept away much that was of vital importance in the way of life of the people of Merthyr. 'Mr Crawshay's ironworks at Cyfarthfa, by far the largest in Europe and the world... that constantly employed 1,500 men,' for example, are no more and are now represented only by the ruins of some blast furnaces that are virtually unrecognizable. The famous triangle of workers' houses was demolished many years ago, and the nearby town of Dowlais has little to show of its prominence as a centre of iron production. John Josiah Guest's stables still remain but the site of the vast works with its eighteen furnaces that produced rails for

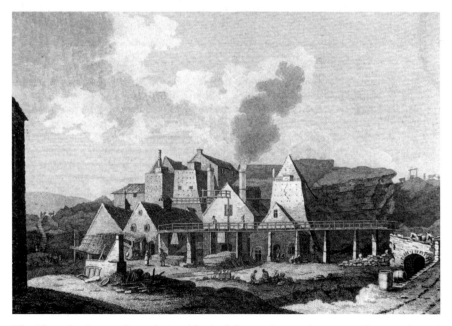

The Blaenafon ironworks as depicted by Archdeacon Cox in the 1790s (Photograph: Torfaen Museum Trust)

the world's railways looks more like the Kalahari Desert than the site of one of the world's greatest industrial enterprises. Other Welsh industrial towns such as Swansea and Llanelli, Tredegar and Ebbw Vale, Shotton and Wrexham have lost most of the industries that brought those settlements into being in the first place.

There are many areas in Wales today which owe their very existence to industry and which, since the contraction of those industries, are now left stranded, their inhabitants bereft of any reference to the driving force that brought their families there in the first instance. A genuine and stimulating interpretation of those towns and areas is necessary to ensure that their heritage is not lost. The need is made even more pressing when there are those in Wales who seem more concerned with tourist market viability rather than historical accuracy. In interpreting the industrial heritage of Wales in particular, there is a danger of false portrayal with a glossing over of some of industry's more unpleasant realities. The turbulent progress of history should be arrested not diluted. In the Textile Museum at Newtown, Powys, there is little to tell us that the weaving industry of the town brought prosperity to the factory owners but abject poverty to the workers. As was noted in a report of 1830, when the industry was at its most flourishing state, 'Weavers marry young and die young... By the introduction of the Factory Act, numbers of children were deprived of employment; their parents being poor and unable to give them education, they roam the streets in vice and ignorance.'[2] Conditions in Newtown were such that the town was a seedbed of discontent and Chartism, with riots and violent protestations at the low wages and appalling conditions in the weaving factories. The picture represented in the museum is that of success and contentment...

> Oh what a blissful place, By Severn's banks so fair
> Happy the inhabitants and wholesome is thy air...
> Go on and flourish, the Markets ever bless
> With Flannel, full of money and success.

Life in Newtown was not as prosperous as the poet Robert Ddu Eryri imagined, for the weaver's trade was 'the most depressed of all trades' and gave birth to severe rioting. The ugly as well as the beautiful, discontentment as well as prosperity have to be presented to provide a true and unbiased story of a people.

It is obvious that in the presentation of the industrial heritage considerably more than the three-dimensional relics of past endeavours have to be interpreted. Although the evolution of machinery, the design and layout of industrial buildings and the development of technological

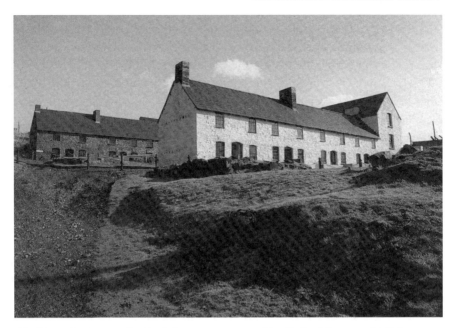

The Blaenafon ironworks: Stack Square as presented by Cadw. (Photograph: Cadw—Welsh Historic Monuments)

and scientific processes may be an integral element in a museum presentation, the principal purpose is to conserve and interpret the character and personality of an industrial community. The objects on view in an industrial museum or heritage centre can never be considered in isolation, they can never be held up to view like pieces of fine porcelain or a Rubens cartoon but they should contribute to a clear understanding of the community that they represent. The history of industry in Wales is not just a history of machines and of technological processes, but a history of a people and of communities that were concerned with making a living. Industry may be defined as the development of skills, raw materials and enterprise, transforming them into usable wealth for the benefit of the maximum number of people. Industrialization is a complex and dynamic process and that complexity and dynamism has to be presented in the clearest possible way.

The Welsh Industrial and Maritime Museum that sets out to present the industrial development of the whole of the Principality was conceived in the 1970s merely as a museum of industrial archaeology, involved with the collection and display of the relics of Wales's industrial past. The items collected, many of them of considerable size, were held up to view in 'A Hall of Power' with scant reference to their context and background. To an engineer, the collection of twenty-six engines that

forms the nucleus of the museum's permanent exhibition may mean something, but what do they mean to the non-technical visitor to the museum? One of the most impressive exhibits at the Welsh Industrial and Maritime Museum is the notable fan engine from the Navigation Colliery, Crumlin. It is only a small part of the original complex at the colliery; there is no indication of how it worked, how it was connected to the ventilation system nor indeed of its appearance on the original site. The label accompanying this impressive exhibit is limited to a technical diatribe:

> Horizontal Triple Expansion engine: 4 cylinders: 15″ x 3′3″.
> Output—500 h.p.; Efficiency 20%.
> Flywheel: 16′ diameter weighing 15 tons.
> Uses steam more efficiently by passing it initially through the first high pressure cylinder, then through the larger intermediate pressure cylinder and finally driving the flow through the two large low pressure cylinders. Made by Walker Bros. Wigan, Lancashire and installed at the Navigation Colliery by Partridge, Jones & Co. in 1911. Used to drive a ventilation fan 24 feet in diameter, 8 feet wide and capable of circulating 300,000 cubic feet of air per minute.

What the labelling does not tell the visitor, at least until recently, was the significance of ventilation in a deep mine; what would happen without a proper ventilation system, and how disasters such as that at Senghenydd during 1913 were the result of a breakdown of a ventilation system. We are not told of other, more primitive methods of searching for gas and providing clean air, nor about the technology of mine ventilation, nor indeed about the original setting of the exhibit. This is an example of 'glass-case presentation' *par excellence*, where the object to be gazed at is the sole purpose of the presentation.

In all museums concerned with industrial history, there is a grave danger of an institution becoming machine-oriented at the expense of other more relevant aspects of the industrial heritage. Indeed the background information may be far more relevant than the object held up to view. The beam engine of 1851 on view at the Welsh Industrial and Maritime Museum is like many another preserved up and down the country. This one was installed at the Ely Pumping House in 1852, remaining in service until 1892. It would be far more significant as an exhibit if the story of Cardiff's growth as a great port was outlined. In that phenomenal development a more efficient means of supplying water to lessen risk of cholera and other waterborne diseases was crucial. The storyline could be something like this:

Museum presentation: a beam engine on display at the Welsh Industrial and Maritime Museum

In 1801 Cardiff had experienced little of the effects of the Industrial Revolution that was transforming certain areas of Britain. Its population in 1801 was 1,860, a figure that had remained at that level for the previous five centuries. By 1840 the number had risen to under 10,000 and by 1850 to 18,000. This dramatic increase was a result of the growing importance of Cardiff as a coal-exporting port, particularly after its unmatched capacity was established with the opening of the West Bute Dock in 1839.

The development of the port led to urbanization on a rapid scale and by 1840 the shape of the town had been revolutionized, but with it came overcrowding, squalor and disease. A community of 2,000 on the banks of the Taff with large open spaces had no problems of water supply, sanitation and drainage; the river had provided an ample and reasonably pure water supply to the town from its earliest history. The well-established techniques of town living were now swamped with the increase in population, and the accompanying pollution and lack of drainage caused the rivers and wells to be contaminated. The existing water supply from the canal, the Taff or from pumps, was inefficient, uncertain, inconvenient and bad. Contemporaries commented on the smell, the filth, the open sewers and the worms in the

water. Not surprisingly typhoid was ever-present and in 1849 a serious outbreak of cholera during the summer claimed the lives of 350 people. Cholera being a waterborne disease, if such an outbreak was to be avoided in future something had to be done to improve the water supply, amongst other things.

In 1850 an inquiry was set up to investigate under the authority of the 1848 Health Act the condition of sewerage, drainage and the supply of water. Its findings revealed the appalling state of the provision of such services in the town. At around the same time a group of Bristol businessmen succeeded in getting an Act passed to allow the formation of the Cardiff Waterworks Company to improve the Cardiff water supply. It embarked on a scheme to draw water from the river Ely, to roughly filter it through a sandbed there and then pump it into a two-million gallon capacity reservoir at Penhill. The beam engine on view worked the pump that fulfilled this function and first began pumping on 12 January 1852. The water was then pumped directly into the mains supplying the town. This water-supply arrangement was maintained for the next twenty years and seems to have been satisfactory in that the improvement in the health of Cardiff's inhabitants was in no small part due to the increased efficiency of the water supply. The effectiveness of this particular beam engine can be measured by the consequent reversal of the trend of deaths exceeding births.

Large immovable objects such as the engines in the Welsh Industrial and Maritime Museum, the Foden engines of the Cydweli Tinplate Museum and the Elliott Colliery winding engine, should be regarded merely as single items in planned displays; they could be more significantly viewed as pegs on which to hang a story. Through the use of photographs, graphic material and smaller associated artefacts, the story of Welsh industry could be unfolded in a more meaningful way.

During the last few decades, particularly the 1960s and 1970s, preservation of the industrial heritage has mushroomed. All kinds of industrial buildings and artefacts have been preserved. Railway engines and aircraft, beam engines and portable engines, power lathes and motor cars have been collected by the dozen, and the scale of preservation for certain items is rapidly attaining the level of an epidemic as if the past were the only future that we have. One wonders whether generations to come will thank us for handing down so many preserved industrial sites and artefacts with all the consequent problems of conservation. Would it not be better to keep a selected few and be content with accurate plans, specifications, illustrations and histories of the remainder? 'Overtaken by other countries in the modernisation of industry', Hewison argues, 'Britain has fallen back on fantasies of a mythical past'. It is essential, in

the field of industrial history in particular, that some coherence should be brought into collecting material objects and remains. The key to a proper policy of conservation must be in depth research work, determining what is significant and worthy of preservation. Without basic research work one can never be sure that the site preserved and the artefacts collected are of relevance in the story that is being presented.

The woollen industry

As mentioned in Chapter 3, the Museum of the Welsh Woollen Industry at Dre-fach Felindre was established as a result of a detailed survey which identified the Dyfed village as a site ideally suited for an interpretive centre.[3] Founded in 1976, the museum is a branch of the National Museum of Wales. It sets out to trace the history of the most extensive and important of all Welsh rural industries in the authentic location of a large, comprehensive woollen mill. The Cambrian Mills, Dre-fach Felindre was the largest of all the mills in a village that was, until 1939, almost entirely dependent on the woollen industry. The mill buildings that accommodate the museum are typical of the large-scale enterprises that dominated the woollen industry in west Wales in its heyday between 1880 and 1925. But the buildings now contain far more than a museum tracing the history and technology of an industry for it is a living museum that also accommodates a fully working mill—Melin Teifi—which is also open to visitors. Here at Melin Teifi, geared entirely to modern production, furnishing fabrics and dress material, shirts and colourful blankets and a wide range of modern fashion wear in light flannel are produced, much of it for the export market. Melin Teifi is an integral part of the museum, for the production of modern textiles is as much a part of the heritage of Wales as the woollen production of a hundred years ago. The museum was planned and conceived as a full interpretive facility for an important industry and in order to make its story relevant it has to be brought up to the present day and provide a sound basis for the future. The Museum of the Welsh Woollen Industry could well have been a museum illustrating a dead, forgotten past; but an attempt has been made to bring the story of the industry right up to date. At Melin Teifi and in the extensive exhibition of modern Welsh textiles representing the production of all the Welsh mills, the present day is as important as the long history of the industry. The Museum has amongst its aims the function of acting as a shop window for the industry in all parts of Wales.

A considerable proportion of the museum building is devoted to the history of the woollen industry in its most important region and as such

it is closely tied to the aims of the Welsh Folk Museum at St Pagans. The Esgair Moel Woollen Mill from Brecknock was moved to the grounds of the Welsh Folk Museum in 1953 as a fully working exhibit but that small mill represents the industry at its simplest level only.[4] Mills such as the Esgair Moel were concerned with supplying a strictly local need and the representation of the industry was far from complete without the preservation of a much larger type of mill in an important textile producing region.

A substantial section of the exhibition at the Museum of the Welsh Woollen Industry is devoted to the exciting, though brief, story of Dre-fach Felindre as a textile producing centre. The character and personality of the area cannot be understood without knowing something about the industry that once employed a large proportion of the population. This remote village was once 'The Huddersfield of Wales' with mills located along the banks of its swiftly flowing streams. The market for its products were the industrial valleys of south Wales and the sale of flannel and tweed brought unprecedented prosperity, albeit shortlived, to the manufacturers of rural west Wales.

'A factory trail' through the village is part of the experience of visiting the museum for within a mile of it all the evolutionary stages in the development of the textile industry from fulling mill to weaver's cottage and from teasel garden to mill leats may be seen. Many of the fifty mills are still standing but only three are still in production.

In addition to the story of Dre-fach Felindre as a centre of textile production, the earlier technical and regional history of the Welsh woollen industry is also presented. Until the mid-nineteenth century for example, the all-important textile region in Wales was the upper Severn Valley and there are a number of sections in the exhibition devoted to the history of the flannel trade in Newtown, Llanidloes and Welshpool. A comprehensive collection of equipment relevant to the development of the woollen industry are exhibited. All these are in working order and are demonstrated by four highly skilled and experienced members of the museum staff. Carding, spinning, weaving and finishing equipment are presented in evolutionary sequence and the collection is probably the most comprehensive in Britain. Outside the main building, a garden growing the plants that were used in cloth dyeing is being developed while an open-sided 'wind-shed' for the drying of woven shawls has recently been restored ready for use. In addition a large building, once a weaving shed, accommodates independent master craftsmen producing the traditional products of west Wales for sale to the public. The whole aim of the complex at Dre-fach Felindre is to present Welsh industrial activity as a living organism contributing not only to the knowledge of the heritage of

Wales but also to the economic welfare of a community that has suffered greatly from the plague of unemployment.

Most of the collections in industrial museums and most of the industrial buildings preserved today only represent a short span in the history of man's industrial activity, and the nostalgia for the age of steam has been the overwhelming concern of industrial archaeologists. It may be of relevance to present the ever-changing dynamism of industrial activity with stories of failures as well as success, providing a balanced picture of man's achievements down to our own day. As the nineteenth and twentieth centuries fade further into the past, the task of making people understand the whole history of man and industry becomes ever more complex. The danger of becoming nothing more than purveyors of nostalgia and sentiment will be with us for ever.

The great little trains of Wales

Nothing evokes more nostalgia than the age of steam. Steam engines, travelling at a snail-like pace through the countryside for a mile or two, drawing passenger-laden coaches, provide a romantic picture of 'the good old days'. In Wales the narrow-gauge network of railways has drawn the attention of individuals and voluntary organizations and an increasing number of lines have been re-opened or built anew to cater for the visitor's interest in the age of steam.

Of course, narrow-gauge railway lines were built for a specific purpose. They were constructed in those difficult mountainous areas with steep slopes and many changes of gradient where it would be impossible to construct a standard, broader gauge track. The main purpose of a narrow-gauge railway line was to bring the products of the mountains, especially slate, from the area of production to the point of export. Thus the famous Ffestiniog Railway, opened in 1836, ran from the mountain-ringed slate town of Blaenau Ffestiniog to the port of Porthmadog, while the Padarn Railway of 1848 ran from the spectacular, many-terraced Dinorwic quarry complex at Llanberis to the port of 'Y Felinheli', renamed Port Dinorwic, on the shores of the Menai Straits. Although in the heyday of the slate industry, passengers were carried, the narrow-gauge railways of Gwynedd were really goods lines designed to transport the products of the most Welsh of all Welsh extractive industries. All the important slate-producing areas of north Wales—Llanberis and Bethesda, Nantlle and Ffestiniog, Croesor and Corris—were served by railways. Most of those lines were abandoned as the slate industry and its associated ports declined.

Llanberis Lake Railway, Locomotive Dolbadarn on a tourist run. (Photograph V. J. Bradley)

Nevertheless, since the mid-1960s groups of enthusiasts have been active in restoring and re-opening long-neglected railway lines and organizing passenger services for the summer tourists. It is not only abandoned narrow-gauge railway lines that have drawn the attention of enthusiasts, but a number of others have been built from new, usually occupying-the dismantled railway track of standard-gauge traffic. New narrow-gauge railways have sprung up in areas where that form of transport was never known, nor indeed necessary in the golden age of rail travel. There is something strange in seeing a meandering 1ft. 11 ⁵/₈in. railway track occupying the bed of a standard-gauge railway running through lush meadows of the Teifi Valley from the village of Henllan to an obscure bridge at Pontprenshitw, barely a mile away. This light railway, in common with newly constructed lines along the south shore of Bala Lake and in the hills north of Merthyr Tudful, has precious little to do with preservation and interpretation of the heritage of Wales, for they are entirely tourist attractions. The current brochure to the Teifi Valley Railway tells us of:

> Unlimited travel on a narrow-gauge railway using steam and diesel locomotives; Woodland walks; Picnic tables; Barbecue areas; Children's playground; Horseshoe throw; Cafe; Souvenir shop; Toilets; ... Included in

the charge is the use of an area where the children can play on the swings, hobby horse, slide, play cottage etc.—have a snack at the cafe where sandwiches, hot dogs, drinks etc. are available... the Forest Amphitheatre seats between 356–400 people.

All this is a long way indeed from the history of a utilitarian standard railway line that served the needs of a market town and the factories of one of the most important woollen manufacturing regions in the United Kingdom.

With the profusion of narrow-gauge railways in many parts of Wales, there may be a danger of over-provision of this form of amenity; a journey along a narrow-gauge line ceases to be a novelty. Many of the railway lines, and more are contemplated, could find themselves in difficulty with a falling number of passengers. Moreover, locomotives and rolling stock of historic significance are becoming scarce and the physical and financial effort needed to rebuild long-neglected lines and to restore badly corroded locomotives may be a task well beyond the resources of most organizations concerned with preservation.

The main narrow-gauge railways marketed as 'The Great Little Trains of Wales' that provide a service for summer tourists are:

Llanberis Lake Railway The two-mile lakeside remains of the slate railway that took the products of the massive Dinorwic quarry to the port of Felinheli until its closure in 1961. With souvenir and gift shop and cafeteria the railway terminus at Gilfach Ddu is part of the Country Park which 'offers a wide range of facilities to appeal to the whole family'.

Ffestiniog Railway The 1836 line from Porthmadog to Blaenau Ffestiniog. It was re-opened in 1955 after intensive work by a group of enthusiasts. Both diesel and steam trains are used and amongst the attractions are a railway museum at Porthmadog, restaurants and shops which operate March-November.

Tal-y-llyn Railway Conceived in 1866 as a railway to connect the Bryn-yr-Eglwys quarry w!th the port of Aberdyfi, but it never ran further than Tywyn, the present terminus of the line. Operating a steam service to Abergynol and Nant Gwernol, the railway company also possesses a museum at Wharf Station, Tywyn.

Welsh Highland Railway Ran from Dinas, near Caernarfon, to Rhyd-Ddu. In 1923 at a time when the slate industry was already in decline it was surprisingly extended to Beddgelert to join the Croesor tramway to Porthmadog. In 1960 a long programme of restoration at the Porthmadog

end was begun but progress has been painfully slow—three-quarters of a mile in thirty-two years.

Fairbourne Railway Originally built as a horse tramway for the construction of a holiday village: Opened as a tourist attraction in 1946 using steam locomotives that are miniature replicas of bigger ones.

Corris Railway A railway that served the needs of a slate quarrying village and ran for 5½ miles from the village to Machynlleth. A ¾ mile section has been reinstated.

Welshpool and Llanfair Railway Opened principally as a mineral line connecting the market town of Llanfair Caereinion, some stone quarries and Welshpool.

Snowdon Mountain Railway A true tourist railway from Llanberis to the summit of Snowdon, opened in 1896.

Vale of Rheidol Railway Built in 1902 to carry lead ore from the hills of northern Ceredigion to the port of Aberystwyth. The 12-mile long railway to Devil's Bridge is now privately owned after being operated by British Rail until 1988.

Great Orme Tramway, Llandudno Cable-operated funicular, opened in 1902 to add lustre to Llandudno's thriving tourist trade.

Bala Lake Railway Runs on the bed of the old Rhiwabon-Barmouth standard-gauge railway line and was opened as a summer tourist amenity in 1972.

Teifi Valley Railway Runs the route of the old Pencader-Newcastle Emlyn railway line from Henllan for a short distance in the direction of Newcastle Emlyn.

Brecon Mountain Railway A narrow-gauge railway that follows the track of the old Brecon-Newport line, closed in the 1960s. Runs from Pant, near Merthyr into the heart of the National Park at Ponsticill and Torpantau. Partly opened 1980.

(A map showing the location of these railways can be found on p.167)

Although the reasonably easily managed narrow-gauge railways were the first to draw the interest of individuals and voluntary organizations, now

standard-gauge railways, presenting many more problems of maintenance and finance are receiving much more attention. Those lines where the romance of steam days can be recreated are becoming increasingly popular and railway preservation societies are gaining in number throughout the Principality. Steam railway centres in Butetown, Cardiff and at Caerffili are well established; the Gwili Valley Railway that runs for a few miles west of Carmarthen town provides regular steam-hauled excursions, while preservation societies at Llangollen, Oswestry, Blaenafon, Pontypool and elsewhere are already running trains along short lengths of railway. In Merthyr Tudful and Dyserth, Swansea and Morriston, there are active preservation societies and all these developments together with collections in a number of museums ensure that the railway industry, once so vital to Wales, will be more than fully interpreted.

Townscapes

Intrinsically related to the industrial development of Wales were the urban centres that accommodated industry and its workers. In the eighteenth century for example, the ancient borough of Llanfair-yng-Nghedewain became Newtown, 'the Leeds of Wales'. In the nineteenth century, Cardiff developed from a small market town into one of the world's great ports, 'the coal metropolis of the world' while Porthmadog developed from nothing into an important slate exporting port as a result of the efforts of one pioneering entrepreneur. Within the last thirty years or so, many of the urban settlements of Wales have changed out of all recognition and in order to present 'a brave new world' many buildings and features of considerable historic significance have been swept away. To replace them, the same type of glass menageries seen everywhere from Milton Keynes to Calgary, Warrington to Toledo have mushroomed. Dixons and Dorothy Perkins, Boots and Dewhurst, Stead and Simpson and Currys now dominate High Streets and since the 1960s 'The Anywhere Town' has arrived and flourished. In this great standardizing movement that ignores all national and cultural boundaries, a blanket of sameness seems to have fallen over most of the western world.

There is no doubt that during the wholesale demolition of the sixties and seventies in particular, certain structures should have been preserved, even if given new roles and functions, in an attempt to retain a town's essential identity. In the New World, the combination of conservation and modern development has been successfully achieved in such places as Baltimore, Boston, Halifax and Vancouver. In Wales we have been far more content to sweep away the old and replace it with the new, whatever the quality

of the old and the nature of the new. In Butetown, that rough and tough sailortown of Cardiff for example, the well-proportioned town houses of Loudon Square were replaced by high-rise flats in the sixties; the elegant office buildings constructed when Cardiff reigned supreme as Britain's premier coal exporting port were demolished by the dozen, to be replaced by car parks. The sixty or more taverns, the rows of small shops and eating places, once essential to the life of a seaport town were abandoned, to be replaced by brewery-designed public houses and characterless glazed-fronted supermarkets that within a space of a few years became tatty and uncared for. Many buildings were of course ripe for demolition but what replaced them was no improvement and the majestic but rough Bute Street that ran from the city centre to the foreshore was developed into a characterless throughway with little to show of its past history as the main artery of dockland life. Many other Welsh towns suffered from the public vandalism of the sixties and seventies.

It seems, however, that in the more historically aware 1980s, when conservation became the 'in thing', authorities grew much more conscious of the importance of preserving features of the past. In the mid-Wales town of Llandrindod Wells for example, one of the main health spas of Victorian and Edwardian Wales, the Pumphouse that had been almost derelict for decades was restored and is now a centre-piece of the annual Victorian festival and of tourist amenities in the town. A number of hotels have been given a new lease of life and throughout the town a conscious attempt has been made to preserve the best features and the genuine quality of a Victorian resort. Not all Welsh towns have been so lucky. At Caernarfon and Haverfordwest for example, a system of roadways penetrate the heart of those historic settlements and many a notable building has disappeared in response to the needs of ever-improving motor transport facilities. Certain other towns such as Cowbridge and Llanidloes now have bypasses so that it is possible to preserve historic features within a largely car-free zone.

In the regeneration of derelict urban areas, historic industries are on the whole ignored, although in some areas such as Swansea dockside, warehouses have been put to new uses. However, in far too many instances industrial buildings have been demolished and replaced with the new. In Merthyr Tudful, Pembroke Dock, Newtown and Wrexham for instance, a great deal of the evidence for past industrial endeavour has been largely obliterated. In some areas such as the Cynon and Sirhywi valleys, extensive sites of past industrial activity have been demolished and, because nothing has replaced them, large sections of those valleys have the appearance of an empty inactive desert.

All that glitters

In 1989 an ambitious plan to convert one of the many gold-mines in the 'Dolgellau Gold Belt' or 'the California of Wales' into a major tourist paradise was turned down by the Snowdonia National Park Planning Authority. If nothing else, the gold belt on the north bank of the River Mawddach is a monument to the optimism of Victorian prospectors who, in the middle years of the nineteenth century imagined that they had found a source of untold wealth. The gold discoveries of Australasia and California provided the stimulus for a large number of hopeful entrepreneurs who between them managed to excavate and prospect well over a hundred and fifty sites in what was after all a rural backwater. So optimistic of success were some of the immigrant prospectors that mine buildings were constructed and refining machinery was purchased at great cost before a single ounce of gold was obtained, and many of the new mines contained gold only in the imagination of the prospectors. Many of those intimately concerned with the development of mining had little knowledge of geological conditions nor of the methods of gold recovery. On the whole the prospects of 'the California of Wales' turned out to be an

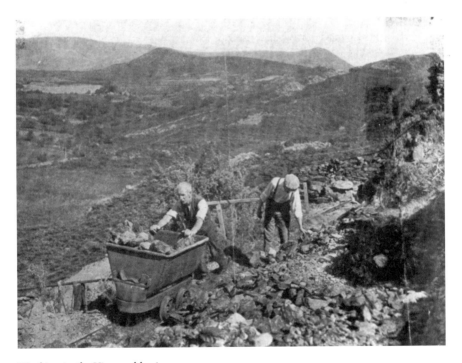

Working in the Vigra gold-mine, 1947

empty dream and many optimistic entrepreneurs had to face the reality of bankruptcy.

Nevertheless one or two of the mines did produce substantial quantities of gold dust. The Clogau mine at Bontddu for instance, provided gold for royal wedding rings and was worked intermittently until recent times. It was certainly no Klondyke for its peak production between 1863 and 1865 only realized gold to the value of £43,000. The Gwynfynydd mine located in the heart of the beautiful Coed-y-Brenin forest near Ganllwyd was as important as Clogau and it operated until 1938. Its most productive era began during the last decade of the nineteenth century and ended in 1910. Substantial remains of gold-mining may be seen on a variety of sites in the Mawddach Valley, but whether a minor extractive industry that was often only a gleam in the eyes of Victorian optimists deserves a full interpretation on the scale of the slate industry or the coal industry is dubious.

The other gold-working area in Wales is a long way from the valley of the Mawddach. In west Wales, in the well-wooded valley of the River Cothi, the Dolaucothi gold-mine near Pumsaint has been preserved and interpreted. This was no mid-Victorian 'flash in the pan'; it was not just a symbol of the mid-nineteenth century gold fever, for the Romans mined for gold in the Cothi Valley and the mine provided bullion for the Imperial Mints at Lyon and Rome. With its well-designed visitor centre, underground galleries and aqueducts, the site has much to offer, not only in the interpretation of the Roman remains but of later efforts such as the costly work carried out in the 1930s by such prospecting companies as the Roman Deep Mines Ltd. when 'a very promising prospect....was not given a fair chance!'

Parys Mountain in the north-east of Ynys Môn (Anglesey), is a blot on the landscape. Its lunar-like appearance would not attract many twentieth-century tourists and a deserted mountain with its dangerous shafts and pits would hardly be the place to bring a coach-load of visitors. Yet in the history of metallurgical mining in Wales, the 'Copper Mountain' was amongst the most important of Welsh industrial sites and the Parys Mountain copper mine was the most productive in Europe. The port of Amlwch was constructed especially to transport the copper ore to Swansea, Liverpool and St Helens. Although copper mining on the Parys Mountain began as a series of small mines in the 1760s, by 1790 it was a huge complex that employed 1,500 men, women and children. If there is any place crying out for a full-scale interpretation of a very important historic industry then it is north-east Anglesey, but unfortunately it is the more scenically beautiful Gwynant Valley near Beddgelert, a tourist honey-pot, that accommodates the only interpretation of this vital metallurgical industry—at the Sygun copper mine. Compared with

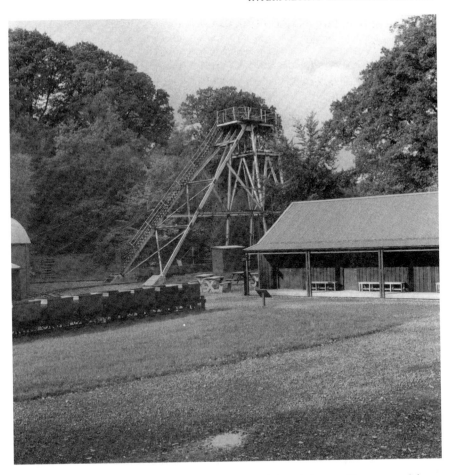

Dolaucothi gold-mine, showing the visitor centre and the mining machinery moved from the Olwyn Goch mine in north Wales
(Photograph: National Trust and Kathy De Witt)

Mynydd Parys, Sygun was of very minor importance, but being located in a far more desirable landscape than that of the Amlwch district, it attracts more visitors. Of course Sygun was but one of a number of profitable copper mines located in the valleys of Snowdonia but today only the ruins of barracks that once accommodated a migrant labour force, a few water-wheel pits and the ruins of mine buildings remind us that life in this region was not always aimed at catering for the needs of summer visitors. 'Sygun copper mine is one of the wonders of Wales' says the museum brochure… 'The mine, a unique modern-day reminder of nineteenth century methods of ore extraction and processing, is situated in the glorious Gwynant Valley—the heart of the stunning Snowdonia National Park, and on probably the most popular tourist route in Wales.' Undoubtedly, the interpretation of the copper industry in a relatively obscure location was brought into being by private entrepreneurs because of its tourism potential rather than the suitability of the site for the comprehensive presentation of an industry.

While the copper industry that brought prosperity to north-east Anglesey and to the lower Swansea Valley is represented by a complex in the heart of rural Gwynedd, the lead and silver mining industries are at least presented in an area where they were of overwhelming importance. North-east Ceredigion, a land of windswept rolling hills, was not always a rural backwater and not all the pursuits of the people were associated with the breeding and shepherding of the flocks of mountain sheep, for the area saw the development of a very important lead and silver mining complex. Villages such as Cwmsymiog and Cwmystwyth in Ceredigion and Dylife and Fan in Powys came into existence to provide homes for hundreds of lead and silver miners who migrated to the area from all parts of the country.

For a short period the remote hill country of central Wales witnessed the equivalent of a gold rush. Although the mining of lead and silver was carried out in prehistoric times, it was during the reign of Elizabeth I and the foundation of the Society of Mines Royal that the industry really developed. People like Sir Hugh Middleton made a huge fortune from the hills of Ceredigion while an entrepreneur, Thomas Bushell, was given the right to mint silver coin at Aberystwyth in 1637. Ten years later, Oliver Cromwell demolished Aberystwyth Castle and the minting of silver coin ceased. During the last decade of the seventeenth century Sir Henry Mackworth formed the Mine Adventurers Company and for the next 150 years or so the hills of mid-Wales became one of the most productive lead and silver mining complexes in the kingdom. Cornish miners in particular migrated to Cwmystwyth and Ystumtuen, Goginan and Pontrhydygroes bringing with them their own brand of Wesleyan Methodism that still

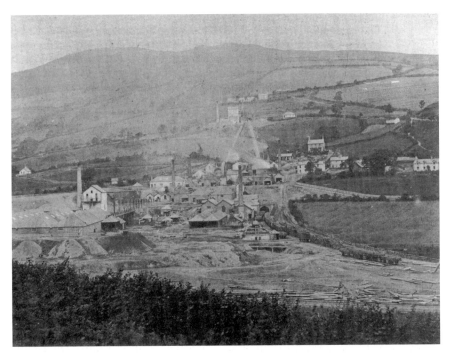

Van lead-mine near Llanidloes, Powys, in its heyday

dominates the religious affiliations of the inhabitants of the region. All was well until the 1880s, but unfortunately cheap ore from Spain, North America and Australasia flooded the market and an extractive industry that brought prosperity to a remote corner of the Welsh countryside declined rapidly, leaving only the derelict remains of mine workings that still dominate the landscape. There was intense depopulation: the large Nonconformist chapels designed to seat a congregation of hundreds and school buildings designed to take a large number of pupils are reminders of the days when this now sparsely populated region enjoyed a golden era as a centre of industry. Many of the settlements are now ghost villages providing few opportunities for employment, but amongst the desolation the remains of workshops and tramways, adits and shafts as well as the ruins of thousands of cottage dwellings are vivid reminders of more prosperous days. Outside mid-Wales, lead mining was carried out in a large number of places and the Minera lead mines near Wrexham were particularly productive.

An extractive industry of international importance certainly deserves a full interpretation. The character of many a desolate village cannot be understood without some knowledge of an industry that dominated the economic and social life of its inhabitants. Unlike the coal and

slate industries that are perhaps over-interpreted on too many sites, only one, privately owned, enterprise attempts the presentation of lead and silver mining: the Llywernog mine near the remote village of Ponterwyd was a mine famed for its silver as well as its lead and as such it has been developed within the last fifteen years or so as a major tourist attraction.

Of course, a number of the extractive industries of Wales have been developed to attract visitors because they are located in scenically beautiful areas such as the heart of Snowdonia. Whether all the sites chosen are the most appropriate ones for setting up an interpretive facility is beside the point, for few tourists would be drawn to such places of dereliction as the lower Swansea Valley and the lunar landscape of Mynydd Parys and Cwmystwyth when they can enjoy the sylvan surroundings of Beddgelert or Ponterwyd. The White Rock copper works in Swansea, that accounted for half Britain's output of copper in the mid and late nineteenth century, is far less appealing than the tiny Sygun copper mine in Snowdonia. Similarly, the remains of the ironworks at Abersychan and the Forgeside Works at Blaenafon compare very unfavourably with the romantic site of the Dyfi furnaces to the north of Aberystwyth.

Conveying the history of an extractive industry is a vast task. More often than not the question is not asked whether a resource is a true representation of the heritage that is being conserved and interpreted. Certain major industries, such as iron and steel, are not interpreted in any systematic way: only the scattered, derelict remains remind us that this was one of the most vital of Welsh industries. Obviously iron-making awaits its first full-scale interpretation.

The processing of tinplate that was to the Swansea region what slate quarrying was to north Wales is another industry that deserves a full interpretation. In 1913 four out of every five tinplate workers in the United Kingdom lived within a twenty mile radius of Swansea and the whole economy of towns and villages such as Llanelli, Morriston, Briton Ferry and Gorseinon was tied up with the tinplate industry that gave employment to men, women and children.

Tinplate-iron or steel bar rolled into sheets and coated with tin, was first made in Wales in the late seventeenth century but it was really during the eighteenth century that the industry expanded in south-west Wales, the development of the United States of America leading to its rapid growth. Tinplate provided cheap material for the domestic utensils needed by the pioneering families of the New World; roofing material for their homesteads, drums for the developing oil industry and cans for the meat producers of Chicago and the fruit farmers of California. So successful was the Welsh tinplate industry that in 1891 President McKinley imposed a

tariff on all imported tinplate. West Wales suffered badly, tinplate workers emigrated to the United States by the thousand and many works in the Swansea Valley closed, never to open again.

Not until the opening of the Cydweli Industrial Museum in 1982 was an attempt made to provide an interpretive facility for this labour-intensive and very Welsh industry. Unfortunately much of the original equipment associated with the Cydweli Tinplate Works had been removed for scrap in the 1970s so that the opportunity of creating a comprehensive and evocative facility was lost for ever. A great deal has been done to redevelop the site, but the result is a presentation of relics rather than the preservation of a complete site. Pit-head gear from the nearby Morlais Colliery has been re-erected on the site, there are two locomotives and a steam crane and a number of exhibits relating to the tinplate industry moved to Cydweli from other works in the region. Among the relics of the industry used on the site itself are a water-powered mill, a large 'Foden' steam engine which powered the cold rolls, cropping shears, and a steam locomotive. According to a plaque affixed to an office building at the entrance to the site, the Cydweli tinplate works was rebuilt in 1801 and was 'the oldest in the kingdom'. The original forge was set up as early

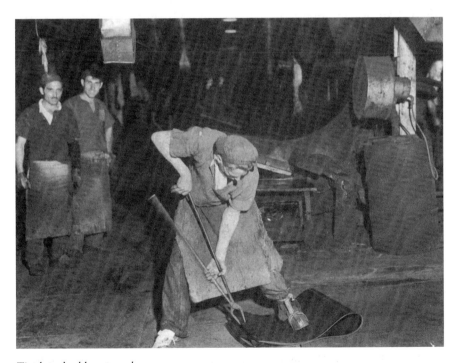

Tinplate doubler at work

as 1719 followed by the 'tin mills' set up by Robert Morgan. The water-powered works established in 1737 with steam being introduced in the 1860s, and the works were in continuous use until 1941. Located on the banks of the river Gwendraeth Fach, the thirteen-acre site today consists of four original buildings comprising the box room, a sorting room, cold rolls, engine house and mess room, a chimney stack and machinery.

The main aim of the museum is to reconstruct as much as possible of the tinplate process—both the methods of production and the desperately hard life of the tinplate workers—and to interpret it to the visiting public. It also aims to record and preserve material relating to the other industries of the Llanelli area that in recent years has suffered greatly from the process of de-industrialization. These are early days at Cydweli; a great deal has been achieved within a few years, but there is no doubt that the museum has the potential to develop into a first-class recreational and educational facility and one of the attractions provided by the Llanelli Borough Council. At present, interpretation is basic and visitors find their own way around the site following a route set out in the printed guide. Eventually it is hoped to engage tinplate workers as guides, but with the passage of time, those unique artisans are becoming far fewer in numbers.

To the east of Llanelli, in the shadow of the modern Trostre Tinplate Works another small museum has been established at the former Trostre Farm. Visits to this can only be made by prior arrangement with the Works Manager. Trostre Farm, rethatched and renovated, contains a fascinating exhibition of small items including tinplate workers' dress and a can of the first beer canned in tinplate for the nearby Felinfoel Brewery. Of course the area around Llanelli was famous for its tinplate; hence the saucepans on top of the rugby goal-posts at the famous Stradey Park and the old song 'Sospan Fach' (the Little Saucepan), the battle cry of all those who owe allegiance to this fascinating Welsh town.

Notes

1. Harris, J. R. Quoted in 'The Present Status of Industrial Archaeology' in *Industrial Archaeologists' Guide* (London 1972) p.20.
2. Jenkins, J. G. op. cit. (1969) p.147.
3. Jenkins, J. G. *Dre-fach Felindre and the Woollen Industry* (Llandysul 1976).
4. Jenkins, J. G. *The Esgair Moel Woollen Mill* (Cardiff 1975).

5 COAL IS KING

The task of communicating an unexpurgated history of the most important of Welsh extractive industries and its profound effects on Welsh economy and society is a daunting one. For over a century the extraction of coal was the main activity of dozens of settlements that sprang up in south Wales. 'Coal in truth', said Stanley Jeavons in 1866, 'stands not beside but above all other commodities. It is the material energy of the country; the universal aid, the factor in everything we do. With coal any feat is possible and easy, without it we are thrown back into the laborious poverty of early times. The railway network, the growth of ports, industrial development, all depend on this, the most important of all fuels'.[1]

In recent times, that position of pre-eminence has been eroded and south Wales, the land of coal mining, has no deep coal mines within its boundaries. Very rapidly we are seeing the demise of a vital industry that gave the narrow valleys of Glamorgan and Gwent their own unique character and personality. That industry which brought so much prosperity and suffering to so many communities is disappearing before our very eyes and soon there will be little left to tell our people that those dark, narrow valleys were to migrant workers of the nineteenth and early twentieth centuries what Saudi Arabia has been in more recent times. The interpretation of that vast industry is a challenge demanding knowledge and expertise to ensure that at least a small proportion of its exciting story is preserved for all time, for this was an industry of world relevance. 'The incredible world empire of south Wales coal is familiar' said Gwyn A. Williams:

> But this was much more than a simple matter of coal export. South Wales capital, south Wales technology, south Wales enterprise, south Wales labour not only fertilised whole tracts of the world from Pennsylvania to the Donetz basin; they were a critical factor in world economic development. The growth of Spain was completely distorted by the power of south Wales which wrenched its natural heavy industry base from the Asturias to the Basque provinces; south Wales merchants bought up the shipping companies of French ports and of Hamburg. Italy, Argentina, Brazil worked to the rhythm of south Wales trade. In consequence, a whole new industrial civilisation grew up in the south.[2]

The south Wales coalfield, stretching over a thousand square miles of land, extends from the Pembrokeshire peninsula almost to the Severn and it differs from other British coalfields in its wide range of coals—from anthracite to superb steam-coal. The extraction of coal was never easy in south Wales and in the steam-coal mines of the Rhondda for instance as much labour and material was expended in the maintenance of mines as in the extraction and raising of the coal itself. The amount of pit-wood required to support the roof and sides of a. mine was three times the amount required in other coalfields. The quantity of debris and rubbish that had to be handled, much of it contributing to the Matterhorn-like slag that were such a feature of the south Wales landscape, was in many cases more than the quantity of usable coal raised. The geological problems of the south Wales coalfield have always been complex and insurmountable ecological complications have been cited as the reason for the closure of many mines.

Although coal was known to the Romans in Wales, it was not greatly used as a fuel until the thirteenth century. By the fifteenth century it was being mined in Anglesey, Flintshire, Monmouthshire, Glamorgan and Pembrokeshire. It was used by blacksmiths, lime-burners and to some extent, in domestic fires. Attempts towards the substitution of coal for wood in ironmaking during the seventeenth century began to change the picture. When the difficulties encountered were mastered, the use of coke

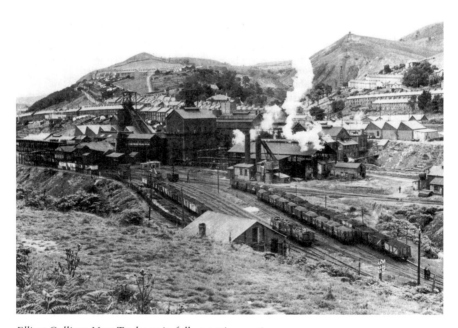

Elliott Colliery, New Tredegar in full operation, 1960

Elliott Colliery, New Tredegar: the preserved 'monument', 1980

from pit-coal was swiftly developed and the demand for coal increased in proportion.[3]

The growth of the industry during the seventeenth and eighteenth centuries was based very largely on the expansion of the iron, tinplate and copper industries. But alongside these there grew up in the early nineteenth century a 'sale coal' trade in the hands of local businessmen. The first Welsh steam-coals to attain eminence were those from Llangennech near Llanelli, but the mining of sale coal at the eastern end followed soon after. Within a few years, because it made less smoke, Welsh coal had supplanted coal from Newcastle in many London grates, and a number of speculators, including Thomas Powell, Thomas Wayne and John Nixon, sank pits in the Aberdare area in the late 1830s and 1840s. Powell linked his name with the two pits he sank in 1844 and made Powell Duffryn a familiar name in many parts of the world. From London, John Nixon turned overseas for markets and developed the coal trade with France which became an important market for Welsh coal. Coal exports sharply increased in the 1840s.

By 1874, the annual production of coal in south Wales had reached nearly 16½ million tons, an increase of between three and four times the production since 1840, and foreign shipments of coal amounted to nearly 4 million tons compared with 63,000 tons in 1840. As late as 1850 however, industrial activity in south Wales was still highly localized—along the eighteen-mile strip at the northern end of the valleys where the iron industry was centred, and in the Swansea-Neath area where the copper industry and some tinplate manufacturing was situated. Only slowly did

industry penetrate the 'Valleys' and it was not until the 1850s that steam-coal pits were sunk in the Upper Rhondda. The vital industrial experience of the Welsh mining valleys is therefore encompassed within less than seventy-five years. The key to their exploitation was the railway. The Taff Vale Railway opened between Abercynon and Cardiff in 1840 and was extended to Merthyr in 1841, with further extensions into the Rhondda Valleys in the next two decades. Brunel built the South Wales Railway from Chepstow to Swansea in 1850, and two years later linked it with the Great Western Railway. This provided direct rail communication between south Wales, the Midlands and London.

As more capital was invested and the industry experienced its phenomenal growth, workmen were drawn from a widening radius; from the rural areas of Wales, from England and Scotland, and from abroad. Indeed in the first decade of this century south Wales was absorbing population at a rate second only to that of the United States of America. The most remarkable example of headlong expansion occurred in the Rhondda, where the population grew from 4,000 in 1861 to reach a peak of 163,000 in 1921.

The consequences of population growth quickly became visible on the face of south Wales as the coal-mining valleys were rapidly urbanized. The characteristics typical of a south Wales mining community emerged, with the communication networks and pits on the valley floor and the linear, ribbon settlements with the institutes, the chapels, the pubs and the police station along the sides of the narrow valleys, all overshadowed by the ever-present and ever-growing waste tips. The influx of population also had a serious impact on the established institutions of Wales, on religion, on the Welsh language and on political development. A new society was being forged in Wales as a result of the unprecedented growth of the coal industry. Between 1850 and 1870 the superiority of Welsh 'smokeless' coal over all others had been demonstrated during a number of trials carried out by the British Admiralty. This led to its total acceptance by the Royal Navy, a decision which influenced other navies and was a major contribution to increased demand. The Naval and Ocean collieries took their names from these significant happenings.

The Rhondda Valley may well be regarded as the archetype of the coalmining valleys running northwards from the coast of south-east Wales. The term 'Rhondda' set the supreme standard for steam-coal, but on the human side the story at times was one of social turbulence and bitter industrial relations between the coalowners and the miners. During the final decade of the nineteenth century it became clear to coalowners that if the potential of the Rhondda as a steam-coal producing district was to be realized they would have to introduce deeper mining, more intensive

mechanization and improved ventilation. Such development depended considerably on the technical skill of engineers which, progressively, became available through the establishment of such institutions as the Treforest School of Mines and the South Wales Institute of Engineers. The formation of public limited companies was also important in order to mobilize the capital resources required to finance the technical developments involved in deep mining.

The output of the south Wales coalfield reached a peak of approximately 57 million tons, or one-fifth of the total output of the United Kingdom in 1913 when there were 620 working coal-mines, including small mines, and employing 232,800 men. During the years of development towards this peak of production, the methods of working had progressed from hand operation to coal-cutting machines worked by compressed air and afterwards by electricity. Methods of raising coal improved in stages from the use of hand windlasses, horse gins, to the various kinds of steam winding-engines developed to meet new demands to reach the deeper coal measures. There were equivalent developments towards improvements in winding ropes. Transport of coal below ground was achieved through the use of various haulage systems; a coal-face conveyor was introduced in 1902; the shaker conveyor powered by electricity was used a great deal in south Wales and conveyor belts have been features of mine roadways for a considerable time.[4]

A great deal of attention was given to mine drainage and ventilation, but nevertheless the loss of life in the industry was heavy. The frequent explosions and flooding disasters with their terrible death tolls, and the almost daily loss through rock falls and tram accidents, stand as vivid reminders of the perilous conditions of work that mining involved. Indeed, the common experience of working in the same industry and of the dangers involved forged an intense community spirit among the inhabitants of the coal-mining towns. Considerable progress was made in the use of personal lighting, and electrical-flameproof fittings were introduced for the lighting of main roadways. In parallel with these developments progress was made in the field of safety and health, in particular the deadly hazard of coal dust was being looked at by a research committee in 1939.

After 1921 the south Wales coalfield suffered marked industrial recession. The mining valleys were totally dependent on the coal industry for employment as there had been no industrial diversification. The industrial exploitation of the Valleys was characterized by the drive to get as much coal out as quickly and as cheaply as possible, with no reference to environmental consequences whatsoever. Furthermore, the export-based nature of the south Wales coal economy exacerbated the depression

created by the switch to oil and the development of coal industries abroad. The recession in the coal industry, as in the other heavy industries which formed the mainstay of the economy, had serious repercussions. One was unemployment: between 1925 and 1932 unemployment in Wales reached a peak figure of 234,730. Another consequence was a remarkable decline in population as migration from the mining valleys to the new industrial centres of the Midlands and south-east England continued apace throughout the inter-war years. Between 1921 and 1940, 430,000 people left Wales.

The subsequent history of the coal industry in Wales has been one of continuing decline both in the number of collieries and in manpower. In 1981, there were in south Wales a total of thirty-seven working deep mines, administered by the National Coal Board, employing about 28,000 men. In addition there were about eighty small licensed mines employing a further 6,000. Economically and politically the south Wales coal industry was a force in the land and miners' galas and *eisteddfodau* were notable events in the annual calendar of the valley communities. All in all coal mining was of major importance in the Welsh economy as it had been for the preceeding hundred years or more.

But obliteration and disaster was to come, for by 1990 the whole

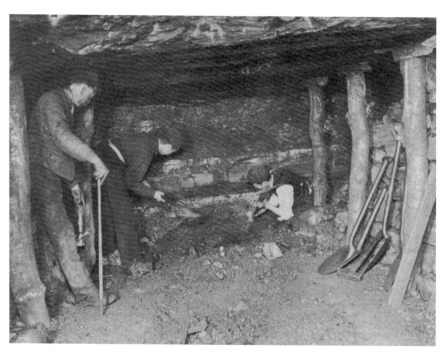

The reality of coal-mining at No.8 Pit, Tredegar, 1898

Interpreting the coal industry: the Mining Gallery at the National Museum of Wales, 1987

of the industry in the once great coalfield was represented by only five working mines: Blaenant Colliery (Creunant), Tower-Maerdy Colliery (Rhondda), Penallta (Hengoed), Deep Navigation (Treharris), Taff Merthyr (Bedlinog), and the sole anthracite mine at Betws (Ammanford). In 1990 Blaenant and Maerdy Collieries closed while early in 1991 the old established and once prolific Deep Navigation Mine at Treharris was closed after a hundred years of production. Later in the year Penallta Colliery closed. An industry that once employed a large proportion of the population of numerous virile Welsh communities is obviously in its death throes. Coal from China and Australia, the United States and Poland is shipped to the once great coal-exporting ports of Cardiff and Barry and the future of the whole industry that shaped a society is being rapidly obliterated. The Rhondda Valley, whose name was synonymous with coal, no longer has a single coal mine within it. No more than fifty years ago it had as many as fifty pits producing 9.5 million tons of high quality coal annually. In the 1990s those interested in the Rhondda, its economy and society have to be content with the Rhondda Heritage Park; reality has gone.

Today the whole of the south Wales coal industry employs only about 1,000 men; the DVLA at Swansea and the branches of Marks and Spencer in Wales employ more. In the reorganization of the industry nationally, the south Wales coalfield no longer merits the status and title of 'an area' and an industry that contributed so much to the economic, social and cultural life of the United Kingdom is near oblivion for even the three mines in production in 1992 do not have an assured future. Today the industry in the whole of Wales employs less than 16,000, compared with 90,000 in 1945. The industry that shaped valleys such as the Dulais, Garw, Rhondda, Ogmore and Sirhywi no longer exists in those valleys. In February 1991 the post of President of the South Wales National Union of Mineworkers was obliterated; a further death knell.

Nevertheless, highly mechanized, open-cast coal extraction that leaves such an indelible blot on the landscape employs about 1,500 men. This flourishes especially along the northern and western rim of the coalfield and environmentally its development is a disaster. The reinstatement of exhausted sites as at the Bryn Bach Country Park in the upper Rhymney Valley has created an artificial landscape despite heavy tree planting and the creation of amenity lakes. A new, machine-made landscape is becoming ever more common in the valleys of south Wales. Evidence of past endeavours is being obliterated—even the conical spoil heaps of the past that were so characteristic of the Valleys are no more and soon pithead gear will only be visible in museums.

In north Wales the story has been the same and coal mining that was the life-blood of such villages as Bersham, Rhosllannerchrugog and Gresford has disappeared and the industry is now represented by one coastal coal mine at Point of Ayr. In Wales generally, the future of the industry seems to lie in the development of the Margam 'super-pit'—a project that is fraught with difficulty.

In view of the wholesale changes that have taken place in the coal industry and in view of its tremendous contribution to the personality of Wales, an attempt has to be made to interpret that industry. It is a monumental task and the facilities that have been developed are not worthy, as yet, of the phenomenal importance of coal in the life of a substantial proportion of the people of Wales. The coal industry and its generations of remarkable workers deserve far more than a tourist peepshow that disregards strife and unrest. In the ambitious plan for the creation of a heritage park for the Rhondda for example, a disused colliery site at Trehafod is rapidly being turned into one of the leading tourist spots of the future, but one can express a little apprehension regarding the eventual outcome of the scheme for it is an example, yet again, of solving serious economic distress by providing a tourist

attraction. Proximity to the motorway network seems to have been a far more important consideration in its siting and development than the intention of providing the kind of interpretive centre that the Rhondda deserves. Of course, many schemes for heritage parks such as this could develop into fun palaces, presenting an innocuous, sanitized community with performing choirs singing the nostalgic songs of Joseph Parry with 'recreated cinema... complete with organist; ice cream and fish and chips wrapped in a reproduction period newspaper which might be sold from a period tricycle and shop respectively; perhaps visitors might even be given period money to use at period prices, their allowances being equal to a miner's pay packet'. So the initial report on the project stated.

The following section of an article by Kate Muir (*Sunday Correspondent* 27 May 1990) quite rightly points out the dangers of such a scheme of interpretation:

The Rhondda Valley, heart of the South Wales coalfield, had 41,000 miners. Now it has 300.

The worker is on the scrapheap, along with rusting pitheads and engine parts, which is alright for the younger models who can still be melted down to fit other job descriptions. But relocating and retraining are not easy options for the less malleable over-50s. With them comes a psychological baggage, an almost masochistic pride in their work and the toughness and courage it demanded, a need that a job stacking shelves in Do-It-All does not fulfil.

But wait. In the Rhondda, a group of developers believe they have found the solution. A solution which will conveniently dispose of redundant machinery and miners in one money-making concept. A solution which can be applied to industrial wastelands countrywide. A solution which involves turning the Rhondda Valley into a giant theme park celebrating mining—a Disneyland, Scargill-style.

It may sound like a joke, but it is going to cost £12m, much of it public money. Soon, predict the local council and development agency, up to 250,000 tourists a year will come to the Rhondda Heritage Park to observe the habitat and work of a newly-abolished species, the miner. 'See the past in a new light', says the logo over a now defunct miner's lamp.

Some snippets from the Heritage Park visitor centre wall display: 'Sculpted figures, actors, theatrical scenes and projected images... will allow the visitor to step back in time and enjoy the sights, sounds and smells of yesteryear. Hot chestnuts from barrows and ice creams from the Bracci Cafe will once again become a reality.'

It is possible that ex-miners will be employed to act as miners or guides in the genuine Twenties mining village being built, although there is a genuine Nineties village, Trehafod, nearby.

There is also a genuine mine, Lewis Merthyr, on the site, but 'Black Gold—the underground experience' will be built for convenience just below the surface.

In fact, 'sanitized for your convenience' would be a good motto for the Heritage Park. The words are more usually seen on those strips of paper put across newly-cleaned toilets in hotel-rooms, but the locals expect their story will require a lot of sanitizing to attract tourists. Already, the five-minute video history of the South Wales coalfield—a taste of things to come—mentions the 1910 Cambrian miners' strike (history) but fails to discuss the 1984 strike (politics).

Former union lodge secretary Ivor England, 54, last seen on television marching back to work, under the banner of the Maerdy strikers, to the pit which closed a year later, was worried the truth would give way to tourism.

He walked by the plastic life-sized miners with staring blue eyes and had coffee at the lace-covered table in the cafe atop the mine where he started work at 17. 'You can't tart up history. They say it's too grey and melancholy, it won't sell, but you can go too far. The history of the South Wales miners is a history of turbulence and struggle. This heritage idea is giving out the wrong vibes. There's something undignified about it.'

The conservation and presentation of industrial heritage particularly that of an extractive industry such as coal mining involves the preservation of small items as well as items of considerable size. Collieries are large-scale enterprises, each one with numerous surface buildings, widespread underground workings and thousands of tons of engines, machinery and other equipment. Furthermore, the colliery was merely a part of a much larger complex. In interpreting the coal industry consideration should be given not only to the pit itself with its shafts, its headgear, its workshops, its screens and washery and its tips. Of equal importance for its economic functioning was the communications network—roads, railways, canals and port facilities that ensured the transport of coal from pit to market. The houses that accommodated the workers and the mining community that grew around each pit are of considerable significance as were the stores where the mining families shopped and the institutes, public houses and chapels that fulfilled their recreational and spiritual needs. All these are as much an integral part of the heritage of the coal industry as the headgear and winders of a pit. If the coalmine is not to be viewed in isolation, but rather as one part of a much greater complex, then the magnitude of the task of conserving and interpreting this vital part of the heritage of Wales is staggering.

One reason why Big Pit, Blaenafon, one of south Wales's principal

tourist attractions, falls short of expectations is that it consists merely of the pit-head gear with the associated colliery buildings around it, stuck in the middle of a reclaimed, featureless industrial desert. The spaghetti network of railways has gone, the rows of cottages were demolished years ago and the slag heap that loomed over the now vanished pit village has been flattened and landscaped. But one of the great attractions of Big Pit, that operated from 1870 until 1980 as a working mine, is that groups of visitors can be taken underground for tours conducted by ex-miners. Equipped with safety helmets and cap lamps, visitors get a taste of life underground; yet because they can walk comfortably upright along well-lit corridors the reality of coal mining can hardly be presented to them. Most of the pits of south Wales were damp and low ceilinged with noise, coal-dust laden air and little light. If the visitor relies on impressions of the coal industry gathered from a visit to Big Pit, then he or she will hardly understand why coal miners throughout history fought employer and government over the wretched conditions of work in the mines, their accidents and disasters, their contribution to disease and to the heavy death toll associated with the most brutalizing of all industries. Nor would they know how coal operations scarred the countryside and about life in many a wretched village that nestled in the shadow of a mine.

Perhaps the problems of conveying harsh reality are insurmountable and a sound and video programme might achieve greater authenticity than a sanitized walkway of whitewashed galleries. In presenting the coal industry, the undesirable and the ugly are of importance and in order to provide a true picture it is necessary to go beyond nostalgia and romanticism. This was a tough, hard industry manned by tough, hard men whose story has to be told with sympathy and understanding; the pressures of a very competitive tourist industry need not distract from authenticity. Indeed the visiting public may well be far more appreciative of accuracy rather than the over commercialization that is always a temptation for those concerned with interpretation.

In addition to a full-scale interpretation of the coal industry in such places as Big Pit, Blaenafon, the Welsh Miners' Museum at Cynonville, the Rhondda Heritage Park at Trehafod and the Cefn Coed Coal and Steam Centre at Crynant, a number of 'monuments' of the industry have been preserved. Many of these look incrongruous as the sole remaining structures in a once important complex. The Elliott Colliery Engine House at New Tredegar in Gwent, for instance, contains the last twin-tandem compound winding engine in south Wales. The engine house is located in the middle of a reclaimed site, for the coal mine and its associated buildings and headgear were demolished years ago; the banks of terraced houses

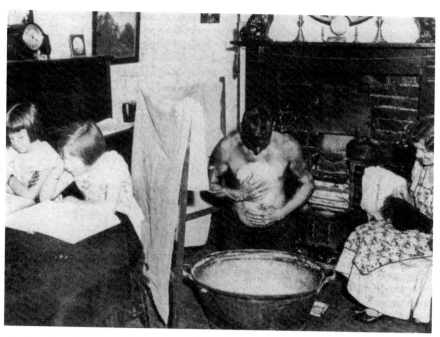

A miner's kitchen in the Rhymney Valley, 1935

that surrounded it have all disappeared and the maze of railway lines and the slag heaps have all gone. Boarded up and vandalized, the poor engine house looks somewhat forlorn in its isolation; its visitors are few and until the proposals for the construction of an adjacent full-scale interpretive centre are developed the Elliott Colliery engine house contributes little to an appreciation of the importance of coal in the life of the Rhymney Valley.

Of course in the interpretation of the coal industry, in-situ preservation is the only way of proceeding. Museums may include extensive collections of small tools and equipment but a carefully selected number of industrial buildings need to be preserved. It is necessary to determine what should be retained in order to create an accurate picture of the industry and then to select the most suitable sites. The remainder can only be recorded photographically and by detailed plans or drawings: we cannot preserve everything. An inventory of buildings and artefacts worthy of preservation can only be compiled after thorough research into the history of the Welsh coal industry. If the present trend continues, as the process of de-industrialization proceeds, will future generations thank us for handing down so many industrial sites and artefacts? As more and more coal mines have closed, an increasing number of sites and artefacts have become available, and soon a large proportion of the coal

The Miner's kitchen as presented at the Valley Inheritance, Pontypool, 1985 (Photograph: Torfaen Museum Trust)

mines of south Wales could become tourist attractions. The only way forward must be the drawing up of a plan of priorities; the inventory of what is worthy of preservation and what is representative of the heritage of the industry. It is not enough to say that if a coal-mine ceases to exist as a production unit, that this should be the site of an interpretive centre, for in every field of activity one needs a blueprint for development, based on good academic research and a thorough understanding of the subject matter. Far too often, when a coal-mine closes, someone will propose its development as a centre of tourism, forgetting the heavy costs and the substantial problems of health and safety associated with those mines. In 1982 for example, the Fernhill Colliery in the Upper Rhondda was offered to the Borough Council for the price of £1 for the purpose of establishing a museum! The Council in their wisdom turned down the offer for the development of a tourist facility that even at that time would have cost over £4 million.

Finding adequate space and resources for the storage and display of the physical and documentary evidence of King Coal is a challenging task. Nearly all relevant artefacts are of considerable size while the documentary remains of the industry are extensive. Colliery records, Coal Board records, union and mine lodge records, maps, plans, photographs etc. are all of crucial importance. There is a very real danger that in interpreting such a

complex industry, the evolution of mining techniques and the importance of machinery are given a position of dominance over documentary evidence which is of equal if not greater significance in the story of the valley communities and the human cost of coal.

Notes

1. Jeavons, W. Stanley. *The Coal Question; an enquiry concerning the progress of the nation and the probable exhaustion of the coal mines* (London 1866), p.5.
2. Williams, G. A. *When was Wales?* (BBC Radio Lecture 1979).
3. I am grateful to Dr W. D. Jones for information on the economic and social development of the South Wales Coal Industry.'
4. *The Coal Mining Industry in Wales—Its Conservation, Preservation and Interpretation* (Welsh Industrial and Maritime Museum Discussion Paper 1983): unpublished.

6 THE MOST WELSH OF WELSH INDUSTRIES

Just as the coal industry dominated the life of a substantial proportion of the population of the south Wales valleys, so did the extraction of slate provide the lifeblood of many a north Wales community. Towns and villages such as Blaenau Ffestiniog, Llanberis and Bethesda were overwhelmingly concerned with the production of slate and dark, sombre waste tips loomed over the settlements as a testament to the labours of generations of workers who were employed in one of the most brutalizing of industries. The railway system and the ports of north-west Wales were developed specifically to deal with the export of slates. In the quarrying communities themselves English was 'a foreign language and those shapeless monotonous villages... grey and drab... [were] the homes of a vigorous native culture'.[1]

Although slate has been quarried intermittently in north Wales since Roman times, it was really in the closing years of the eighteenth century with the demand for cheap roofing material for the factories, mills and houses of mushrooming industrial Britain that the Welsh industry came into its own. Throughout the nineteenth century, the industry boomed to reach its peak in 1898 when 16,766 men were employed. Most of the principal slate rocks are situated in the heart of Snowdonia too remote to attract immigrant labour. Much of the capital for the development of the industry came from outside the region, primarily from Lancashire.[2] By 1860, The Mining Journal could state that 'there is no investment which has provided such remunerative results and profits almost fabulous have been realised'. The endeavours of the slate quarrymen have left an indelible and overpowering impact on the landscape and society of the localities where the industry developed. The isolation and remoteness of the slate rocks determined that the industry developed relatively late and that the Welsh character of the industry was preserved.

From its peak during the last quarter of the nineteenth century, the Welsh slate industry in Gwynedd has declined in importance and an activity that contributed so much to the character of a substantial part of Wales is no longer of international significance. Nevertheless some semblance of the industry remains in some of the tourist-oriented mines and quarries that during the last quarter of the twentieth century have proliferated in settlements which in the past could never have been regarded as tourist

honeypots. The recession in slate production has really taken place since 1900. In Blaenau Ffestiniog for example, 'A recession set in, there was a cutback in profits and there was a shortage of working capital; in addition French and American slates were being imported.'[3] It was a slowing down rather than a collapse, and in 1901 the labour force in the Ffestiniog quarries was 3,495 as compared with 4,022 in 1878. In 1900, one of the bitterest disputes in British industrial history occurred between Lord Penrhyn, owner of the huge Bethesda slate quarries, and the North Wales Quarrymen's Union.[4] It lasted three years, resulting in the complete defeat of the Union. The dispute had a disastrous effect on the whole industry. Emigration to better paid jobs in the industrial Midlands and the USA increased rapidly; moreover many skilled men were killed in the 1914 war. The most serious blow to the industry was the invention of cheap mass-produced tiles. Slates cannot be mass-produced in the same way and the quarry owners used little of their vast profits in research, marketing or mechanization. Control was exercised by absentee overlords; the managers on the site were more or less helpless. Things went from bad to worse; eight small quarries closed in the Ffestiniog area between 1908 and 1913. The labour force fell from 2,975 in 1906 to 762 in 1918; production in 1954 was about a tenth of the peak year 1889.

In other slate localities, the story has been the same. The vast pit of the Dorothea Quarry, Dyffryn Nantlle, for example, ceased production in 1970; the impressive mountain-side Dinorwic Quarry at Llanberis was suddenly closed in December 1969 and a number of others such as Glyn Rhonwy at Llanberis, Foty and Bowydd at Blaenau Ffestiniog and Penybryn at Dyffryn Nantlle have been altered out of all recognition by land reclamation and landscaping schemes. A few that are still in production at Bethesda, Blaenau Ffestiniog and Dyffryn Nantlle for example, where the slate was extracted from the sides of a huge hole in the ground has been opened to road transport. The many-galleried Penrhyn Quarry at Bethesda has been likewise opened to road transport so that the once vital railway network has been obliterated and rubble has been tipped over many galleries. Further south, at the Aberllefenni quarries where, until recently, all the workings were underground, the present method of quarrying involves the uncapping of previously-worked chambers and transporting the slate by road.

The challenge facing those concerned with the interpretation of the slate industry is not only to preserve and present the physical remains of a remarkable industry, its quarries and mines, its equipment and buildings but also to transmit something of the character of the slate quarrying communities. 'Wales will never see a class of Welsh workers such as these again; their unique society has been fragmented and there is little demand

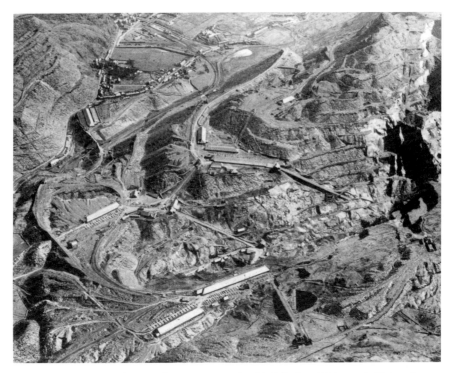

The Oakeley Quarry, Blaenau Ffestiniog—now the Gloddfa Ganol Mountain Visitor Centre

for their craftsmanship nowadays, but *Craig yr Undeb* [meeting place of the trade unions near Llanberis] remains and so do the scars on the mountain slopes, and the talented generation of men and women nurtured there—a testimony to the glory that was once evident among the crags of the blue slates.'[5]

In the heyday of the Welsh slate industry, commercially important veins of slate occurred in five areas:

1. The area from Bethesda to Nantlle in Arfon where there are several veins of Cambrian age forming the Great Slate Belt.
2. The area around Blaenau Ffestiniog in Meirionnydd where slates of the Ordovician age are on the whole of finer grain than those of Arfon. Exceedingly thin slates could be produced, most of them a blue-grey colour with lustrous surface.
3. The area between Corwen and Llangollen in Glyndwr where slates of Silurian age are less smooth and less finely cleaved. Traditionally slabs rather than thin roofing slates were produced in this area.
4. The area between Corris, Aberllefenni and Abergynolwyn in Meirionnydd—Silurian and Ordovician slates.

5. The Preseli district of Pembrokeshire where the slates of Ordovician age range in colour from olive green to silvery grey and have a rough spotted appearance.

Where the slate beds are steeply inclined or nearly vertical they are worked in open quarries if the strata are exposed on the steep side of a mountain. The results of this mountainside quarrying technique may be seen at such places as Dinorwic, above Llanberis and at the Penrhyn Quarry, Bethesda. If on the other hand the slate outcrop occurs in a valley or on a hillside of moderate slope, deep, chasm-like pits of frightening proportions were bored in the ground to expose the beds. The holes, known locally as 'sincs' were the most common method of extraction in Dyffryn Nantlle. The Penyrorsedd Quarry that once employed over 400 men for example was basically a vast hole with a maze of aerial ropeways (known locally as 'Blondins') to hoist the rocks to the surface. In areas where slate beds are more gently inclined as at Blaenau Ffestiniog and Aberllefenni, open quarrying soon became unprofitable because as the quarry developed, the slate beds passed beneath an increasingly thick layer of very hard rock that had to be removed to reach the slates. In such cases it was far more convenient to follow the bed underground and to work it in mines. A slate mine consists of a series of chambers which are in effect underground quarries. Those mines could be huge; at Blaenau Ffestiniog for example, the horizontal direction of workings extended for over a mile while chambers could be as much as 300 feet long, 400 feet wide and 100 feet high. The pillars or walls of rocks left between one chamber and the other to support the roof were usually about 40 feet thick. In one Ffestiniog mine there were as many as twenty-four levels and as much as twenty-five miles of underground tunnels bored into the rocks. The industry was indeed one that operated on a grand scale.

As far as the interpretation of the slate industry is concerned, a number of slate mines (as opposed to open quarries and 'sincs') have been presented, with the result that a slate town such as Blaenau Ffestiniog has become an unlikely tourist magnet. The Llechwedd Slate Caverns, first opened in 1846, now provide the visitor with a full-day experience of exhibitions, exciting train rides into the heart of the mountain and all the commercial facilities that a tourist expects. Nevertheless, integrity and authenticity of presentation has been ensured. The nearby Gloddfa Ganol, based on the old Oakeley Quarry, also sets out to interpret the slate industry while near Harlech on the coast the old Llanfair Slate Caverns are open to the public. The slate industry in the Corwen-Llangollen area is represented by the small Chwarel Wynne—a difficult quarry to reach—where again underground workings are interpreted. In

Dyffryn Nantlle, the Dorothea Beam Engine, 'a monument' located in the dereliction of a defunct slate quarry, is almost all that is preserved of the 'sinc' method of quarrying.

Undoubtedly the most significant development in the interpretation of the slate industry is provided at the National Slate Museum, Llanberis, a branch of the National Museum of Wales. It is located at the foot of Snowdon in the village of Llanberis—today a centre of tourism, yesterday, the most important of slate quarrying centres. Dominating the village is the vast Dinorwic Quarry covering 700 acres of mountainside, rising in steps to a height of 1,400 feet above the lake of Llyn Peris. The quarry, which dates from the late eighteenth century, became the largest slate quarry in the world and employed more than 4,000 men and boys. Those quarrymen worked in a harsh environment but nevertheless contributed much to the cultural and literary heritage of Wales. Towards the end of 1969 the Dinorwic Quarry closed but the central workshops below the quarry on the banks of the lake, Llyn Padarn, were acquired by the then Caernarvonshire County Council for guardianship by the Department of Environment.

The National Museum of Wales was invited to set up a museum relating to the slate industry within the so-called Gilfach Ddu workshops. Its role is the preservation, study and interpretation of material that relates to the history of the Welsh slate industry in all parts of the Principality. Located in the centre of the Padarn Country Park, the extensive museum buildings erected in 1870 are reminiscent of a fort in the mountains of northern India; indeed the association of the masters of the Dinorwic quarry in the late nineteenth century with the outposts of the British Empire may explain the fort-like appearance of the workshops. During the working life of the quarry the need for new machinery and plant as well as for the continuing maintenance of equipment, railway rolling stock and even the steamships that carried slate from Y Felinheli, renamed Port Dinorwic, was met by the highly skilled craftsmen of Gilfach Ddu. It had an iron casting workshop and a brass foundry; it had its contingent of highly skilled pattern makers and metal founders; its locomotive engineers and blacksmiths. The Dinorwic quarry was a self-sufficient unit with workshops capable of producing all the necessities of an important industrial undertaking. Most of that machinery, once used to maintain the equipment of quarrying, is still in place at the museum and most of it is in full working order. Museum staff who once worked in the slate quarries show the techniques of blacksmithing, iron and brass founding as well as splitting and trimming slates. Thus the National Slate Museum is a living museum staffed by Welsh-speaking craftsmen who have spent a lifetime in the slate industry. The integrity and authenticity

of the institution are therefore above reproach.

Power for the machines was provided by a huge cast-iron water-wheel, said to be the largest in Wales, which draws its power from a water pipe that runs for miles from the northern slopes of Snowdon. This impressive structure has been fully restored by the museum's craftsmen, for the self-sufficiency of the complex is still an important element in its development.

In addition to the preservation of important items of machinery in an authentic setting, the museum sets out to communicate the economic, social

Exploring the underground workings of the Llechwedd slate-mine, Blaenau Ffestiniog (Photograph: Llechwedd Slate Caverns)

or 'Gwalia' scattered throughout the quarry. Constructed entirely of slate blocks with the occasional length of purloined rail bar used as support for the large roofing slabs, they were usually three-sided, the open side occasionally covered with a sheet of brattice cloth as protection against the rigours of the winters. Although abandoned for many years, examples can still be seen and in some of the large quarries it is not uncommon to find the remains of rows of twenty or more.

Outside the *Gwalia* were the stacking areas divided into enclosures where the slates of various sizes were stored prior to being loaded on the trucks. It was inside the *Gwalia* that the quarryman split the blocks into slates. First, he split the block by driving one or more wedges along the plane of cleavage and holding the split ends open with a small fragment of waste rock. He then 'pillared' the block either by hammering in a plug and feathers into the pillaring line or by chiselling a groove down the side of the block on the same line. This edge chiselling produced a fine hair crack along the line of pillaring which was detected by blowing a fine spray of moisture along the split. Wedges were then driven in to widen the crack. A large timber mallet, known as *Rhys Mawr* or 'Big Rhys', its striking face-ends bound with iron bands, was sometimes used in this reduction process. The reduced block was then passed for the final splitting into the thickness of slate required or attainable. The splitter sat (and indeed still does because this function has not been successfully mechanized) on a low, high-backed stool with his legs crossed and the block placed against his thigh. The workman's leg was protected either by padding (often a rolled up jacket) or by a halved section of car tyre. Once again utilizing the natural cleavage the block was split using one, or sometimes two, broad-bladed chisels called *manhollt* and a small mallet, with banded striking face-ends made of African oak. The *manhollt* was placed against the edge of the block and lightly tapped with the mallet until a small crack was opened sufficiently wide and deep enough so that by using gentle leverage the block was split in two. A second chisel was sometimes necessary to ensure that the fine crack continued in a straight line along the top edge of the block. Always working from the centre of the remaining block the finished sheets were produced at a surprisingly rapid rate. The blocks when passed to the splitter were usually about 2in. in thickness (depending on the heaviness of the slate required and the quality of the rock) from which the workman was expected to produce at least six slates. Experienced quarrymen only undertook this work; an apprentice could expect to wait four or five years before being given the opportunity to try his skills.

The final process was the measurement and the trimming to size of the slate. The tools required were: the *Cylleth Fawr* or 'Big Knife', the *trafal* and notched measuring stick. The split slates were stacked flat in piles of

Working the rock face: Penhryn Quarry. Bethesda

all more-or-less the same size in readiness for dressing. This was carried out on the *trafal*, an inclined bench approximately 64in. long by 17in. wide. The metal cutting edge was mounted centrally with sufficient space allowed at one end for the workman to sit astride the bench, and fixed some 10 to 12in. above the surface of the bench. By placing the sheet of slate on top of the cutting edge and striking it with the knife a straight edge was produced. The handle of the knife was cranked out of alignment with the blade so that the user's hand did not come into contact with the cutting edge of the *trafal* while chopping the slate. This action produced a nearly perfect straight edge complete with the chamfer on the underside necessary when covering a roof. The dresser would trim one side and one end at right angles before measuring. A stick, notched along its length and fitted with a short nail protruding from the same surface as the notches, was used for this job. Each notch indicated a particular size and by hooking a notch into the straight side of the slate and drawing the stick along the straight edge the nail would scratch the surface marking the size of slate to be produced. The sizes varied greatly, from as little as 9 by 4in. to mammoth proportions. The different sizes were originally named 'singles', 'double' or 'double doubles', but were later given the titles of Empress (26 x 16in.), Princess (24 x 14in.), Duchess (24 x 12in.), Small Duchess (22 x 12in.), Marchioness (22 x 11 in.), Countess (20 x 10in.), Wide Countess (18 x 10in.), Viscountess (18 x 9in.) and Wide Lady (16 x 10in.).

With the introduction of the British Standards in 1929, some of these delightful names were replaced either by the simple sizes of measurement or by the terms 'unit', 'fraction' or 'odd'. The slates produced were not consistent in quality, either due to geological factors or to poor production methods. Consequently firsts, seconds and more rarely, thirds, were distinguished. Dressing was commonly the work given to apprentices or rubblers and in the Dinorwic Quarry in the 1920s an older man would place a half-crown piece near the bottom of a large pile of undressed slate as an encouragement to the lad to work quickly to clear the pile and thus obtain his bonus. Rarely, if ever, was the young man able to gain his objective.

Mechanization at the quarry face and of the dressing processes began in the 1860s when drills powered by steam, water and compressed air were introduced. The mechanization of the dressing processes brought about significant changes in the industry with the gradual abandonment of the small *Gwalia* in favour of the huge dressing and splitting mills where large numbers of machines could be more economically sited. The simple guillotine action of dressing slates on a *trafal* was easily imitated by machines of basic design consisting of a foot-operated treadle connected to the cutting blade via a spring-loaded arm. The slate was placed slightly overlapping the edge of a fixed cutting edge so that the moving blade could

crop off the rough edges of the slate. A rotative dressing machine (still in common use today) was developed by Messrs Greaves and Company of the Llechwedd Quarries in Blaenau Ffestiniog, around 1850, and very rapidly became accepted throughout the industry. Blades are mounted around a drum which when rotated come in contact with the rough edges of the slate placed over a fixed cutting edge. A fixed measuring gauge is fitted to the machine.

Another major development in splitting and dressing of slates was the introduction of mechanical sawing tables in the Ffestiniog area from the 1850s onwards. These increased in popularity towards the end of the century although the speed of adoption was somewhat slower in the areas where the geological nature of the slate did not require such devices to produce good blocks. In the quarries that worked the slates in the Ordovician beds the incidence of natural foot joints meant that the blocks could be removed at the quarry face in convenient sizes to be shaped into blocks for dressing; in Ffestiniog where natural joints were not so common, large elongated slabs of slate which were difficult to pillar were removed, therefore the sawing tables were perfectly adapted to overcome these problems.

This mechanization had an impact on the working life of the quarryman because, with the centralization of the sawing tables and dressing machines in huge 'aircraft hangar' style buildings, the men worked in a factory-type environment with all its attendant hazards of moving belts and shafts and an increase of dust particles in the atmosphere. The bargain or team system was not abandoned but a little of the greatly valued independence of the quarryman was lost.

Notes

1. Dodd, A. H. *The Industrial Revolution in North Wales* (Cardiff 1933) p.203
2. Jones, R. M. *The North Wales Quarrymen 1874–1922* (Cardiff 1981) p. 3
3. Gloddfa Ganol Guide (n.d.) p.2.
4. Jones, R. M. op. cit. pp.210 et seq.
5. Jones, Gwilym R, *Gwŷr Glew y Garreg Lâs* (BBC Wales Annual Lecture, 1974.)

7 THE SEA

With an indented coastline almost a thousand miles in length, broad river estuaries and numerous offshore islands, Wales inevitably developed a tradition of maritime activity which can be traced to the earliest times.

The Celtic settlers whose language grew into the Welsh of today first came from across the sea, and it was by sea that the countries of Atlantic Europe communicated, creating elements of a common culture. It was along the seaways that the missionaries of the Dark Ages carried their ascetic religion of the Celtic church. Viking invaders and Flemish settlers, Cistercian monks and French mercenaries, all came to Wales by sea, and the sea routes were crucial to the military campaigns of Norman and English invaders.

In later centuries, inshore and estuarine fishing, the transporting of both goods and people by sea, were vital elements in the life of the people of Wales. After the Act of Union with England in 1536, Wales was to witness phenomenal maritime activity that only declined during the second half of the nineteenth century when the railway network penetrated even the remotest corner of Wales. Until then, travelling over hills and mountain passes along inferior roads was hazardous in the extreme and although cattle on the hoof and woollen and other goods carried on horseback were exported to English markets along the difficult overland routes, the transporting of merchandise by sea was of far greater significance. The movement of materials, products and people was primarily dependent on water transportation and sections of the coast that had well-protected harbours were favoured sites for the development of settlements. It was only natural that those settlements should have evolved their own character and personality for in many of those towns and villages, the oceans dominated the life and thoughts of the inhabitants. In the coastal villages of west and north Wales in particular, the intense maritime activity produced unique communities that looked outwards to the sea and were in effect, isolated and cut off from the society of the land. Maritime activity was not confined to one or two members of a village community but was all-embracing, claiming to a greater extent, the time and interest of the majority of the inhabitants. Ships were the topic of conversation; faraway places were household names and the names of shipowners and shipping companies were as well-known to the inhabitants of the seaboard

The Milford Haven trawler fleet in the 1920s

communities as were the names of the more familiar Nonconformist ministers.[1]

The intense commercial activity that was such a notable feature of life in the coastal communities of the Principality was eroded very quickly during the second half of the nineteenth century with the arrival of more efficient and more rapid means of transportation. But the development of heavy industry also necessitated the use of shipping for the export of industrial products. The period witnessed the concentration of commercial activity in purpose-built ports, while shipping declined in the remote creeks and bays of rural Wales. There was a phenomenal growth in those urban centres that served an industrial hinterland. But although the ships had virtually disappeared from the small seaports of the west and north, the maritime tradition still lived on after the disappearance of local fleets. Welsh sailors still sailed the seven seas, but they now set out from the great ports of Britain—from Swansea and Cardiff, from Liverpool and the Tyne ports, from Glasgow and the Humber rather than from their home villages.

Today, the maritime economy of Wales is but a shadow of what it was a century or even twenty-five years ago. The decline of commercial maritime activity along substantial sections of the Welsh coast was rapid and 'the great ports' of the first half of the twentieth century have

This was Cardiff Bay. The Bute West dock—now filled in—as it was in 1895

witnessed a spectacular decline as the process of de-industrialization has marched on at an ever increasing rate. The seaways around Wales are no longer the highways they once were; the ports and harbours that witnessed intense activity in the past are silent and a tradition of centuries has died. Nevertheless, as in the case of the re-development of Cardiff, Swansea and Penarth, for instance, waterfronts are great assets if managed and developed carefully, but there is always a danger in that the massive clearance of harbour areas to prepare for something new can obliterate significant historic features.

In search for new uses for deserted harbours, authorities have inevitably looked towards leisure facilities to replace economic activity and the whole of coastal Wales has been caught in the grip of 'marina mania'. Barrages to impound extensive areas of tidal water have been proposed for many a muddy estuary and plans for the construction of extensive estates of 'desirable' waterside residence have proliferated. Features of considerable historic significance have been obliterated, for instance at Port Dinorwic (Y Felinheli), once one of north Wales's principal slate exporting ports. Porthmadog, famed for the shipyards that built the 'Western Ocean Yachts' now has an urban growth of *bijou* houses. 'Imagine the sheer delight' says one recent publicity brochure 'not to mention the convenience of a luxury waterside home with its own adjacent mooring.' But the Welsh coast with its strong currents, exposure to rapidly changing weather conditions and hidden rocks and inlets make sailing a serious undertaking. In the past,

101

the Welsh coast has witnessed its share of shipwrecks and some of the proposed marina sites have a notorious reputation.

Of course, in the refurbishment of many harbours, the decorative feature, a ship, preferably 'a tall ship', is desired by project leaders. With a limited number of historic vessels available world-wide, people are searching for anything that floats. They can easily add masts and yards. Thus, for example, 'the Spanish galleon' in the new marina complex at Swansea is nothing but the old Milford trawler *Picton Sea Eagle* of 1958 with a replica sixteenth century superstructure. The accuracy of that superstructure is questionable. The sailing barge *Maiike Marie* that sailed the Zuider Zee now adorns the Bute East Dock in Cardiff—a stranger indeed to the shores of Wales.

It must be remembered that conservation and restoration of ships is a very expensive and time-consuming exercise and those people concerned with the interpretation of maritime history have to look very critically at the preservation of vessels. Escalating costs, the ever-increasing difficulty of finding competent craftsmen to carry out restoration work and the constant attention that even the smallest vessels demand are factors that have to be taken into account when contemplating preservation. 'We think we can preserve ships' said the Canadian maritime historian Niels Jannasch,

> ...when ships by their very nature are ephemeral creations designed and built for a purpose; to carry cargoes or passengers, to make war, to explore, to give pleasure, to fish and to smuggle. If a ship had a useful life of twenty to thirty years, her owners were happy—now we are trying to preserve whole fleets of vessels, most of which only represent a tiny period of man's history. A ship is, alas, only doing her work with a crew, not as a museum ship or restaurant or an adornment for a harbor, serving as a surrogate for real life in our plastic surroundings.[2]

Of course nostalgia for a bygone age has its part to play, and reproducing history as it really was is a well-nigh impossible task. For example, to fully interpret the all-important south Wales coal trade and its world-wide associations, a steam tramp vessel of a type widely used between about 1870 and 1939 would be a very desirable item for preservation. The maintenance of such a vessel normally designed for a working life of barely twenty-five years would present insurmountable problems of conservation, if indeed such a vessel still exists anywhere in the world. Resources should be directed to preserving models, drawings, photographs and documentary material relating to those vitally important vessels.

The preservation of many objects of maritime history may demand an expertise that no longer exists and raw materials that are now impossible to obtain. In order to conserve the smallest sailing ship for example, a museum not only needs substantial funds, but should also be able to draw on a pool of expertise in the techniques of wooden shipbuilding, mast and spar making, pulley-block making, iron founding, copper-smithing and sail making. It should obtain a plentiful supply of raw materials in the form of well-seasoned oak and other timbers, cast iron and copper sheathing. Ships, whether preserved on dry land or in water, said Basil Greenhill, demand as much 'endless attention as a herd of cows or a team of oxen or draught horses' and without an almost bottomless pocket and an extensive staff of a very skilled nature, the preservation of vessels may be difficult to contemplate. Without proper skills and the correct raw materials a museum is merely in the replica business and not in conservation. Moreover there is no virtue whatsoever in a museum obtaining artefacts that cannot possibly be conserved, leave alone restored. Nevertheless, it is important that detailed plans, photographs and other documentary material relating to historically important vessels are collected and held in maritime museums.

As far as maritime museums in Wales are concerned—and there is a proliferation of them in the tourist areas of the north-west—in no way do they mirror the importance of the sea in the life of the Welsh nation. The collections that do exist are, to say the least, haphazard and do not reflect a planned campaign of collection by the various museum authorities. The sea has been such a vital element in Welsh life that it deserves a full interpretation. The principal aim of a maritime museum should be to acquire material in the widest sense relating to the sea and seafaring and to interpret its importance as reflected in the lives of a people throughout the ages.

The beautiful, the unique and the extraordinary, exhibited out of context, may conjure up the romance of the Age of Sail, but they should offer more than a nostalgic value. We have to be as concerned with the way of life of riverside and coastal dwellers and not just with the material objects that they produced or utilized.

For example, the coracle has been used from time immemorial for the capture of migrating fish in a number of Welsh rivers.[3] It is a rather uninteresting, canvas or skin-covered fishing craft with a hazel framework, an ash seat and a carrying strap of leather or twisted willow. In a maritime museum, it is necessary to go beyond displaying and conserving this unique fishing craft to trace its evolution and the variations in design from river to river. We have to be concerned above all with the customs and practices associated with its use, with the men

The romance of the Age of Sail. Painting of the New Quay Schooner Matilda *in the Bay of Naples, 1852*

who obtained a livelihood from its operation and with their place in the local community. In writing of the Pacific, Bronislaw Malinowski stressed:

> ... the cultural reality of a canoe cannot be brought home to a student by placing a perfect specimen in front of him. To understand the canoe fully, the student would need to know the rules concerning its ownership; how and by what people it was sailed, the ceremonies associated with its construction and use and particularly the emotional attitude of the craftsman for his craft, which he surrounds with an atmosphere of romance, built up of tradition and of personal experience.[4]

In the collection of maritime material we have to be interested not only in the boats and ships, the tools of shipbuilding and the instruments of navigation, but also with the tradition, with the human endeavour that gave existence to those material objects. The collections should therefore contribute to a clearer understanding of the community that is being studied: collection is not an end in itself but merely a means of reaching the people to whom those material objects had the meaning of everyday things.

In creating a maritime museum or heritage centre no time element

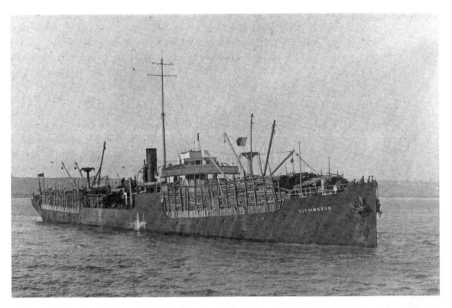

The Cardiff tramp steamer SS Withington *of 1919 entering Cardiff with Scandinavian pit props. The south Wales coal trade depended on these tramp steamers. Not one has been preserved.*

should restrict the story that needs to be told. On the one hand it is necessary to consider material that pre-dates 'the golden age of sail' with its connotations of romance, while on the other hand due attention should be paid to more recent developments in marine history. It is no longer enough to present a nostalgic picture of a few ships in full sail, for those vessels, beautiful as they were, only represented a very short span in man's utilization of the oceans. The period from about 1950 for example has witnessed a reduction in shipping as great as that brought about by the replacement of sail by steam in the late nineteenth century. Merchant fleets throughout the world have been completely changed and standardized; container vessels, barge carriers, roll-on, roll-off ships, super oil tankers and bulk ore carriers have replaced the steamships of an earlier era. Most of the vessels sailing the oceans today were built to a standard pattern in some yard or other; many fly flags that have little meaning and are engaged in carrying cargoes for the accounts of multi-national companies.

The life of the sailor has also changed, for ships' crews are flown all over the world and will disembark anywhere in a few weeks or months having completed a precise contract. 'Not for them the true adventure of the sea' said David Loshak, in an article in *Now*:

A restored lightship open to visitors at Swansea (Photograph: Swansea Maritime and Industrial Museum)

...the bracing sting of salt and spume; the exhilaration of pitting wits against the treacheries of currents, winds and waves. Our latter day Magellans sit remote, high above the swell, capsuled in double glazed security, cosseted by automatic navigation aids and perhaps misled by them, for they lack the true visual perspective and are deaf to the living sounds of the heaving ocean. It is the atmosphere of boredom, unreality, distorted perception, lack of mental stimulus, the worst possible recipe for men in whom life-preserving adrenalin needs to course.

In addition, the location of many a port has changed to cope with larger vessels: few important ports today are located in the heart of urban centres as was the case in the past. Container ports and wharfs for the discharge of ore are, more often than not, in isolated positions, well away from cities and towns. 'The man on the shore doesn't bother very much about the man on the sea' said E. Tupper: 'The sailor-man comes and goes. For brief spells he touches the fringes of the land that is his; comparatively seldom does he make his way through the sailortown which lines the edge of the sea; generally he doesn't reach the centre of the big towns of the harbour in which his ship rides in.' In the past when ports were very much a part of the urban centres of such places as Cardiff, Barry and Swansea, the

areas surrounding the docks developed a character and personality all of their own. Writing of Butetown, Martin Daunton for example, states 'The seaman arriving with several months' wages would indulge himself in the pleasures of "fiddler's green" until all his money was gone and he was forced to sign on for another voyage at whatever rate he could get...Cardiff was the most undesirable port in the United Kingdom—the dumping ground of Europe.'[6]

Life in the sailor towns' of the world has changed out of all recognition and in the interpretation of the maritime heritage, due attention has to be paid to those revolutionary changes unpalatable though they be to the romantic enthusiast. The development in shipping and the changes in the life-style of mariners are aspects of maritime history often conveniently forgotten. Objects and documents associated with such topics as the exploitation of oil and mineral from the sea and the use of waves and currents to provide power, the effects of pollution and the use of the sea for leisure are all aspects that could effectively be explored as part of the heritage—of maritime communities. There is much more to interpreting maritime history than presenting the nostalgia of a bygone age.

The brief of a maritime museum or heritage centre, located on the edge of the sea and the edge of the land should encompass the following:

a) It should look inwards towards the hinterland, to the area from which the port drew its wealth.

b) It should look in detail at the coastal settlements that it represents.

c) By its very nature it should look outwards across the sea: a museum of this type can never consider itself in isolation from the rest of the world.

a) Interpreting a hinterland

Most Welsh seaports, with the exception of ferry ports such as Holyhead and Fishguard, fishing ports such as Milford Haven and naval ports such as Pembroke Dock, were creations of their hinterland and an exploration of those hinterlands is vital in the interpretation of the maritime heritage of various parts of the Principality. The port of Cardiff for example, that developed spectacularly in the late nineteenth century as one of the world's great ports, was very much a creation of its hinterland. Its geographical position astride three river estuaries contributed to its stunning development as the point of export for one of the richest coal-mining and iron manufacturing regions in Britain. Cardiff was the gateway to that wealth and its rise as a city cannot be explained without reference to the Glamorgan valleys from whence it drew its riches. In the

The restored warehouse that houses Swansea's National Waterfront Museum

same way there would be no reason at all for such ports as Porthmadog, Port Dinorwic and Port Penrhyn to have existed were it not for the slate industry in Snowdonia and the need for transporting that product to a world-wide market. Lesser ports such as Amlwch on Ynys Môn that served the Parys Mountain copper-mining industry, Llanfairfechan and Trefor in Gwynedd and Porthgain and Porthglais in Dyfed for the export of stone, came into existence specifically to take away the products of a local industry. In any exercise aimed at interpreting the maritime heritage of a seaport the story is far from complete unless a picture of a port's hinterland, and hence its reason for existence, is presented.

b) Interpreting a maritime community

A substantial part of any maritime heritage centre must be directed to a presentation of the history and traditions of the port or area that the museum represents. For example, the Gwynedd Maritime Museum at Porthmadog that has potential for development should have collections that are representative of the Porthmadog community in its heyday. The museum could, with careful planning, fulfil the role of an interpretive

Those who survived: reunion of master mariners, Cardigan, 1937

centre for the industries of the Vale of Ffestiniog, Porthmadog's hinterland, but it should also look at features of the seaport itself. Amongst the points of interest are the slate wharfs of the Maenofferen, Cwmorthin, Foty, Diphwys, Oakeley and Greaves quarries; the quayside buildings that once accommodated the School of Navigation, Shipbroker's Offices and the ballast bank with its varied flora where ballast from a variety of sources was dumped by in-coming vessels. A maritime museum must be concerned with collecting anything that contributes to the total picture of the personality of the communities that it represents.

c) Interpreting the seaman's world

A maritime museum by its very nature must look outwards across the sea and a heritage centre of this type can never consider itself in isolation from the rest of the world. Within its collections the museum or heritage centre should have a record of the ships and seamen that sailed from ports in the area; it should have the instruments that assisted the mariners in their voyages to distant lands and these should be an indication of the contribution that Welsh seamen have made and are making to maritime affairs the world over.

To do justice to a vitally important element in the heritage of Wales, in-depth research work is essential, for it is only in recent years – as a response

to tourist needs – that local maritime museums have been set up. Many of these display the nostalgia of a bygone age and few attempts have been made to present the way of life associated with the artefacts on display. Few have conservation facilities or a trained staff and the documentation of the collections is poor. A programme of intensive research work in all parts of Wales needs to be instituted and a substantial body of information as well as artefacts has to be gathered in before a maritime museum is set up.

In Gwynedd the pioneering work of such eminent maritime historians as Aled Eames and Lewis Lloyd has provided the academic basis for the establishment of maritime heritage centres within the county. The County Archives are particularly rich in documents and illustrative material associated with seafaring activity. Other parts of Wales have not been as fortunate although the port of Cardiff is fairly well documented and Milford Haven has a recently established preservation society. Only by carrying out extensive research will it be possible to set up heritage centres that are worthy of the historical importance of the sea in the life of the people of Wales. Unfortunately, time is running out, and maritime activity on any considerable scale in many parts of Wales is now increasingly fading into the dim, forgotten past and the gathering together of both information and artefacts is becoming ever more difficult. In Ceredigion, for example, it is now well over a hundred years since the last sailing ship was launched from the once-important port of New Quay; few sailors now figure in the population make-up of the once vigorous maritime villages where most of the men worked at sea. A tradition has died and relics of this past way of life are increasingly rare: only the 'remnants of history which have casually escaped the shipwreck of time' now remain.

Notes

1. Jenkins, J. G. *Maritime Heritage—The Ships and Sailors of Southern Ceredigion* (Llandysul 1984)
2. Jannasch, N. 'The Maritime Museum of the Future': *International Congress of Maritime Museums Conference Proceedings*, (Paris 1981) pp. 189/90.
3. Jenkins, J. G. *The Coracle* (Carmarthen, Golden Grove, 1988).
4. Malinowski, Bronislaw: *Argonauts of the Western Pacific* (London 1922). p.12.
5. Tupper, E. Seamen's *Torch—The Life Story of Captain Edward Tupper* (London 1938) p.23.
6. Daunton, M. J. 'Jack Ashore—Seamen in Cardiff before 1914': *Welsh History Review* Vol. 9, No. 2 (1978).

8 INTERPRETING BUILDINGS

Castles

'Wales is a country of castles' said Lord Parry in his introduction to a splendid AA/Wales Tourist Board book on the subject. 'Wales's turbulent history built them. From the English border to the Irish Sea, from the Severn Estuary to the mountains of Snowdonia, they mark the movement of invading armies and the stubborn defence lines of the native Welsh.'[1] To many Welsh people they are symbols of the subjugation of Wales, alien structures that are nevertheless 'the stepping stones, the milestones of the evolution of Wales'. Whatever one thinks of castles, they cannot be ignored for they are dominant features in the Welsh landscape and even the ruined walls of Penrice Castle in Gower and Ogmore Castle in the Vale of Glamorgan are great attractions to the visiting public. Structures that are fairly intact like the castles at Caernarfon, Caerffili and Conwy are major tourist honeypots. Even a gigantic mock-Norman edifice like Penrhyn Castle and the sugar-like Bodelwyddan Castle renovated in the nineteenth century by Hansom, more famous for his cabs than his buildings, are being developed as major attractions.

Of course, all castles need some interpretation, for spectacular and dominating though a large building may be, it is necessary to provide some information regarding its construction and history and not be content with allowing the building to speak for itself. Green, closely cropped lawns, immaculate gravel paths, inadequate direction signs and over-complex labels so commonplace in Wales, hardly ever convey the excitement of life in castles. Dry-as-dust academic handbooks with an emphasis on the more obscure aspects of architectural technology may still be the only available guides to many sites. Valuable as those detailed guide books may be to the specialist, they hardly inspire the casual visitor. They rarely provide an insight into the life of the castle's former occupants and few point out the importance of these sites not only as military establishments but also as the nucleii around which important towns were to develop.

Welsh castles attract many visitors. In 1989–90 for instance Caernarfon attracted 285,789 visitors, Conwy 214,534 and Pembroke 132,551. All of the eighty or more castles in Wales require proper interpretation, for the

visiting public deserves far more than the turgid, stodgy exposition that characterized so many of them until recently. The introduction of proper, well-designed labels, audio-visual presentations and the innovation of new readable handbooks and guides by Cadw has transformed the interpretation of Welsh castles. Not only has there been a vast improvement in the standard of interpretation but also in the use of some castles for musical and historical re-enactments. Some castles however, although open to the public, are hardly interpreted. Newcastle Emlyn for instance, that occupies a promontory overlooking the river Teifi, is not interpreted in any way and is occupied by more sheep than visitors. Aberystwyth Castle, with its association with the minting of silver coins and its part demolition in the Civil War, has very little information on site to tell its exciting story. Nothing is sadder than the rapidly deteriorating Cardigan Castle, the scene of Wales's first Eisteddford in 1176, where a private owner has withstood all attempts at preserving and interpreting a site of national importance. Some castles such as Chirk in Clwyd, Penhow in Gwent and Powys Castle in Welshpool successfully combine their occupation as homes with a meaningful interpretation for the visitor.

Chirk Castle: a fortress built by Edward I and occupied continuously since 1595 (Photograph: National Trust)

Although Wales had many fortified encampments dating back to prehistoric and Roman times, it was the Norman conquest of the country that created the most spectacular and permanent structures that are symbolic of an alien invasion. Beaumaris and Conwy, Caernarfon and Pembroke, Aberystwyth and Caerffili and many others still stand as monuments to an alien power that attempted to subjugate the people of Wales. Undoubtedly castle building was a most expensive and time-consuming exercise demanding a huge labour force imported from other parts of the world that left an indelible imprint on life in medieval towns. Caernarfon Castle, to some the most splendid of Welsh castles, took forty years in the construction and its enduring splendour makes it Wales's premier tourist attraction. Of course in the interpretation of Welsh castles, it is necessary to look beyond their role as defensive, military structures and beyond their detailed architectural design. After all, castles were the nucleii around which many important Welsh towns developed. Castles occupying positions near the sea or navigable waterways were strategically essential in an attempt to subjugate the native population. There were quays where foreign soldiers could disembark and where military supplies could be landed. In time towns grew in the shadow of castle walls as at Pembroke, Carmarthen and Caernarfon and in more peaceful times those castle towns developed into key trading centres when the sea routes around Wales became important for the pursuit of trade and commerce. The 'Castle Towns' are a vital element in the heritage of the people of Wales and all need not only interpretation but also sensitive and sympathetic development. Urban roadways as at Caernarfon and Haverfordwest have done much to dilute the character of those ancient boroughs, while in other insensitive urban sprawls, modern marina developments and industrial enterprises have had the effect of destroying the environs of many noble structures. Love them as spectacular examples of planning and construction or hate them as symbols of the subjugation and the oppression of a people, the castles of Wales are among the grandest sights in the country.

Not all Welsh castles date from the days of Edward I for with the industrialization of Wales in the late eighteenth and early nineteenth centuries, many rich industrialists saw the castle, whether a restoration of the old or the construction of the new, as symbols of wealth and status. Cardiff Castle and Castell Coch, Cyfarthfa Castle at Merthyr Tudful, and fanciful Gwrych Castle at Abergele were all symbols of a newly found wealth by people who were barons of industry or landowners, conscious of their status as leaders of society.

The homes of the gentry and the *gwerin*

Throughout Wales, especially in the lush river valleys, may be seen the stately homes of a gentry that once held considerable influence in the social, cultural and political life of the communities in which they lived. Nevertheless as Thomas Lloyd pointed out in his classic *Lost Houses of Wales* 'Wales is not well-known for country houses. Castles, chapels, cottages are all expected sights, but the country house, as popularly conceived, remains a firmly English showpiece.'[2] Despite this Wales did have a substantial number of large houses of the 'English' variety, both in the countryside and on the fringes of industrial towns where the captains of industry built impressive edifices as symbols of their wealth and position. Cyfarthfa Castle at Merthyr Tudful, and Plas Tan-y-Bwlch near Maentwrog for instance were built by rich entrepreneurs within easy reach of their industrial enterprises. In rural Wales many noble houses have disappeared, for the dereliction and demolition of historically and architecturally interesting buildings 'has been continuous in Wales throughout this century for the most part little noticed or resisted'.[3] Some of those houses preserved as visitor amenities, the few owned by the National Trust in Wales and the few owned by local authorities, are the only ones where the historical associations of the houses as well as their architectural history are outlined. On the whole the surviving stately homes of Wales can make no claim to be examples of fine architecture compared to those of England and it may be necessary to offer the visiting public far more than a showcase presentation of architectural features. A house cannot speak for itself and some interpretation is desirable. Erddig, near Wrexham for example, offers the most successfully rounded interpretation because there is a human as well as an architectural story to present. This seventeenth-century house with eighteenth-century additions is in itself a folk museum interpreting not only architectural history but also the life of a landed gentry, the domestic servants and the estate workers that were once essential for the smooth operation of a large scale enterprise. In contrast, Ty Mawr, Wybrnant near Betws-y-coed in Gwynedd is a small stone-built cottage noted not for its architectural merits but as the home of Bishop William Morgan (c. 1545–1604), the first translator of the Bible into Welsh. Here the National Trust has presented the story of that notable Welshman. In some cases, much more needs to be done by the National Trust to interpret not only architectural history but the historic associations of some of their properties. For example, interesting though the Tudor Merchant's House at Tenby is architecturally, the exciting story of Tenby as the principal trading port and centre for piracy and smuggling is left untouched. In Wales, the National Trust operates the following buildings:

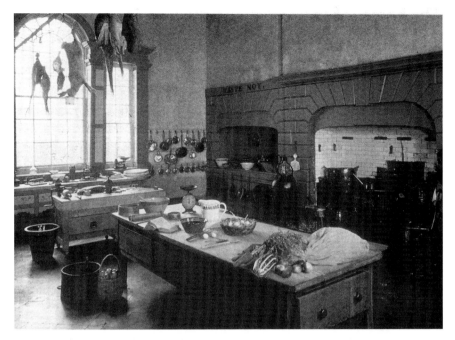

The restored kitchen at Erddig near Wrexham (Photograph: National Trust)

Clwyd *Chirk Castle*

A marcher fortress of the fourteenth century still occupied, comprising elegant, fully furnished rooms and formal gardens, set in eighteenth century parkland.

Erddig, near Wrexham

A seventeenth-century great house with eighteenth-century additions, retaining most of its original furniture. The range of outbuildings includes kitchen, laundry, bakehouse, stables, sawmills, smith's and joiner's shops and extensive gardens. The adjacent visitor centre houses an exhibition depicting changes on the Erddig estate.

Dyfed *Tudor Merchant's House,* Tenby

A late fifteenth-century town-house with little interpretation.

Dinefwr Castle, Llandeilo

A large complex with a castle and Victorian mansion, taken over by the National Trust in January 1991. Set in beautiful parkland designed by Capability Brown, the castle, once occupied by the rulers of south Wales, dates from the ninth century. It was occupied from the twelfth century until the 1960s by the same Rhys family.

Gwynedd *Aberconwy House*, Conwy
A fourteenth-century town-house with an exhibition tracing the history of Conwy from Roman times to the present day.
Penrhyn Castle, near Bangor
A huge neo-Norman edifice built between 1820 and 1845 by a rich family that operated the Penrhyn Slate Quarries at Bethesda.
Plas Newydd, Llanfairpwll
An eighteenth-century house still occupied by the Marquis of Anglesey on a site overlooking the Menai Straits.
Plas-yn-Rhiw, near Aberdaron
A small manor house, part medieval, part Tudor and Georgian on the west shore of Porth Neigwl (Hell's Mouth Bay).
Ty Mawr, Wybrnant, Penmachno
The birthplace of Bishop William Morgan, translator of the Bible into Welsh.

Powys *Powys Castle*, near Welshpool
An occupied castle built c.1200 with a fine collection of furniture etc. The gardens are of the highest horticultural and historical importance.

(A map showing the location of houses open to the public can be found on p.169)

Within recent years, as large stately homes have ceased to exist as homes for families, a few local authorities have taken over some of the mansions and opened them to the public. In north Wales, for example, the substantial Glynllifon estate near Caernarfon is planned to be developed as an agricultural museum by the Gwynedd County Council; Plas Tan-y-Bwlch near Maentwrog is a National Parks Study Centre while Bodelwyddan Castle is being developed, despite much opposition, as a museum and portrait gallery by the Clwyd County Council. In south Wales, undoubtedly the most important development in this field has been on the outskirts of Newport at the beautiful Tredegar House, once the home of the influential Lords Tredegar.

Since 1974 Tredegar House has been gradually restored and refurbished as one of the finest country houses in the Principality. For 800 years Tredegar House was the home of the Morgan family, later the Lords Tredegar, industrialists and entrepreneurs who for centuries were the leaders of political and social life in Gwent. Although one wing of a medieval stone manor remains, Tredegar House owes its character to the reconstruction in brick that provided a series of stupendous rooms. As the Morgan family became ever more rich in the nineteenth century,

Tredegar House, near Newport, Gwent: now fully restored and open to the public.
(Photograph: Newport Museum and Art Gallery)

servants quarters and new servants' wing were added to cope with the increasing needs of the family and their visitors. The Lords Tredegar are no more, and with the departure of the last Lord Tredegar to the tax haven of Monte Carlo in 1951, the connection between Newport and its most influential aristocrat was severed and Tredegar House became a Catholic Girls Boarding School. In 1974 the house and grounds were put up for sale—only for the second time in 500 years—and it was purchased by the Newport Borough Council. During the 1950s all Tredegar contents were sold and have had to be bought back piecemeal.

Although Tredegar House is an impressive palace that once accommodated a posh family, in its new guise as a local authority museum it is much more than yet another historic house open to the public. Of course the house does contain a wealth of material relating to the prosperity, power and influence of the Morgan family; from Llewelyn ap Morgan in 1402 to John, the last Lord Tredegar who died in 1962. Paintings and photographs of family members from the worthy to the eccentric are on display in the house and many fine pieces of furniture are on view in the twenty-five rooms open to the public. The house and its contents provide an illuminating picture of some of the past residents. The so-called King's Room for example, refurbished by Evan, Viscount Tredegar in the 1930s was designed to accommodate one of the many altars he erected in the house. As a young man Evan became a Roman Catholic, and was awarded the office of Chamberlain to the Pope, an appointment that necessitated his presence in Rome for a month every year. Despite his faith, he still

dabbled in black magic and Tredegar House was a venue for a curious mixture of people attending wild and notorious weekend parties. They were kept entertained not only by Evan but by his menagerie of animals. The animals were as eccentric and talented as their master – the kangaroo for example boxed as well as hopped.

In addition to showing the life-style of an aristocratic family, Tredegar House contains a substantial section devoted to life 'below stairs'. In such a grand house there were as many rooms below stairs as there were above; in 1911 for instance the house kept as many as twenty-two servants, not including non-residents who came into work every day. Today the visitor is able to visit the Great Kitchen with all its utensils and furniture; the Game Larder and Pastry Room; the Butler's Pantry and the huge Servant's Hall that was the uncomfortable, cheerless home for so many of the staff of a great house.

Tredegar was of course a substantial country estate and like most others it was virtually self-sufficient with its own Home Farm supplying all the essential food and services. The farm buildings, clustered close to the service entrance to Tredegar House, range in date from the early seventeenth to the twentieth century. Here in the old implement sheds a number of craftsmen now demonstrate their skills.

With the demolition of so many large houses, Wales has certainly lost a valuable resource, although the existence of mansions and their occupants must have been an anathema to many of the inhabitants of Wales. The associations of wealthy families with an alien language and the Anglican church would not have endeared those aristocrats to the ordinary people, but nevertheless in the destruction of so many of their homes and the disappearance of so many noble families to other countries, Wales has lost a valuable architectural resource. As Thomas Lloyd has pointed out:

> Twenty years ago—country hotels and holiday cottages were virtually unknown. Schools and hospitals have gone to purpose-built accommodation. Developers and rating authorities preferred their new houses on the site of the old and there was then no strong heritage lobby to say no. They did not look enough like Castle Howard. Above all we forget that there has been a revolution which one set of figures will adequately show: in 1872 Thomas Nicholas published his *Annals and Antiquities of the Counties and County Families of Wales*... In Carmarthenshire he covered fifty families (excluding clergy) and their houses. Today twenty-one of those fifty houses have gone and forty of those families have either failed in the male line of inheritance or have no further connection with the county. Only five of the surviving houses have remained unsold in the hands of direct descendants and only

one has come down through just three generations directly from father to son to son. After the stability of centuries, it has been quite a shake out.[4]

The stately home is no longer of major importance in Wales. Nevertheless within recent years a number of mansions have been put to new uses, principally as country-house hotels. Admirable though some of those developments have been as at Llangoed Hall, near Builth Wells and Bodysgallen Hall, near Llandudno, the developers have to a great extent ignored the opportunity to explore historical links with the locality. A visit to the Castell Maelgwyn Hotel at Llechryd in the Teifi Valley for instance would be of considerable interest if the mansion's association with an unlikely local tinplate works, an eighteenth-century canal, coracle and weir salmon fishing and the Rebecca Riots were presented; it would be an even greater attraction if the associations of the Gower family with the mansion were outlined. This beautifully located house was after all the home of the ancestors of one of England's most illustrious and elegant batsmen.

The existing castles, the few stately homes and many churches are on the whole well cared for by public institutions, wealthy individuals and groups and they draw substantial crowds to view the prosperity of the past. But the heritage of Wales, as elsewhere, is not all about wealth and privilege, defensive structures and fine ecclesiastical buildings, but about the homes and life of a peasantry that has always formed the overwhelming proportion of any national group. Those more humble dwellings and workshops, meeting places and farmsteads also deserve interpretation if an authentic picture of the true heritage of a national group is to be presented. While eighty-two castles are preserved in Wales, very few vernacular dwelling houses, unless they are associated with important personalities in Welsh life, like David Lloyd George, the poet Elfed and Bishop William Morgan, have been maintained on their original sites. One preserved dwelling that had no connection whatsoever with the good and the worthy is the small cottage of Penrhos in the Preseli foothills. Penrhos contains all the furniture usually associated with cottages from the Welsh uplands. With dresser and two-piece cupboard, simple furniture and locally made dairy equipment, it is typical of its era and region. The building dates back to a period of transition in Welsh agricultural history. The area around it was formerly a bleak, exposed area on a high north-south ridge that was completely unenclosed. With the enclosure of the common land in the late eighteenth and early nineteenth centuries, isolated homesteads such as this assumed a leading role in the battle for farming rights and ownership. Peasant families set up *tŷ un-nos* (one-night houses) on the hitherto unoccupied land. The custom was that if a house of turf was built in a single night and smoke

was seen emanating from the chimney at dawn, then the occupier of that temporary dwelling had a legal right to the homestead. An axe thrown from the house marked the extent of an enclosure around the cottage. In time, the claims of the occupier were consolidated and a stone dwelling was constructed to replace the temporary *tŷ un-nos*. That is the tradition presented in the humble dwelling at Penrhos.

In the preservation and presentation of Welsh vernacular buildings, the National History Museum is the only centre where the regional styles of building construction dating back over the course of nearly five hundred years are adequately represented. One of the main purposes of this national institution is not only to present the evolution and the difference in building techniques but to present the life and the skills of those Welsh people to whom the houses in the museum once had the meaning of home. St Fagans is not primarily a museum of buildings but a centre that interprets the character and the essence of Welsh life.

The traditional houses of rural Wales owe their design and layout to a complex interaction of geological, geographical, economic and social factors. The nature of the climate, the conditions of local geology and the availability of local building materials all had their effect on determining the type of house found in a particular area. In the past, country people built their homes from the materials occurring locally; they often designed their own homes; they built according to their needs; and they considered primarily not architectural beauty of design but the utility of the building. In so doing, they followed no particular style or fashion that was prevalent in other districts at the time. On the Llŷn peninsula, for example, much of the surface of the land is covered with coarse boulder clay and in many parts of the peninsula there is little suitable building stone; from time immemorial, therefore, the peasant farmers of the district utilized earth intermixed with straw, cow dung and other commodities for the construction of the walls and floors of their cottage homes. In south Ceredigion, to quote another example, mud-walled cottages were commonplace until the mid-nineteenth century, but if the dwelling was close to the sea, well rounded pebbles from the shore were used to construct an uneven cobbled floor. Roofs were thatched with wheat straw or sometimes with heather, rushes or gorse. During the eighteenth century, however, roofing slates were imported by sea and small stone quarries supplied raw materials especially for farmhouses. Although by the beginning of the nineteenth century, stone buildings had become fairly common, the cost in labour, money and time of extracting those stones was so great that the poorer section of the community could not afford them. For the cottager, mud-walled homes were still the order of the day until well on into the nineteenth century.

Variety in Welsh vernacular architecture:

A timber-framed farmhouse from Llangadfan, Powys (now at the National History Museum)

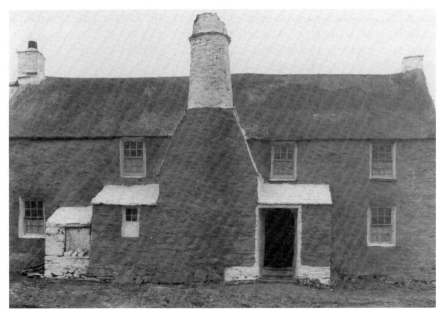

A farmhouse with 'Flemish chimney' from St David's, Dyfed (National History Museum)

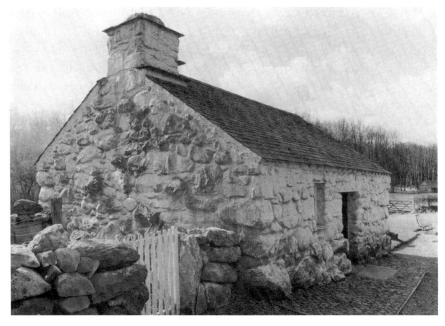

A stone-built quarryman's cottage from Rhostryfan, Gwynedd (National History Museum)

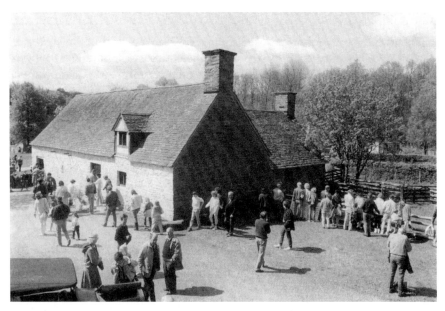

A long-house from the Claerwen Valley, Powys (National History Museum)

Wales is predominantly a high moorland plateau dissected by deep river valleys that branch out from the central core. Along the valleys that run eastwards, many alien influences entered the Principality. Along these valleys, for example, came not only the English language but also the English four-wheeled farm wagon, and short-handled spade. Along these valleys too—where the oak tree predominated—vernacular buildings sprung up in the style of the architecture of Herefordshire, Shropshire and Cheshire. In these oak-growing river valleys of the Welsh borderland the half-timbered house predominates, and this attractive form of dwelling is found in such valleys as the Severn, crossing the watershed almost to the shores of Cardigan Bay; the Wye valley nearly to the heart of the Plynlimon range, and the Dee valley almost to the source of the river at Bala.

The National History Museum has two buildings that represent the 'border' tradition; Abernodwydd from Llangadfan in Powys and Hendre'r-ywydd Uchaf from Llangynhafal in Clwyd. Abernodwydd, a sixteenth-century farmhouse, was occupied continuously until 1937 and is an oak-framed structure with hazel wattle-and-daub panels finished with a layer of whitewashed plaster. Hendre'r-ywydd Uchaf is an oak-framed long-house that accommodated man and beast under the same roof and was built around 1470.

The market town of Llanidloes in mid Wales was described in 1798 as: 'a town of houses built with laths and mud filling up the intermediate spaces of a timber frame'; and in 1822 as 'a mean town, composed chiefly of lath and plaster houses'. Newtown, too, was dominated by half-timbered houses, while in the surrounding countryside, farmhouses, cottages, inns and mansions were until the early nineteenth century often built with timber frames with the intermediate spaces infilled with wattles and daub.

Just as the valleys of the Severn, Wye and other rivers led into the heart of Wales, so too does the southern coastal plain, the Vale of Glamorgan, act as a routeway from the English plain into Wales. Along the Vale came the four-wheeler wagon of exquisite design that bears a close similarity to the wagons of Wiltshire and lowland Gloucestershire. Here too was found a technique of thatching far superior to that found in any other part of Wales: in a vale of trim, whitewashed villages one sees a settlement pattern far more closely related to the west of England than to moorland Wales.

The design and technique of building cottages and farmhouses in Glamorgan are also quite different from those of other parts of Wales. The houses of the slate quarrying areas of north Wales have a character of their own, while the bleak promontories of the Llŷn peninsula and Pembrokeshire have houses built solidly from massive stones as befit an area where the force of westerly gales bearing in from the sea could easily destroy more fragile structures. On Bardsey and the St David's peninsula

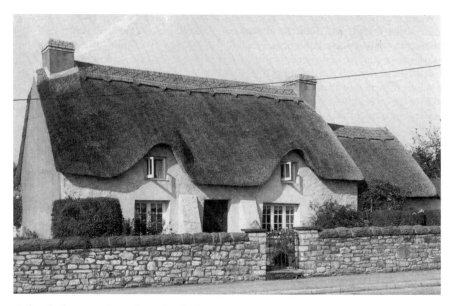

A thatched cottage from the Vale of Glamorgan

in Pembrokeshire local granite was used for the construction of dwellings, and in the latter region the houses were influenced by the style of the Norman castles, one of the features being an adaptation for domestic purposes of the round chimneys of those castles. These houses possess thick stone walls, deeply recessed windows, arched doorways, massive chimneys, stone staircases and built-in stone benches, strongly reminiscent of Norman castles. On Bardsey Island, too, the houses are equally massive and all farmhouses are built behind the tall, thick walls of a courtyard and resemble fortified settlements.

However, both in Pembrokeshire and the Llŷn peninsula the granite rocks were difficult to shape for building purposes; igneous rocks and stones from the glacial drift were utilized for building many dwellings, especially substantial farmhouses and mansions. 'But', says Iorwerth Peate, 'in Llŷn, clay or mud was formerly used for the small cottages so characteristic of the area. Habitations... particularly in Llŷn consist of walls built of... cob, that is an argillaceous earth having straw or rushes mixed with it while in a state of paste, and then laid layer upon layer, between boards'.[5] In Pembrokeshire 'the whitewashed cottage, either stone or mud stands out clearly in the mountain landscape on the side of the Preselly range... and the prevalent type was described in 1814 as "a mud walling about five feet high, a hipped end, low roofing of straw with a wattle and daub chimney, kept together with hay-rope bandages, the disgrace of the country".'

The major part of Gwynedd is stone country; this is a land of dry-stone walls, of slate and stone tile roofs. There are dwellings whose walls consist of huge boulders; there are others where narrow slabs of slate are used for wall construction. Many of the cottages are small with walls of great thickness and all windows are at the front of the house. Chimney places are large and capacious and inside them bacon or herrings were dried after salting. Llainfadyn, a one-roomed cottage at the Welsh Folk Museum, is typical of the cottage homes of Snowdonia. The house from Rhostryfan, Caernarfonshire, dates from the mid-eighteenth century, and roughly hewn boulders of tremendous size are used in the construction of its walls.

'Welsh cottages' says Peate, 'have belonged... to the single room tradition... very often the simple form of single room for living and sleeping—and a more developed variant e.g. the *croglofft* (half-loft) stage could be found at the same time in the same district... The cottages appear scattered throughout the countryside... in the corner of a field, on the side of a road, in the shelter of a hillside, under the shade of an old holly tree'.[3]

Conspicuous in the landscape of Snowdonia are the dry-stone walls that surround the cottages and farmhouses. Although no mortar or cement is used in the erection of these walls, they have to be solid enough to withstand the strong force of winds and storms on exposed upland farms. The waller's art lies in his ability to work with irregular material of many sizes, for he must size up the possibility of each stone and judge whether it will fit into a particular gap. The true stone-waller does not cut his raw material to size if he can possibly help it. This is particularly true in north Wales where the native stone is hard and difficult to cleave cleanly.

Much of Wales, of course, consists of a moorland plateau of scattered homesteads. Many of the houses are located on a windy and rather rainswept upland, where it was important to have access to cattle at all times. The farmhouse of Cilewent (now at St Fagans), is representative of this upland tradition. This farmstead from the Claerwen valley in old Radnorshire is typical of moorland long-houses once so common in rural mid Wales. Of course, not all the traditional homes of the moorland core of Wales were longhouses, for rectangular buildings and two-roomed dwellings were commonplace throughout the region.

In west Wales, two-roomed cottages were known as *tai dau ben* (two ended/two roomed houses) the two rooms being known as *pen ucha* (the upper end or kitchen) and the pen isa (the lower end or chamber). The outside walls, whether they were stone or mud built, were always whitewashed, with two small, four-paned windows providing insufficient light to the low-ceilinged interior. In some houses, additional sleeping accommodation was provided by the addition of a cockloft *(dowlad or taflod)*. In some houses the cockloft covered the whole cottage, but in the

majority of cases it covered the kitchen only, the chamber having a much higher ceiling with no loft above it.

A natural development from the *tŷ dau ben* was the addition of a second storey to provide two rooms on the first floor. In the second half of the nineteenth century the conversion of two-roomed cottage was commonplace. All the activities of the family, work and leisure, all took place in the pen ucha or kitchen, while the other room on the ground floor was converted from a bedroom to a parlour. In most dwellings this was a prestige room, uncomfortable and unused, into which none but the most respectable callers was admitted. On the rare occasions when a member of a family suffered a prolonged illness, the parlour came into its use as a sick room. On death it was customary to bring the corpse of the deceased to rest in the parlour before burial. Except on those special occasions the Welsh parlour was a museum of forgotten things—family portraits, china souvenirs and the best but often most uncomfortable furniture. The parlour is like the 'west room' in an Irish cottage described by C. M. Arensburg:

> It soon becomes apparent that there is something special about the west room... the room was a sort of parlour, into which none but distinguished guests were admitted. In it were kept pictures of the dead and emigrated members of the family and all fine pieces of furniture. Nor were my hosts alone in keeping objects of sentimental and religious value in the special room... The general feeling was, that such things belonged there.[5]

On the more substantial farms, large dwellings were commonplace in many parts of Wales from the late eighteenth century. These were often rectangular houses, usually with four rooms on the ground floor and three or more bedrooms above. In southern Ceredigion, for example, the most common type of farmhouse has a large kitchen, traditionally with an open chimney, a small, unused parlour at the front of the house; and two rooms and dairy and eating room (*rûm ford*—table room), at the back. Here the family and its servants traditionally ate all their meals, and it was furnished with a long, rectangular scrubbed table and two wooden benches; it had no fireplace. Most of these farmhouses possessed three bedrooms at the front of the dwelling, with a long narrow *aisle* above the dairy and eating room. In the past this room was used for storing grain after threshing and in many farmhouses it could be entered by a stone staircase on the outside.

A museum such as the Welsh Folk Museum not only has to preserve buildings that are of significance in the architectural evolution of Wales, but it also has a duty to present and interpret those buildings to produce a portrait of the country's social and cultural inheritance. The primary

purpose of an open-air museum that concerns itself with the preservation and presentation of the homes and workplaces of the people is not to show things that are unique, neither is it to show gems of architectural history. The whole concept of such an institution is to take the visitor straight to the people that lived in some bygone age. Professor Andreas Lindblom in his description of the early Skansen near Stockholm said 'Do not ponder over the reason why the old houses and rooms at Skansen give you so much pleasure. They are comforting and stimulating because they suggest life, not death.'[6] The aim of an open-air museum is to take the beholder straight to the people to whom the re-erected cottage had the meaning of home and the furniture and utensils within it, the meaning of everyday things.

In the development of museums of building or of open-air museums, it is essential that curators know exactly what type of house or other building should be preserved before they even begin on the task of dismantling and restoration. Ideally a full-scale survey of the area that is served by the museum should be carried out and, before a single stone is transported to a museum site, the curator of the museum in question should know exactly what type of building is required; of what date; from which district and how that house fits into the overall plan of the museum. After all, a museum such as St Fagans is an interpretation on one site of the character and personality of the whole of Wales. Llainfadyn cottage for example has few architectural merits, it is plain and unornamented but the cottage was typical of the slate quarrying districts of north-west Wales. There may have been better houses in the district; there may have been older ones displaying more sophisticated design and architectural taste but the function of an open-air museum is not to collect the unusual but the typical, in an attempt to present a picture of national life.

Church and chapel

A stranger to Wales could be forgiven for thinking that he was in a country firmly in the grip of religious fervour were he to look only at the proliferation of places of worship that dominate both town and village. Wales has its Salems and Seions, Bethesdas and Tabernacles, indicating a mania for chapel building particularly in Victorian times. When those hundreds of chapels were built, people, especially those in the industrial valleys of the south thought of expansion and growth, but in many cases there was no great increase in the number of worshippers. The result of that proliferation of chapel buildings meant big chapels and small congregations and, with the march of time, many of those congregations

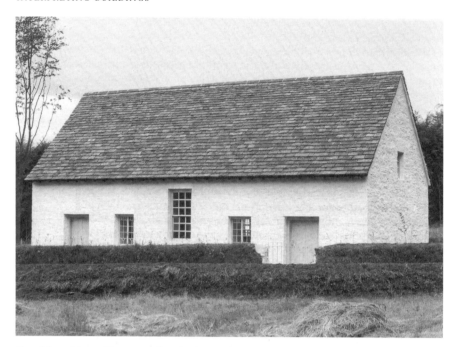

Capel Pen-rhiw: a Unitarian chapel of 1777 from Dre-fach Felindre, Dyfed, now re-erected at the Welsh Folk Museum

who had an allegiance to particular places of worship found the burden of maintenance so heavy that there was no alternative but to close the chapels. In 1990 according to Capel, the Chapel Heritage Society, chapels were closing at the rate of one a week. It is obvious that many chapels from Presbyterian to Scotch Baptist and from Unitarian to Congregational are now redundant. The structures that dominate the landscape, often built at great expense, are no longer of relevance as the tide of religious fervour that swept the land after the intense Revivals of 1859 and 1904 has receded into the dim, forgotten past. The strict, God-fearing, chapel-going Welsh population that once expressed such fervour and loyalty for their chapels have all but disappeared leaving a legacy of unwanted and elaborate buildings for which there are no obvious uses.

Realistically, all chapels cannot and do not deserve to be preserved but a selection of the best examples so characteristic of nineteenth-century Welsh life should be kept. Dozens of chapels are demolished each year, others are unsympathetically converted to other uses without first being photographed or recorded in any way. Many chapel buildings are of outstanding architectural interest, but few are accorded protection by being made listed buildings. Due to the wealth and proliferation of its

Revd Ceri Jones and the Elders of Capel-y-Parc, Cwm-parc, Mid Glamorgan, 1930s

ecclesiastical buildings and due to the influence of religious affiliations on the life of generations of Welsh people, church and chapel cannot be ignored in any interpretation of the heritage of Wales.

Although the influence of religion may have become diluted in the post-1945 era, an appreciation of its importance in the eighteenth, nineteenth and early twentieth centuries cannot be disputed; an understanding of the religious affiliations and all that they implied in the past is of considerable importance in understanding present-day Wales. Everywhere there is evidence of intense religious activity in the past and some of the structures associated with Christianity—monuments, crosses and episcopal churches—date back to the days of the itinerant Celtic saints who brought Christianity to Wales in the fourth and fifth centuries AD. Those holy men utilized the Western seaways for their travels and the religious settlements that they established occur in all parts of Wales. The prefix *Llan*, plus the name of a saint—Llangurig, Llangrannog, Llandysul and many others, bear witness to the importance of the Celtic church in Welsh life.

The Anglican movement and the Reformation were largely a matter of English politics and although many of the old Celtic churches became Anglican establishments and numerous new places of worship were built,

Anglicanism in general aroused little fervour or enthusiasm amongst the people of Wales and they seem to have entered a period of slumber from which they did not really awake until the Methodist Revival two centuries later. The Anglican Church was an alien intrusion that conducted its services in an alien tongue and as such found no favour amongst the Welsh population. Even the seventeenth-century Puritan movement failed to take root over a major part of the Principality. It came from England through a series of border towns—Brecon, Wrexham and Newtown and obtained a strong grip in the woollen manufacturing area of mid Wales. It secured the outposts of the traditional culture of Wales amongst a population concerned with commerce and business.

Much of Wales at the dawn of the eighteenth century was in a condition of extreme languor. The only spiritual earnestness that was found, apart from a few parishes, was provided by a number of Nonconformist itinerant preachers. In Welsh-speaking parishes, services were irregular and preaching in Welsh was very rare. Clergy and flock alike had no zeal or enthusiasm for their religion. All the necessary ingredients were assembled for a sudden intellectual and moral expansion: the renaissance in Wales came in the form of a religious revival, great in its intensity and consequence. Whereas the earlier Puritanism was an intrusive religion, Methodism was native, originating in Trefeca, Llandovery and Llangeitho—in the heart of rural Welsh-speaking Wales. Pulpit oratory became an art that appealed to the people, for Methodism's armament was the explosive force of enthusiasm. 'We preach to the heart', said one of its leaders, 'so that there be faith in the heart rather than enlightenment in the head.' Within a few years much of Wales was dominated by Nonconformist religion that was strengthened by intense revivalist movements in 1859 and again in 1904.

Although there has been a spectacular decline in the religious life of Wales within the last fifty years or so, although there has been erosion and cataclysm, vestiges of the past – not only in buildings but also in moral attitudes—still exist. The patterns have certainly survived but the colours are faded; yet an understanding of that pattern that so dominated the life of bygone Wales is essential for those who wish to interpret the character of a national group.

Of course, in all parts of Wales, despite the overwhelming importance of Nonconformity, Anglican churches, some dating back to the days of the itinerant Celtic saints of the Dark Ages, may still be seen, but on the whole few of those buildings are interpreted. Notable exceptions are St Asaph Cathedral and the parish church of Llanbadarn Fawr near Aberystwyth. With the rapid decline in church-going during the present century, hundreds of churches, some of great antiquity, have become derelict or have been demolished. In 1990 for instance no fewer than sixty-one churches out of

a total of 598 owned by the Church in Wales closed. Many of them, and the ones that remain, contain the best examples of Welsh craftsmanship both in woodwork and stonemasonry but with the disappearance of so many with their associated graveyards, Wales has suffered a severe loss of examples of the work of many generations of skilled craftsmen. Of course, many of the best examples of parish churches even if not used for worship are actually preserved as churches (though not interpreted), but few of the Nonconformist chapels that so dominated the life of Wales have been preserved.

Some, such as Yr Hen Gapel (The Old Chapel) at Tre'r-ddôl, to the north of Aberystwyth, have been converted into museums. This was preserved partly to illustrate the religious life of Nonconformist Wales, but has now closed. Capel Pen-rhiw, a plain Unitarian chapel of 1777 has been re-erected at the National History Museum. A chapel in the centre of Llangollen now accommodates the European Centre for Traditional and Regional Culture (ECTARC) while Tabernacle Chapel at Pontypridd, typical of the large elaborate chapels of the south Wales valleys, now accommodates a museum and heritage centre devoted to the interpretation of a town that was once regarded as the capital of the Rhondda. A new life has been found for some in conversion, sometimes without sympathy, into dwellings, craft centres, garages and carpet warehouses; many have been demolished or fallen into disrepair often through lack of funds or interest from the population. With the sole exception of the Mid-Glamorgan County Council, who in the 1970s commissioned teams to draw every chapel in the county, very little has been done to record chapel buildings over the major part of Wales. As Professor Anthony Jones has pointed out:

> Information needs to be disseminated so that the public at large are made aware of this neglected heritage... A key to that effort [of preservation] must be the selection of the best example... Identifying and guarding such examples by affording them Listed Building protection is a matter of real urgency. The decimation in the ranks of chapel buildings has seen a dreadful acceleration in the last decade. [Professor Jones was writing in 1984.] Much has already been lost and without a concerted conservation effort the remaining chapels will just as quickly vanish.[7]

The task is vast and local authorities, institutions and societies have a duty to preserve the best examples 'of these virile expressions of the national genius but [this can be achieved] only if a co-ordinated conservation effort is made to protect them for future generations'.

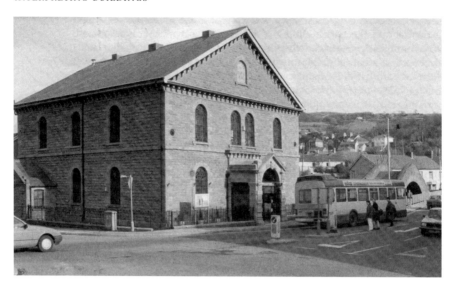

Pontypridd Historical and Cultural Centre (formerly Tabernacle Chapel) (Photograph: Historical and Cultural Centre, Pontypridd)

Notes

1. AA/Wales Tourist Board: *Castles in Wales* (London 1982) p.5.
2. Lloyd, Thomas: *The Lost Houses of Wales* (London 2nd ed. 1989) p. 3.
3. Ibid. P 9.
4. Peate, I. C. *The Welsh House* (London 1940) p.19.
5. Arensburg, C.P. *The Irish Countryman* (London 1937) p. 24.
6. Peate, I. C. *Amgueddfeydd Gwerin: Folk Museums* (Cardiff 1948) p.21.
7. Jones, A. *Welsh Chapels* (Cardiff 1984) pp. 84/5.

A SELECT-INVENTORY OF MUSEUMS AND HERITAGE SITES IN WALES

Clwyd

Bersham *Industrial Heritage Centre*
 The heritage centre occupies an old Victorian school in the heart of the village of Bersham, once important for iron manufacturing. The presentation is concerned principally with the development of iron making and the association of the village with 'Iron Mad' John Wilkinson who created a notable cannon-making industry in the late eighteenth and early nineteenth centuries. With cottages, ballistics bank, weirs etc. the industrial trail along eight miles of the river Clywedog has much to offer.

Buckley *Pottery Museum*
 A collection of artefacts relating to the best known of all north Wales pottery manufacturing centres. Only occasionally on view to the public.

Cerrigydrudion *Llyn Brenig Information Centre*
 Located on Welsh Water Authority property it sets out to interpret an important reservoir. It also includes an archaeological trail and leisure facilities.

Chirk *Chirk Castle*
 An occupied marcher fortress built in 1310. This National Trust property still provides a home for the Myddleton family who have occupied the property since 1595. It also includes a museum.

Erddig *Erddig Hall*
 A late seventeenth and early eighteenth century house, fully furnished. A visitor centre depicts changes in the Erddig estate. A National Trust property.

Glynceiriog *Neuadd Goffa/Memorial Institute, High Street*
 A village hall that contains an exhibition relating to the Ceiriog Valley, once famed for its woollen manufacturing and slate and stone quarrying.

 Chwarel Wynne
 A slate mine and museum occupying a 12-acre site. Includes a video presentation and half-hour tour of underground workings.

Greenfield *Valley Heritage Park*
 A 60-acre site including Abbey Farm Museum, St Winifrede's Holy Well,

industrial sites, 'Mary Williams' Knitwear' and Basingwerk Abbey. The Greenfield valley, with its metal and textile industries, was one of the most important manufacturing areas of north-east Wales.

Llangernyw *Sir Henry Jones Cottage Museum, Plas Aelas*
A small social history museum.

Llangollen *Plas Newydd, Butler Hill*
A splendid black and white house, home from 1780 to 1831 of Lady Eleanor Butler and Miss Sarah Ponsonby—'The Ladies of Llangollen'.

European Centre for Traditional and Regional Cultures (ECTARC)
An exhibition and study centre that occupies a renovated Nonconformist chapel 'that seeks to promote the traditional and regional cultures of Europe'.

Canal Museum
A museum aimed at interpreting the history of canal transport in Britain generally, with special emphasis on the Llangollen Canal that is open to pleasure craft. A passenger service to the spectacular Pontcysyllte Aqueduct four and a half miles away is a considerable attraction.

Mancot *Green Acres Farm Park, Deeside*
A developing working farm that sets out to interpret the agriculture of Clwyd.

Mold *Daniel Owen Museum*
A museum devoted to Wales's most important nineteenth-century novelist who practised as a tailor in the town.

Pentre Water Mill, Loggerheads County Park
A water-driven saw and corn mill.

Pentrefoelas *Pentrefoelas Mill*
A water-powered corn mill of 1815 in full production.

Rhyl *Museum*
A new venture opened in 1986 exploring the growth of Rhyl as one of Wales's premier seaside resorts.

Knight's Caverns
A fantastic multi-media journey through the legends, castles and rebellions of ancient north Wales. A brash exposition of history on the seafront at Rhyl.

St Asaph *Cathedral Museum*
Interprets the history of the smallest cathedral in England and Wales.

Wrexham *Wrexham–Maelor Heritage Centre*
A developing museum exploring such local themes as brick and the manufacturing, clock making and beer brewing that were once all important in the large sprawling market and industrial town.

West Wales

Aberystwyth *Aberystwyth Yesterday*
A private collection amassed by Mrs Margaret Evans with photographs and artefacts relating to the history of this university and seaside town. Housed in the Little Chapel in New Street it is shown in the summer months in a variety of venues, such as the railway station buildings.

Ceredigion Museum, Ffordd y Mor (Terrace Road)
A museum that explores the social history of the old county of Cardigan in a most effective and attractive way. It occupies the old Coliseum theatre which retains many of its original features.

National Library of Wales, Department of Pictures and Maps
A national collection of paintings, watercolours, photographs, maps and prints relating to Wales, presented in an attractive gallery. There is a constantly changing exhibition programme.

Caeo *Textile Museum, The Post Office*
A first-class private collection of mainly Welsh costume assembled by Mrs Gwenfudd James, the Caeo postmistress. Open by arrangement.

Capel Dewi *(Llandysul) Rock Mill*
A water-driven, fully working woollen mill built in 1890 by the present owner's great-grandfather. One of the few woollen mills that concerns itself with all processes of manufacture from sorting raw wool to finishing cloth.

Cardigan *Wildlife Park*
With disused slate quarry and demonstrations of coracle fishing in addition to a miscellany of wild and domestic animals, the Wildlife Park closed temporarily in 1990, pending improvements in safety. Reopened in the summer of 1991. Very little interpretation. Now owned by the West Wales Naturalist Trust.

Carew *Tide Mill*
The only surviving tide corn mill in Wales. It dates back to 1558.

Carmarthen *Carmarthen Museum, Abergwili*
Occupies the old Bishop's Palace, a mile from the centre of the county town. It is aimed at interpreting the environment, history and culture of the old

county of Carmarthen, especially the Tywi Valley.

Felin Wen
A working corn mill.

Cenarth *Cenarth Mill*
An eighteenth-century corn mill that works very occasionally; includes an art gallery.

Coracle Centre
A new venture opened in July 1991 to exhibit the variety of coracles in use on British and other rivers.

The Old Smithy Craftshop and Heritage Centre
A small commercial venture more concerned with sales than interpretation.

Cilgerran *Coracle Centre*
A modest local authority venture opened on the riverbank in 1992 to interpret the history of the Teifi coracle.

Clarbeston Road *Llys-y-Fran Country Park and Reservoir*
Interprets the natural and farming history of a modern reservoir.

Selvedge Farm Museum
A museum, with animals and vintage machines.

Clunderwen *Penrhos Cottage, Llanycefn*
A small, fully-furnished Preseli cottage with its original contents.

Cribyn *Noah's Ark Rare Breeds, Rhyd-y-Cwrt Farm*
A working smallholding, open to the public.

Crugybar *Felin Newydd*
Working water-driven corn mill said to date from 1400.

Crymych *Ffynnon Steam & Vintage Museum*
A collection of farm tools and implements; vintage and veteran cars and motorcycles. Open by arrangement and on special open days.

Cydweli *Cydweli Industrial Museum*
A developing museum occupying the site of the old tinplate works that are said to be the oidest in Britain. It sets out not only to interpret the tinplate industry, but also the general industrial development of the Llanelli district.

Cynwyl *Elfed Y Gangell, Blaenycoed*
A museum devoted to Wales's well known poet and hymnologist the Revd Elfed Lewis who was born in the cottage. Open by arrangement.

Dinefwr *Carreg Cennen Castle*
A dramatically located castle with working hill farm, rare animals and seventeenth-century long-house.

Dolaucothi *Gold Mines, Pumsaint*
Preserved gold mine with visitor centre and underground tours. Now owned by the National Trust, the mine dates from Roman times, last worked in 1938.

Dre-fach Felindre *National Woollen Museum*
Sets out to interpret the history of the woollen industry in its most important centre, once known as 'The Huddersfield of Wales'. Contains a working woollen mill (Melin Teifi), craft workshops (spinning, knitting and papermaking) and an interpretive exhibition. The exhibition is concerned with the technological development of the textile industry and its regional development in Wales. Also contains a comprehensive collection of Welsh textiles produced by contemporary craftsmen.

Glynarthen *Penbontbren Farm Museum*
A miscellaneous collection of farm and domestic equipment that forms an added attraction at the Penbontbren Farm Hotel.

Haverfordwest *Castle Museum*
Devoted to an interpretation of the old county of Pembroke and includes a substantial exhibition on the development of Haverfordwest as a centre of commerce and administration.

Kilgetty *Folly Farm*
A working farm open to the public. Includes dairying museum, restaurant and farm trails.

Laugharne *Dylan Thomas Boathouse*
A furnished house, once the poet's home. Contains interpretive panels and audio-visual presentation, all devoted to the memory of the Anglo-Welsh poet.

Letterston *Tregwynt Woollen Mill, St Nicholas*
A fully working mill producing a wide range of saleable textiles.

Llanddowror *Pant-y-rhuad*
Traditional Welsh farm of 500 acres. Both wild and domestic animals are kept. Fishing and an assault course are also available on the site.

139

Llandeilo *Gelli Aur Country Park*
Deer park and arboretum surrounding a mansion, once the country seat of the Vaughan and Cawdor families.

Llanelli *Parc Howard Museum*
Located in a Victorian mansion and containing a modest collection of local paintings and pottery.

Bwlch Farm, Bynea
Old tools and relics of agriculture and the Bynea iron industry. Of limited appeal and limited opening hours.

Trostre Tinplate Works Museum
A small museum, open by arrangement, occupying an old farmhouse adjacent to the. modern Trostre works.

Llannon *(Llanelli) Gwendraeth Valley Community Archive*
A project housed in the County Primary School.

Llanwnen *Felin yr Aber*
Restored corn mill with working pottery, vintage agricultural machinery etc.

Mathry *Llangloffan Farm, Castle museum*
A working cheese farm with a small museum of dairy untensils.

Milford Haven *Museum, Milford Docks*
A small local museum that sets out to trace the history of the town as a passenger and fishing port. Staffed entirely by volunteers.

West Wales Maritime Heritage Society
A voluntary group established in 1984 which has as one of its aims the preservation of vessels, buildings and sites in the Milford Haven waterway.

Narberth *Blackpool Mill, Canaston Bridge*
A water-driven corn mill containing a wheelwright's shop and dubious life-sized replicas of Welsh dragons and prehistoric animals.

Landsker Borderlands Tourism Centre
Explores the heritage of the borderland between 'Welsh Pembrokeshire' and 'Little England beyond Wales'.

Wilson Museum
A small local history museum established in the late 1980s and accommodated in the offices of an obsolete brewery.

Newport *Castell Henllys, Iron Age Fort, Felindre Farchog*
Living history open-air museum with reconstructions of dwellings and fortifications and craft activity. Operated by the Dyfed County Council.

Pembroke *Museum of the Home*
Small and miscellaneous collection of domestic utensils and craft work.

Pembrokeshire Coast National Park *Information Centres*
Fishguard (Town Hall), Broad Haven, Haverfordwest, Kilgetty, Milford Haven (Town Hall), Pembroke, St Davids (City Hall), Tenby.

Ponterwyd *Forest Visitor Centre, Bwlch Nant-yr-Arian*
Owned by the Forestry Commission, this centre sets out to interpret the extensive forests of north-east Ceredigion.

Llywernog Silver–Lead Mine and Museum
Occupying an old mine site, the museum sets out to present and interpret the story of lead and silver mining in mid-Wales. A visitor can follow a 'Miner's Trail' and visit a floodlit underground cavern—'The Blue Pool'—a prospecting pit of *c*.1795.

Pontsian *Llwynrhydowen Unitarian Museum*
A small museum devoted to the history of the Unitarian movement in the Teifi Valley—the centre of Unitarianism.

Porth-y-rhyd *Melin Maes Dulais*
A working flour mill.

St Davids *Farm Park Rare Breeds Survival Centre*
Located on a 20-acre site. Rural crafts and wagon rides.

Lleithyr Farm Museum, Whitesands Bay
One of the many private farm museums in adapted outhouses showing the usual variety of farm implements, tractors and dairy and domestic utensils.

Marine Life Centre
Local marine life and an interpretation of the Pembrokeshire coast.

St Dogmaels *Y Felin*
A working corn mill in full production.

Scolton *Scolton Manor Museum, Spittal*
A Pembrokeshire county museum in a country park, illustrating the agricultural, industrial, social and architectural history of south-west Wales.

Solva *Middle Mill*

A woollen mill established in 1907 mainly concerned with carpet and rug production.

Stepaside *Heritage Museum*

Interprets the remnants of a once important coal-mining and iron-founding industry in a small south Pembrokeshire village.

Tenby *Tenby Museum, Castle Hill*

A general local museum of high quality that sets out to trace the development of one of Wales's premier seaside resorts and to interpret its long history as an important trading and fishing port.

Tudor Merchants' House

A fifteenth-century town house, now owned by the National Trust, once occupied by powerful merchants who operated from what was in Tudor times the principal trading port of south Wales.

Trapp *Llwyndewi Arts and Crafts Centre*

Exhibition and demonstration of a variety of hand crafts together with a visitor centre.

Whitland *Hywel Dda Centre*

A memorial to the Welsh King who codified a system of laws (C.AD 940). The site includes a small interpretive centre.

Wiston *(Haverfordwest) Woodlands Farm Park*

A small working farm open to the public. Little interpretation.

Wolfscastle *Nantygoy Mill Tourist Centre and Museum*

A nineteenth-century flour mill that contains a miscellany of farm tools and implements and, surprisingly, a collection of over 200 jugs.

Gwent

Abergavenny *Abergavenny Museum and Castle*

A castle dating in construction from the twelfth to the fourteenth century. Contains a local museum tracing the history of this important market town, rural crafts and the obligatory 'Ye olde Welsh Kitchen'.

Museum of Childhood and Home, Market Street

Established in 1991 to display toys in a series of period rooms.

Blaenafon *Big Pit Mining Museum*

A preserved coal mine that ceased working in 1980, now open to the public as a tourist attraction, with surface buildings and a 300ft. deep mine shaft. Visitors equipped with safety lamps and helmets are guided through the sanitized pit workings. The museum aims to interpret the life and history of the south Wales coal industry.

Ironworks

The remains of the eighteenth-century ironworks now in the process of restoration. In addition to the remains of furnaces, a row of workers' cottages is being slowly refurbished.

Caerleon *Legionary Museum*

An archaeological museum displaying material from the Roman fortress of Isca, one of the most important civil and military settlements in Wales. A branch of the National Museum of Wales.

Caldicot *Caldicot Castle and Museum*

A Norman castle now famous for its 'medieval' banquets; it contains a small local history museum and an art gallery with regular temporary exhibitions.

Chepstow *Chepstow Museum, Gwy House, Bridge Street*

An excellent local history museum that explores the rich heritage of the lower Wye valley, including the once important port of Chepstow. Occupies an eighteenth-century town-house that was for some years a local hospital.

Clydach Gorge

An important early industrial valley with remains of ironworks, tramways etc.

Cwmbrân *Green Meadow Community Farm*

'Family fun days' with craft demonstrations, pony rides and 'bouncy' castle.

Cwmcarn *Scenic Drive*

A drive through a forested landscape, once an important industrial area. Little interpretation of the history of the area.

Monmouth *Monmouth Museum, Priory Street*

A local authority museum containing the Nelson Collection donated to the town by Lady Llangattock, a great admirer of the Admiral. The museum has a miscellany of local history material including a section on the motor pioneer Charles Stuart Rolls, born at Llangattock.

Newport *Museum and Art Gallery, John Frost Square*

A general town museum covering all aspects of local life from Roman

Caerwent to the Chartist Movement.

Tredegar House and Country Park, Coedkernew

A fine Restoration house, once the home of the Lords Tredegar. Now fully furnished and restored with extensive grounds, craft workshops, formal gardens and a regular programme of events and demonstrations.

Penhow *Penhow Castle*

The oldest inhabited house in Wales where Welsh life from the twelfth to the nineteenth century is interpreted.

Pontypool *The Valley Inheritance, Park Buildings*

Housed in the Georgian stables of Pontypool Park House, the exhibition and film presentation tells the story of a heavily industrialized valley. It provides the starting point to a number of attractions in industrial Gwent that are operated as branches of the main museum.

Risca *Risca Industrial Archaeology Society Museum, Pontymister School Annexe*

A miscellaneous and extensive collection of artefacts, including all the contents of a Cardiff chemist's shop. The collections were formed by members of a lively amateur society based at Oxford House Adult Education Centre, Risca. Open by arrangement only.

Ross-on-Wye *Wye Valley Farm Park, Goodrich*

Rogerstone *Fourteen Locks Canal Centre, High Cross, Newport*

Fourteen Locks Canal Centre interprets the history of the Monmouthshire and Brecknock and Abergavenny Canals. The section of canal between Risca and Newport is restored.

Sirhywi Valley Country Park

Extends from Risca to Blackwood and includes the Ynys Hywel Countryside Centre.

Skenfrith

Restored water-driven flour mill.

Tintern *The Old Station Visitor Centre*

Interprets the natural and cultural heritage of this section of the Wye Valley with emphasis on railway history.

Abbey Visitor Centre

Interprets the extensive remains of the thirteenth-century Cistercian Abbey.

Tredegar *Bryn Bach Country Park*
A developing site that accommodated the National Eisteddfod in 1990. With sporting and boating facilities this reclaimed open-cast colliery site has little interpretation of its history as an industrial centre.

Usk *Gwent Rural Life Museum, The Malt Barn*
A collection of farm wagons, implements and domestic equipment, interpreting Gwent over the last two centuries.

Wolvesnewton *The Model Farm Collection*
A collection of items of everyday farming life, mainly Victorian, housed in a late eighteenth-century bam.

Ynys Ddu *Babell Chapel*
A restored chapel in the Sirhywi Valley with an exhibition relating to the poet Islwyn (William Thomas) 1832–1878.

Gwynedd

Aberdyfi *Outward Bound Sailing Museum*
Associated with the Outward Bound School located in this once-important port.

Abergynolwyn *Village Museum, Water Street*
A small, locally run museum devoted to the history of an important slate quarrying village served by the narrow-gauge Tal-y-llyn Railway.

Bangor *Maritime Centre*
A small private museum founded in 1991 by a retired marine engineer to exhibit his miscellaneous collection.

Museum of Welsh Antiquities, Ffordd Gwynedd
A general museum with a very miscellaneous collection of artefacts relating to the history of north Wales. In 1990 due to financial stringencies, the university-run museum was in danger of closure, but through association with the local authority its future is now more certain.

Penrhyn Castle
A neo-Norman creation interpreting the wealth and taste of an important slate-quarry owning family. Now run by the National Trust, the Castle has extensive grounds and a railway collection.

Barmouth *Ty Crwn*
A medieval tower house that contains material from the fifteenth-century

Bronze Bell shipwreck in Cardigan Bay. The vessel was wrecked on the notorious Sarn Badrig with a cargo of Italian marble.

RNLI Museum, Pen-y-Cei
A small museum devoted to the history of the lifeboat service in this once important port.

Beaumaris *Museum of Childhood, Castle Street*
An evocative collection of material associated with the life of children including games, toys etc.

Beaumaris Gaol, Steaple Lane
A restored gaol, built in 1829, with adjoining court-house interpreting the theme of crime and punishment in north Wales. Includes treadmill, cells, workroom and a walk to the scaffold.

The Time Tunnel, The Green
An audio-visual presentation of the 'History of Man and Emigration from Beaumaris to the New World'. A tourist trap with 'Bouncing Castles, Punch and Judy...and Pirate Ship'.

Beddgelert *Sygun Copper Mine*
A restored small copper mine that sets out to interpret an important north Wales extractive industry.

Bethesda *Joys of Life Visitor Centre, Canolfan Bryn Derwen,*
Coed y Parc
A 12-acre site mainly devoted to models of railways.

Betws-y-coed *Conwy Valley Railway Museum*
Narrow-gauge and standard gauge railway items are on view in two buildings in a village that is one of the most frequented tourist traps in Wales. Includes an operating model railway and steam-hauled miniature railway.

Blaenau Ffestiniog *Llechwedd Slate Caverns*
A full interpretation of one of north Wales's most important industries located in a fully working quarry. With underground tours, exhibitions, working craftsmen, inn and shops.

Gloddfa Ganol Slate Mine and Mountain Tourist Centre
The Oakeley Quarries were said to be the world's largest slate complex. Today the huge quarry accommodates mining, railway and wildlife museums in surface buildings and there are tours (on foot) of underground workings and tours (by Land-Rover) of the complexes above the quarry.

Moelwyn Mill, Tanygrisiau
A restored water-driven woollen mill that contains one of the few examples of fulling stocks preserved in Britain.

Boldorgan *Henblas*
Country park with manor-house, machine and animal exhibitions. Working shire-horses, carp pond together with genuine Neolithic burial chamber on site.

Brynkir *Woollen Mill, Golan*
A fully comprehensive working woollen mill converted from an early flour and fulling mill in the early nineteenth century. The mill produces high quality flannel and quilts.

Caernarfon *Maritime Museum, Victoria Dock*
A well-designed small local museum occupying an old mortuary building. In the dock nearby the steam dredger *Seiont II* of 1937 and the Beaumaris-Bangor ferryboat the *Nantlys* are preserved. In the museum the history of Caernarfon as an important slate-exporting port and as a nursery for seamen is interpreted.

Conwy *Aberconwy House, Castle Street*
A medieval town house dating from the fourteenth century that contains an exhibition tracing the history of Conwy from Roman times to the present day.

Corris *Corris Railway Museum*
Devoted to the story of the narrow-gauge slate line that ran from Corris to Machynlleth between 1890 and 1948. Three-quarters of a mile has been relaid.

Centre for Alternative Technology, Llwyngwern Quarry
An investigative exposition of 'Living with only a small share of the world's dwindling resources and creating a minimum of pollution and waste'. A unique and fascinating establishment.

Clynnog Fawr *Museum of Old Welsh Country Life, Felin Faesog*
A miscellaneous, undocumented private collection of 'bygones' occupying an old corn-mill building.

Dolgellau *Quaker Museum and Study Centre*
Opened 1991 in an old bank building. The area around Dolgellau was a centre of Puritanism and many of the persecuted Quakers emigrated to the greater freedom of New England.

Ganllwyd *Coed y Brenin Visitor Centre*
An interpretive centre devoted to forestry, set in a forest and nature reserve.

Harlech *Old Llanfair Quarry (Chwarel Hên)*
Coastal caverns and tunnels where slate was extracted and then exported from the small creek at Llanfair. Includes a visitor centre and tour of slate workings.

Holyhead *Maritime Museum, Rhos-y-Gaer Avenue*
Established in 1986 to trace the history of one of the most important of British ferry ports. Its displays have sections on shipwrecks, marine craftsmen and the whaling industry.

Llanbedr *Maes Artro Tourist Village*
A 10-acre complex of craft workshops, gardens, model village, TV film sets, 'recreated old Welsh street' etc. designed to attract the spending tourist.

Quarry Hospital, Padarn Country Park
Refurbished works' hospital on the shores of Lake Padarn.

National Slate Museum, Gilfach Ddu
A museum located in the old Dinorwic Quarry workshops that sets out to interpret the slate industry in all parts of Wales. It is a working museum employing a number of craftsmen—splitters and dressers, blacksmiths and brass founders—associated with the large slate quarries. All the machinery is in working order.

Llandudno *Doll Museum and Model Railway*
A minor attraction in an important seaside resort.

Llandudno Museum
A new, developing museum that replaced an old established art gallery. It aims to explore the history of the planned seaside resort. 'The Alice in Wonderland' exhibition, set up because Alice Liddel the model for Lewis Carroll's work spent her holidays in Llandudno, has nothing at all to do with the heritage of Wales, but is nevertheless an attraction.

Llanddeusant *Melin Llynnon*
The last of many Anglesey windmills dating from the early nineteenth century, now fully restored.

Llanfairpwll *Plas Newydd*
An eighteenth-century house occupied by the Marquis of Anglesey and now operated by the National Trust.

Llangefni *Anglesey Heritage Gallery*
An important new venture opened in 1991. It contains the Charles

Tunnicliffe collection of bird paintings and material relating to life on the Isle of Anglesey.

Llanrwst *Gwydyr Castle*
Furnished house with Tudor and Victorian contents. Not open to the public at present.

Gwydyr Uchaf Forestry Centre
A Forestry Commission visitor facility in one of their most extensive north Wales forests.

Llanwnda *Inigo Jones & Co., Groeslon*
Fully operational slate works selling a variety of slate goods. Self-guided tour, audio and visual presentation and working craftsmen.

Llanystumdwy *Lloyd George Museum*
Devoted to one of Wales's most illustrious political figures. In addition to the interpretive museum and study centre, Lloyd George's grave, his boyhood home and other buildings associated with him may also be seen in the village.

Maesgwm *Forest Centre*
A Forestry Commission interpretation of its activities.

Nefyn *Llŷn Historical and Maritime Museum, St Mary's Church*
Displays the life and the activities of the local community, from the nineteenth century to the present day. There is a natural emphasis on seafaring and fishing, particularly that of herring fishing for which Nefyn was famous.

Penmachno *Woollen Mill and Museum*
A museum with extensive retail craft shop, associated with a working woollen mill.
Tŷ Mawr, Wybrnant
National Trust property; birthplace of Bishop William Morgan (1545–1604) the first translator of the Bible into Welsh.

Porthmadog *Ffestiniog Railway Museum, Harbour Station*
Traces the history of the important narrow-gauge railway that brought the slates of Blaenau Ffestiniog to the principal exporting port. The operational railway with its regular service is one of the main tourist attractions of the region.

Gwynedd Maritime Museum, Greaves Wharf
Housed in old quayside slate sheds, the museum contains artefacts, documents and photographs relating primarily to Porthmadog as one of the main shipbuilding and exporting ports of north Wales.

Ty'n Llan Farm Museum
A collection of farm tools and domestic and dairy equipment housed in a farm guest-house that is heavily involved in tourist activities.

Portmeirion
A small exhibition area within the unique Italian village devoted to the architectural history of Clough Williams-Ellis's creation.

Rhiw *Plas-yn-Rhiw, near Pwllheli*
A small manor house, on the west shore of Porth Neigwl, part medieval with Tudor and Georgian additions. A National Trust property.

Snowdonia National Park *Information Centres*
Aberdyfi, Bala, Betws-y-coed, Blaenau Ffestiniog, Conwy, Dolgellau, Harlech, Llanberis, Llanrwst.

Tal-y-Bont *(Bangor) Cochwillan Mill*
Fully restored com mill built originally for fulling cloth. Includes an exhibition of spinning and weaving equipment.

Tal-y-Bont *(Barmouth) Old Country Life Centre (Museum of Transport and Rural Life)*
Yet another tourist facility with 'old motors', 'old shops', 'hand-spinning in Welsh costume' and 'Model Reconstruction of Rural Scenes' and even 'Standing Stones and Burial Mounds'.

Trefriw
A fully working woollen mill complex.

Tywyn *Railway Museum, Wharf Station*
An interpretation of the narrow-gauge railway that operates as a tourist route but was once important for transporting the slates of Abergynolwyn and Aberllefenni to the Cambrian Railway at Tywyn.

Powys

Abercrave *Craig-y-Nos Castle*
The home of Adelina Patti, with theatre, restaurant etc. Limited interpretation of the opera singer's life.

Brecon *Brecknock Museum, Captain's Walk*
A general museum concerned with archaeology, folk life, decorative arts and natural history of the old county of Brecknock. With preserved Assize Court, the museum occupies a most important building in the centre of the market town.

Welsh Whisky Company, Penderyn
A developing centre interpreting the techniques of distilling and the history of Welsh 'chwisgi' and its associations with Bourbon distilling in the USA.

Brecon Beacons National Park *Information Centres*
Abergavenny, Brecon, Llandovery, Libanus (Mountain Centre).

Churchstoke *Bacheldre Mill*
Restored corn mill.

Cwm Cadlan *Forestry Centre*

Knighton *Offa's Dyke Centre*
Housed in an old school, the centre explores the history and the scenery along the dyke that separated England from Wales.

Llandrindod Wells *Lears Magical Lanterns Museum*
Opened in summer 1991 to show the equipment of lantern projection with a constantly changing slide presentation.

Llandrindod Wells Museum, Temple Street
A museum of the old county of Radnor with archaeological collections, dolls and a special exhibition devoted to the development of this principal spa town of mid Wales.

Victorian week
In the early 1980s a Victorian week 'with people dressed in appropriate costume' and an extensive programme of 'Victorian entertainment' was instituted. In 1990 grants became available for the 'Victorianization' of the important Edwardian spa town. New shop fronts and replica street lamps have made an appearance in the main streets. The visitor can still 'take the waters' at the Rock Park.

Llanidloes *Museum of Local History and Industry, Old Market Hall*
Occupying the impressive black and white market hall, the modest museum sets out to trace the economic and social history of a small country town, once important as a centre of the woollen and leather trades.

Llanwrtyd Wells *Cambrian Factory*
A woollen mill dating from 1820, now concerned with the employment of disabled people to produce a wide range of textiles. Now closed.

Montgomery *The Old Bell Museum, Arthur Street*
Interprets the history of the small town whose street pattern has remained

unchanged from the thirteenth century. The museum is accommodated in The Old Bell Inn.

Newtown *Robert Owen Museum, Davies Memorial Gallery*
Devoted to a history of the founder of the Co-operative Movement and socialist pioneer who only spent the first four years of his life in this once important manufacturing town.

Textile Museum, Commercial Street
A museum that occupies the third and fourth floors of an old flannel-weaving factory in a town once known as 'The Leeds of Wales'.

Penegoes *(near Machynlleth), Felin Crewi*
A working flour mill.

Rhaeadr *Rhaeadr Museum*
Established in 1986 as an interpretive exhibition tracing the history of a modest market town.

Trefeca *(near Talgarth) Howell Harris Museum*
Devoted to a presentation of the leader of the eighteenth-century Methodist Revival who also carried out experiments in economic and social planning at his 'Trefeca Settlement'.

Welshpool *Powysland Museum and Montgomery Canal Centre*
A museum established originally by the well-known county historical society, the Powysland Club. A new museum on the banks of the canal was opened in 1990 and this sets out to interpret the archaeology and the history of the old county of Montgomery.

Powys Castle
Medieval castle, fully furnished. Built c.1200 and occupied since its construction by members of the Herbert family. A National Trust property.

Mid-Glamorgan

Aberdare *Dare Country Park*
A developing museum and visitor centre, with little to show at present, on a reclaimed industrial site.

Bridgend *Constabulary Museum, Police Headquarters*
A museum open by appointment, tracing the history of law and order in south Wales.

Bryngarw *Country Park*
Caerffili *Mountain Centre*
A small developing venture interpreting the environment of the hill area between Cardiff and Caerffili.

Cefn Cribwr
A museum and visitor centre located in an old signal box interpreting the Porthcawl and Llyfni Valley Railway.

Llantrisant *Model House, Bullring*
Craft and Design Centre with exhibitions and working craftsmen.

Merthyr Tudful *Cyfarthfa Castle Museum*
Occupies the castellated mansion of a nineteenth-century iron-master and sets out to interpret the development of a town that was one of Wales's most important industrial centres.

Heritage Sites
A number of sites ranging from early furnaces to Trevithick's Tunnel, from Nonconformist chapels to the Dowlais stables, all of which explore the significance of the town as a centre of industry. At the Ynysfach Engine House, the story of iron is presented.

Joseph Parry Museum
A terraced house devoted to the memory of Joseph Parry, a composer born in Merthyr, although much of his adult life was spent in the USA and Aberystwyth.

Taf Fechin Visitor Centre
Concerned with the interpretation of the reservoir complex in the Brecon Beacons.

Pontypridd *Historical and Cultural Centre, Bridge Street*
Occupying an old Nonconformist chapel, the centre explores the theme 'Pontypridd—Gateway to the Valley'. While emphasizing the industrial and transport history of the town, the museum also contains an exhibition of Welsh chapels.

Porthcawl *Porthcawl Museum, Old Police Station*
A modest museum devoted to the story of Porthcawl, once an important coal-exporting port but now a somewhat brash seaside resort.

Rhondda *Forest Centre*
Scenic walks with little interpretation.

Trehafod *Rhondda Heritage Park and Visitor Centre*

A new venture on the site of the old Lewis Merthyr, Ty Mawr Colliery that sets out to interpret the unique Rhondda Valleys. It aims to be a major attraction developing such themes as the story of coal, the choral tradition and the social, economic and political traditions of the Rhondda.

Rhymney Valley *Museums*

A series of small museums in preserved buildings aimed at interpreting the most industrialized and perhaps the most depressed of all the south Wales Valleys. A sixteenth-century farmhouse (Llancaiach) and a row of workers' cottages (Butetown), together with pit buildings are the most important in this presentation of the Valley.

South Glamorgan

Cardiff *Cardiff Castle*

The impressive Victorian Gothic structure designed by William Burges, the castle stands on earlier Norman foundations in the heart of the capital city. It houses a collection of material relating to the civic affairs of the capital. The castle itself is fully furnished.

National Museum of Wales, Cathays Park

A multi-disciplinary institution aimed at 'teaching the World about Wales and the Welsh people about the Land of their Fathers'. The museum accommodates five departments—Art, Archaelogy, Geology, Botany and Zoology—all aimed at interpreting the natural and cultural heritage of Wales.

Cowbridge *Old Hall Exhibition Centre, High Street*

Exhibitions held at regular intervals in this historically important market town, the main town of the Vale of Glamorgan.

Pendoylan *Llanerch Vineyard, Hensol Castle*

An active vineyard established in 1985 producing 'Cariad' wines. Includes a visitor centre.

St Fagans *National History Museum*

One of the largest European folk museums, St Fagans sets out to record and interpret the character of the whole of Wales. It occupies a 100-acre site and in addition to the Elizabethan mansion house of St Fagans Castle, it accommodates re-erected buildings that are representative of the traditions of Wales. Farmhouses and cottages, workshops and public meeting places have been re-erected and fully and authentically furnished. Working craftsmen—woodturner, cooper, clogmaker, weaver, potter, blacksmith, saddler, miller and baker—produce goods for sale to the public. The non-material objects of Welsh

culture—music, drama, folklore, customs as well as the Welsh language—are also interpreted.

Southerndown *Glamorgan Heritage Coast*
Explores the landscape and historical associations of an attractive and economically important stretch of coastline. Contains an Information Centre and publishes a series of guides.

West Glamorgan

Abercrave *Dan-yr-Ogof Caves*
Includes museum, audio-visual theatre and dinosaur park.

Aberdulais *Falls and Historic Site*
Waterfalls associated with important industrial development, especially iron making. One of the most important sites in south Wales developed by the National Trust.

Crynant *Cefn Coed Collliery Museum*
Museum and Steam Centre housed in the surface workings of an old colliery. The steam boilers that served the colliery are still in place. The adjacent Blaenant Colliery that provided the right atmosphere for the development of the museum was in production until May 1990 but with the closure, the museum has lost some of its relevance as a heritage site.

Cynonville *Welsh Miners' Museum, Afan Argoed Country Park*
Sets out to trace the technology of coal-mining but also the story of south Wales miners—their families, struggles and achievements.

Knelston *Gower Farm Museum*
Miscellaneous collection designed to show the life of a Gower family over the centuries. Owned by a caravan company.

Margam *Country Park*
Eight hundred acres of open parkland used for leisure activities but including a Museum of Monumental Stone, Sculpture Park, Orangery, a partly derelict mansion, an interpretive exhibition and a herd of wandering deer.

Neath *Canal*
A 4-mile stretch of the Neath and Tennant Canal near Resolven is being restored and interpreted. This together with the Aberdulais Basin will be a major attraction.

Neath Borough Museum, 4 Church Place
A small but developing museum devoted to the history of this industrial town.

Parkmill *Y Felin Ddwr*
Crafts and countryside centre in a restored water mill, said to date from the fourteenth century.

Rhosili *Visitor Centre*
Sets out to interpret the scenically beautiful western tip of the Gower Peninsula. Run by the National Trust.

Seven Sisters *Museum and Saw Mills*
Includes 'Gunsmoke Cowboy Town', Honeysuckle Grove model cottages, mining lamps collection and sawmills.

Swansea *Glynn Vivian Art Gallery, Alexandra Road*
A first-class art gallery with much material relating to Swansea, especially marine paintings and a fine display of ceramics.

South Dock
A developing museum, operated by Swansea City Council, that sets out to trace the history of the industry in Swansea and the valleys of West Glamorgan. It has a substantial maritime section with preserved ships in the reclaimed dock nearby. The Maritime Quarter of Swansea is a first-class example of urban regeneration and the museum and some preserved dockside buildings form a very important element of the exciting development of a once derelict area.

Swansea Museum, The Royal Institution of South Wales
The oldest museum in Wales still maintained by the learned members of the Society that owns the temple-like building. In 1990 the future of the museum was in jeopardy, but with the involvement of the local authorities it will be possible for the institution to continue. The collections of Swansea pottery are outstanding and the museum displays much of historical significance.

Vale of Neath *Country Park*
Includes Gnoll Estate with interpretive centre, Aberdulais Riverside Park and Craig Gwladys.

AN INVENTORY OF CASTLES
OPEN TO THE PUBLIC

Abergavenny, Gwent
Fragments of a twelfth-century castle which once belonged to the notorious William de Braose. The local Abergavenny Museum neighbours it.

Aberystwyth, Dyfed
One of Edward I's first castles completed by 1279. Taken by Owain Glyndŵr in 1404. During the Civil War of the seventeenth century there was a mint within the castle.

Beaumaris, Gwynedd
The castle begun in 1295 was the last and largest of Edward I's Welsh castles, planned on a grand scale.

Beaupre, South Glamorgan
A fourteenth-century fortified residence occupied by the Bassett family, largely rebuilt in the sixteenth century.

Bodelwyddan, Clwyd
A nineteenth-century edifice built on the site of a fifteenth-century house. Bodelwyddan now accommodates a branch of the National Portrait Gallery.

Brecon, Powys
A ruined medieval castle once the centre of power of the Lordship of Brycheiniog.

Bronllys, Powys
The remains of a marcher fortress first established in the eleventh century.

Bryn Bras, Llanrug, Gwynedd
An extravagant sham castle built in the 1830s.

Caernarfon, Gwynedd
The finest and most complete of Edward I's castles. It contains its full history and accommodates the splendid Royal Welch Fusiliers' Museum.

Caerffili, Mid Glamorgan
A very large castle occupying a site of 30 acres. Built on the site of a Roman

fort, the castle saw many battles until the seventeenth century when action in the Civil War is said to have produced its famous leaning tower.

Caldicot, Gwent

A Norman castle occupying a site of strategic importance from Roman times. The castle contains a local history museum and its hall is used for popular, 'medieval' banquets with musicians and mead.

Cardiff, South Glamorgan

A creation of the Victorian architect, William Burges, who designed this extravagant complex for the immensely rich Third Marquis of Bute. Built on the site of a Roman and Norman fortress.

Cardigan, Dyfed

A ruined Norman fortress overlooking the river Teifi. Closed to the public.

Carew, Dyfed

An attractive water-side castle built between 1280 and 1310.

Carmarthen, Dyfed

A hill-top castle, overlooking a bridging point on the river Tywi.

Carreg Cennen, Llandeilo, Dyfed

A spectacularly located thirteenth-century castle built on a limestone crag 300 feet above the Cennen Valley.

Castell Coch, South Glamorgan

A romantic fairy-tale edifice created by the Third Marquis of Bute and his architect William Burges.

Castell y Bere, Abergynolwyn, Gwynedd

A stronghold of Welsh princes, nestling at the foot of Cadair Idris. Built by Llywelyn the Great in the thirteenth century.

Chepstow, Gwent

A large castle built in the eleventh century, high above the Wye.

Chirk, Clwyd

A much altered castle built originally by Edward I and occupied continuously by the Myddleton family since 1595.

Cilgerran, Dyfed

A spectacularly located castle built on a rocky cliff overlooking a gorge of the river Teifi.

Coety, Bridgend, Mid Glamorgan
The remains of a Norman fortress occupied in the Middle Ages by the very influential Turberville family.

Conwy, Gwynedd
Dating from 1283, Conwy Castle remains one of the finest of medieval fortresses.

Cricieth, Gwynedd
A coastal fortress overlooking Tremadog Bay built originally for the Welsh princes and taken over by the English invaders. Attacked and burnt by Owain Glyndŵr in 1404.

Crickhowell, Powys
A ruined marcher fort once a major castles of medieval Brycheiniog.

Cydweli, Dyfed
A well preserved early twelfth century castle that was of key importance in the conquest of south-west Wales.

Cyfarthfa Castle, Merthyr Tudful, Mid Glamorgan
Built in 1824–5 for the rich iron-master William Crawshay II. Contains the Merthyr Tudful Museum.

Denbigh, Clwyd
Overlooking the Vale of Clwyd, Denbigh castle was, like many castles in north Wales, designed by James of St George, master of Edward I's building operations in north Wales.

Dinas Bran, Llangollen, Clwyd
An almost impregnable stronghold built by Madog, Prince of Powys *c.* 1270.

Dinefwr, Llandeilo, Dyfed
Seat of the all-powerful Lord Rhys, Prince of South Wales. Following the Battle of Bosworth in 1485, Henry VII made a gift of the castle to his great supporter Sir Rhys ap Thomas.

Dolbadarn, Llanberis, Gwynedd
A spectacularly located castle of the Welsh princes, above Lake Padarn.

Dolforwyn, Abermiwl, Powys
A Welsh fort built by Prince Llywelyn the Great to overlook the English Lordship of Montgomery. Decayed since the fourteenth century.

Dolwyddelan, Gwynedd
A thirteenth-century Welsh castle built around 1200 to guard an important mountain pass, conquered by the English in 1283.

Dryslwyn, Llandeilo, Dyfed
Originally built by the Welsh Lord of Dryslwyn but conquered by Edward I in 1287 after a revolt by the last Welsh lord, Rhys ap Maredudd. Now in ruins.

Ewloe, Hawarden, Clwyd
A castle of the Princes of Gwynedd. Hidden in a wooded hollow, the building was constructed *c.* 1210.

Flint, Clwyd
The first of Edward I's fortresses. The castle was built in 1277 as part of his campaign for the subjugation of north Wales.

Grosmont, Gwent
One of the three castles in northern Gwent (with Skenfrith and White Castle) built by the Normans to control an important route into Wales.

Harlech, Gwynedd
A spectacularly located castle built by James of St George for Edward I as one of the ring of castles surrounding Snowdonia.

Haverfordwest, Dyfed
Built in the mid-twelfth century by the powerful Earl of Pembroke, in a town that was of considerable commercial importance.

Hawarden, Clwyd
The remains of the first castle on the English-Welsh border. The defences at Hawarden proved very vulnerable to Welsh attacks.

Hay-on-Wye, Powys
Little remains of this border castle that was frequently attacked.

Laugharne, Dyfed
Ruins of a twelfth-century Norman castle on the bank of the river Taf.

Llansteffan, Dyfed
A twelfth-century castle built on a hill overlooking the Tywi estuary, occupying the site of an Iron Age fort.

Llawhaden, Dyfed
An ecclesiastical stronghold described by Giraldus Cambrensis in 1175.

Rebuilt in the fourteenth century as a residence for important clergy with quarters for a permanent garrison.

Loughor, West Glamorgan

Scanty remains of a twelfth-century castle built on the site of an important Roman fort at a bridging point on the River Loughor.

Manorbier, Dyfed

The birthplace of Giraldus Cambrensis—Gerald the Welshman. A Norman castle that was of importance in the conquest of south-west Wales. Due to the durability of the local limestone, the castle is very well preserved.

Monmouth, Gwent

The birthplace of King Henry V. Built in the twelfth century to command the two important crossings of the rivers Wye and Monnow.

Montgomery, Powys

Built by Henry III between 1223–34 on a high rock above the Severn.

Narberth, Dyfed

Fragmentary remains of a once important Pembrokeshire fortress.

Newcastle, Bridgend, Glamorgan

This castle on the bank of the river Ogmore was once in the hands of the Norman Lords of Glamorgan.

Newcastle Emlyn, Dyfed

A Welsh native castle built on a hill, overlooking a loop of the river Teifi. Much of it was demolished in the Civil War.

Ogmore, Mid Glamorgan

The remains of a Norman castle built in the twelfth century by Robert Fitzhamon.

Oxwich, West Glamorgan

The ruins of a house built in the sixteenth century on the site of an earlier castle.

Oystermouth, Swansea, West Glamorgan

Built by the notorious de Braose family in the late thirteenth century on the site of an earlier castle.

Pembroke, Dyfed

Built in the eleventh century, overlooking Milford Haven.

Penhow, Gwent

A well-maintained medieval fortified manor-house.

Pennard, West Glamorgan

Built around 1300 but abandoned by 1400. The scanty remains of the castle are largely covered with sand.

Penrhyn, Bangor, Gwynedd

A neo-Norman edifice built for the rich nineteenth-century Pennant family who drew their wealth from the Bethesda slate quarries.

Picton, Haverfordwest, Dyfed

A thirteenth-century castle that has been extensively restored to provide an art gallery for the work of Graham Sutherland.

Powys, Welshpool, Powys

A fortress that has been occupied as a home since it was built in the thirteenth century.

Raglan, Gwent

A well preserved fifteenth-century castle built on the site of a Norman fort.

Rhuddlan, Clwyd

Built between 1277 and 1282 on the site of an earlier Welsh princely seat. In 1284 the Great Statute of Wales—a landmark in the political history of the country—was issued from here.

Rhuthun, Clwyd

A castle built as a link in Edward I's conquest of north Wales. Considerably altered over the centuries and now serving as a luxurious hotel, famous for its 'medieval' banquets.

Skenfrith, Gwent

Held in common ownership with Grosmont and White Castle as the 'Three Castles' that dominated the life of northern Gwent in the Middle Ages.

Swansea, West Glamorgan

The scanty remains of a castle built by the Earl of Warwick.

Tenby, Dyfed

A spectacularly located coastal fortress dating from the mid-twelfth century. Now accommodates the splendid Tenby Museum.

Tretower Court, Crickhowell, Powys

A fortified manor-house, most of it dating from the fourteenth century.

Usk, Gwent

A small thirteenth-century castle, much of it in ruins but with an occupied gatehouse.

Weobley, Gowerton, West Glamorgan

A beautifully located castle overlooking Llanrhidian sands, built as a fortified house in the thirteenth century.

White Castle, Uantilio Crosseny

One of the 'Three Castles of Gwent' dating from the twelfth century.

MAPS

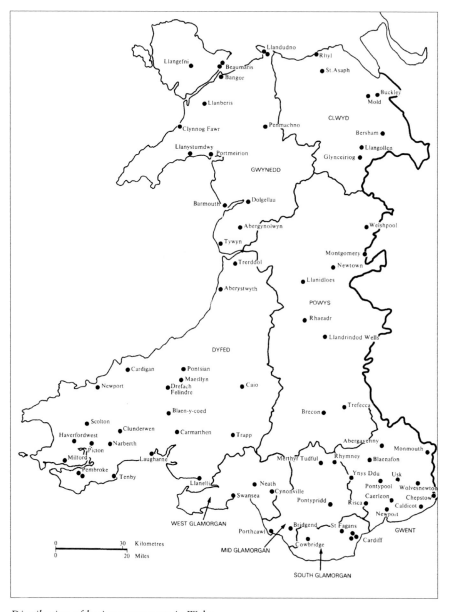

Distribution of heritage museums in Wales

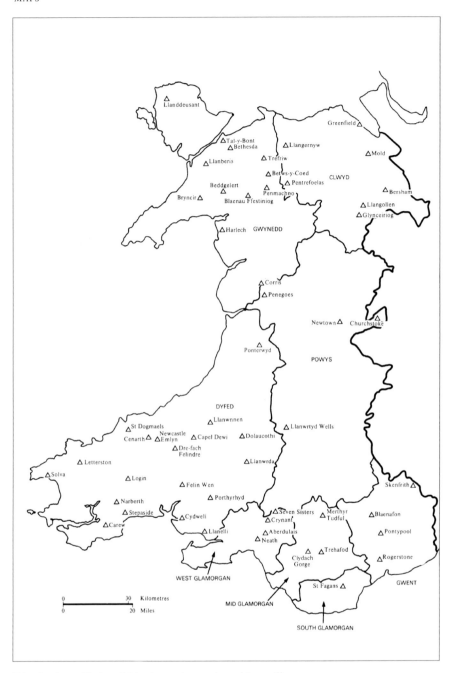

Llanddeusant

Greenfield△

△Tal-y-Bont
△Bethesda △Llangernyw △Mold
△Llanberis △Trefriw
 △Betws-y-Coed CLWYD
Beddgelert △Pentrefoelas
△ △ △Bersham
Bryncir△ Penmachno △Llangollen
 Blaenau Ffestiniog △Glynceiriog

△Harlech GWYNEDD

 △Corris
 △Penegoes

 Newtown△ △Churchstoke

 △
 Ponterwyd

 POWYS

 DYFED
 △Llanwnnen
△St Dogmaels
 Newcastle △Capel Dewi △Dolaucothi △Llanwrtyd Wells
Cenarth△ △Emlyn
 △Dre-fach
 Felindre △Lianwrda
△Letterston
△Solva △Login △Felin Wen Skenfrith△
 △Porthyrhyd
△Narberth △Seven Sisters △Merthyr △Blaenafon
△Stepaside △Cydweli △Crynanf Tudful
△Carew △Pontypool
 △Llanelli △Aberdulais
 △Neath
 △ △Trehafod △Rogerstone
 Clydach
 Gorge
WEST GLAMORGAN St Fagans △ GWENT

 MID GLAMORGAN

0 30 Kilometres
0 20 Miles

SOUTH GLAMORGAN

Distribution of industrial heritage sites and working mills

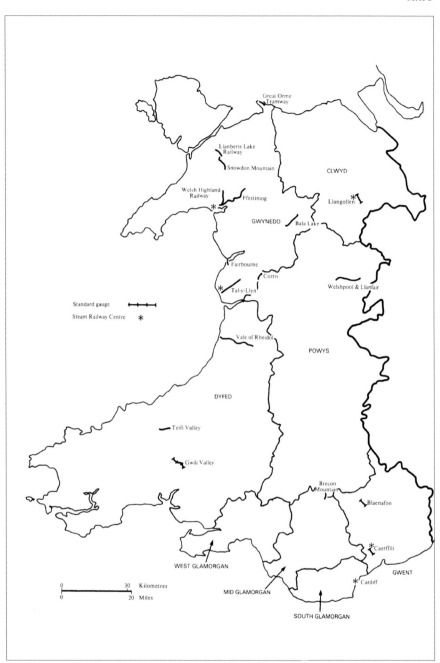

Great little trains of Wales

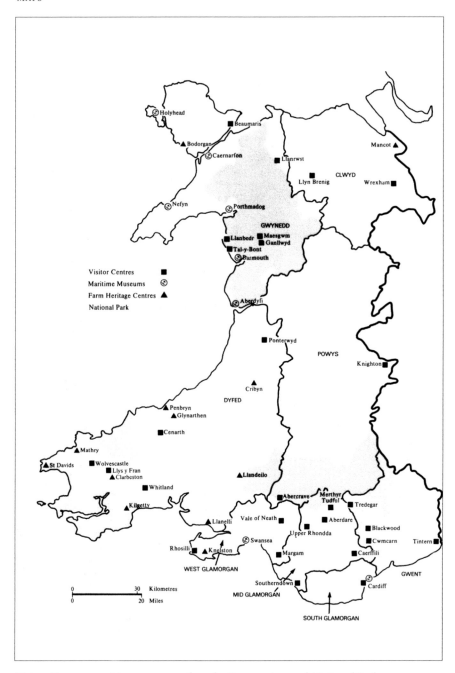

Visitor Centres, maritime museums, farm heritage centres and National Parks

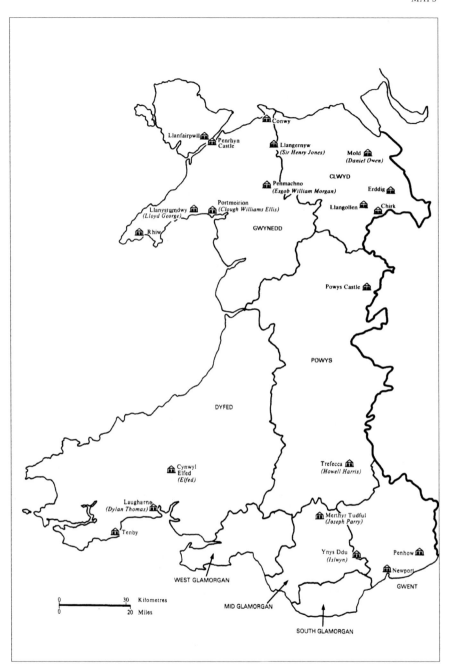

Houses open to the public

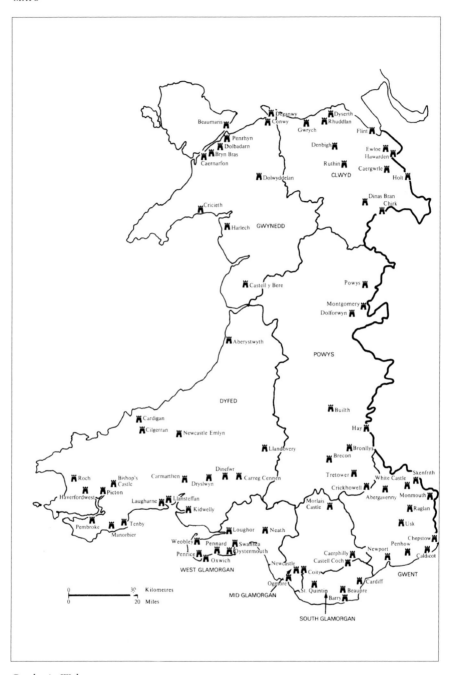

Castles in Wales

INDEX